P9-CCZ-994

A PLUME BOOK

WHY DOES BATMAN CARRY SHARK REPELLENT?

PAUL TALANIAN

BRIAN CRONIN is the writer and producer of the *Comics Should Be Good* blog at Comic Book Resources (www.cbr.cc). He has been writing the online column "Comic Book Legends Revealed" since June 2005. He has a JD from Fordham Law School and is a member of the New York State Bar. For more legends about the world of sports and entertainment, check out www.legendsrevealed.com.

WHY DOES BATMAN CARRY SHARK REPELLENT?

AND OTHER AMAZING COMIC BOOK TRIVIA!

BRIAN CRONIN

A PLUME BOOK

Valley Community Library
739 River Street
Peckville, PA 18452-2313

PLUME
Published by the Penguin Group
Penguin Group (USA) Inc., 375 Hudson Street, New York, New York 10014, U.S.A. • Penguin
Group (Canada), 90 Eglinton Avenue East, Suite 700, Toronto, Ontario, Canada M4P 2Y3 (a
division of Pearson Penguin Canada Inc.) • Penguin Books Ltd., 80 Strand, London WC2R 0RL,
England • Penguin Ireland, 25 St. Stephen's Green, Dublin 2, Ireland (a division of Penguin
Books Ltd.) • Penguin Group (Australia), 250 Camberwell Road, Camberwell, Victoria 3124,
Australia (a division of Pearson Australia Group Pty. Ltd.) • Penguin Books India Pvt. Ltd., 11
Community Centre, Panchsheel Park, New Delhi – 110 017, India • Penguin Group (NZ), 67
Apollo Drive, Rosedale, Auckland 0632, New Zealand (a division of Pearson New Zealand Ltd.)
• Penguin Books (South Africa) (Pty.) Ltd., 24 Sturdee Avenue, Rosebank, Johannesburg 2196,
South Africa

Penguin Books Ltd., Registered Offices: 80 Strand, London WC2R 0RL, England

First published by Plume, a member of Penguin Group (USA) Inc.

First Printing, June 2012
10 9 8 7 6 5 4 3 2 1

Copyright © Ghost of Electricity, Inc., 2012
All rights reserved

Pages 259–262 constitute an extension of this copyright page.

℗ REGISTERED TRADEMARK—MARCA REGISTRADA

LIBRARY OF CONGRESS CATALOGING-IN-PUBLICATION DATA

Cronin, Brian.
Why does Batman carry shark repellent? : and other amazing comic book trivia! / Brian Cronin.
p. cm.
ISBN 978-0-452-29784-5
1. Comic books, strips, etc.—Miscellanea. I. Title.
PN6725.C765 2012
741.5'973—dc23 2011045699

Printed in the United States of America
Set in Chaparral Pro with Cartoon Com and Aptifer Sans LT Pro
Designed by Daniel Lagin

Without limiting the rights under copyright reserved above, no part of this publication may be
reproduced, stored in or introduced into a retrieval system, or transmitted, in any form, or by
any means (electronic, mechanical, photocopying, recording, or otherwise), without the prior
written permission of both the copyright owner and the above publisher of this book.

PUBLISHER'S NOTE
While the author has made every effort to provide accurate telephone numbers and Internet
addresses at the time of publication, neither the publisher nor the author assumes any respon-
sibility for errors, or for changes that occur after publication. Further, the publisher does not
have any control over and does not assume any responsibility for author or third-party Web sites
or their content.

The scanning, uploading, and distribution of this book via the Internet or via any other means
without the permission of the publisher is illegal and punishable by law. Please purchase only
authorized electronic editions, and do not participate in or encourage electronic piracy of copy-
righted materials. Your support of the author's rights is appreciated.

BOOKS ARE AVAILABLE AT QUANTITY DISCOUNTS WHEN USED TO PROMOTE PRODUCTS OR SER-
VICES. FOR INFORMATION PLEASE WRITE TO PREMIUM MARKETING DIVISION, PENGUIN GROUP
(USA) INC., 375 HUDSON STREET, NEW YORK, NEW YORK 10014.

FOR MY PARENTS, **EUGENE AND KATHLEEN,**
WHO BOUGHT ME MY FIRST COMIC BOOKS,
AND FOR MY WIFE, **MEREDITH,** WHO KEEPS
READING THEM WITH ME

CONTENTS

CONTENTS

PART III: COMIC BOOK STORYLINES ⟨83⟩

CONTENTS

PART V: **COMICS AND CULTURE** (183)

PART VI: COMIC BOOK MOVIES AND TV SHOWS (225)

ACKNOWLEDGMENTS

Love and thanks to Meredith, my parents, and my siblings for their love and support.

Thanks to my agent, Rick Broadhead, and my editor at Plume, Kate Napolitano. Thanks to Jonah Weiland and Comic Book Resources (particularly Stephen and Kiel) and the rest of my gang at *Comics Should Be Good* (the Gregs, Bill, Mark, Scott, Chad, Kelly, Sonia, and Megan), plus Joe, Alex, Tadhg, and the Pauls for starting the whole thing with me!

Gigantic thanks, of course, to all the comic book writers and artists who provided lists for the book. You folks went above and beyond the call of duty and I'm awfully grateful!

Thanks also to the following people who helped with the information provided on some of the lists in the book: Mark Engblom, H, Robby Reed, DSK, Kurt Mitchell, Ed Bosnar, Kris Withak, Mark Evanier, Matchstick, Pat Curley, Steven Thompson, Vinnie Bartilucci, and Len Callo. Plus, general thanks to Wayne Hotu, Rob Williams, and Jeremy Goldstone.

Finally, I wish to give thanks to Mrs. Eleanor Spillett and Ms. Virginia Courtney for being the first teachers to make comic book reading seem more than just tolerated, and thanks to Professor Richard Hamm for demonstrating the fascinating aspect of mixing popular culture with history.

INTRODUCTION

I'VE GOT THE STRANGEST FEELING
I'M BEING TURNED INTO A PUPPET.

—The Flash, from the cover of 1962's
***The Flash* #133**

There is a kind of delightful absurdity that you can only find in comic books—a world where a character can say, in all sincerity, that he has the feeling he is turning into a puppet and the audience just keeps reading on as if that statement makes perfect sense. This book is a celebration of that special absurdity, as we dissect the history of comic books with a series of lists. The lists are based on the various features that I have been doing at my comic book blog, *Comics Should Be Good*, for the past seven years. A number of the lists feature the results of popularity polls voted on by readers of Comic Book Resources (the largest online comic book community in North America) while others detail strange pieces of comic book history, like the craziest items Batman has carried in his utility belt (including, as you might have guessed, a particular type of aquatic animal repellent).

The lists are grouped into six parts. One for lists about comic book characters, one for lists about comic book creators, one for lists

about comic book storylines, one for lists that go "beyond the panels" (like comic book covers and strange comic book ads, like ones for X-ray glasses), one for lists about the crossover between comic books and pop culture (like notable rock bands that have taken their names from comic books), and finally, one for lists about movies and television shows based on comic books. Intermixed among my lists are a number of lists from various notable comic book writers and artists, including *Kick-Ass* creator Mark Millar and Dave Gibbons, cocreator of *Watchmen*.

Something you'll likely realize after you are finished reading is that while, yes, comic books *do* enjoy that special kind of absurdity I mentioned before, there is a certain nobility to them as well. After all, one of the most famous comic book quotes is the mantra Peter Parker lives his life by: "With great power comes great responsibility" (a quote, by the way, that Peter credits to his uncle Ben even though we never actually see Uncle Ben say it in the comics—see, you're learning stuff already!).

I hope you enjoy this collection!

Brian Cronin

WHY DOES BATMAN CARRY SHARK REPELLENT?

PART I

COMIC BOOK CHARACTERS

TEN CRAZY ITEMS FOUND ON BATMAN'S UTILITY BELT

Batman's utility belt is one of his most powerful weapons in his fight against crime, containing all sorts of important tools: explosives, "Batarangs," and the ever-so-specific "choking gas." It also holds something else: the ability to overcome seemingly insurmountable situations! Over the years, whenever a writer has needed a particular plot device, Batman's utility belt has magically held the answer. Convenient, eh? Here are ten of the craziest things found on it and how they were used:

1. **Aquatic "sound recorder"** (*Batman* #117). While on another planet for a mission, Batman uses a "sound recorder" to listen to footsteps on the bottom of the ocean while tracking an undersea creature.

2. **Bat-freeze pill** (*Detective Comics* #362). When the Riddler creates a bomb that is set off by body heat, Batman conveniently pulls out a "Bat-freeze pill" from his utility belt that lowers his body temperature enough to deactivate the bomb.

3. **Batman balloon** (*Batman* #115). Batman is transported back in time, where he must save a village from some dastardly bad guys.

He inflates a giant Batman balloon, which convinces them that he's a huge, all-powerful genie, and scares them off.

④ **Batman costume** (*Batman* #71). Always prepared for emergencies (fashion or otherwise), Batman carries a special lightweight version of his costume inside his utility belt. It comes in handy during this issue, when he disguises a bad guy as Batman to fool the rest of his crew.

⑤ **A crayon** (*Batman* #149). While riding aboard a runaway train, Batman remarks how lucky it is that both he and Robin carry crayons with them at all times, as it allows them to draw a (surely very convincing) stop sign that they throw into the street to prevent traffic from being struck by the train.

⑥ **Geiger counter** (*Batman* #117). While on a mission to another planet, Batman conveniently has a miniature Geiger counter that allows him to track a radioactive monster.

⑦ **Makeup kit** (*Batman* #4). Batman uses a makeup kit from his utility belt to make himself look exactly like a professional football quarterback who has been kidnapped by a gambling ring in an effort to throw the "big game." Not only is he a convincing doppelgänger but he is also, unsurprisingly, great at football and wins the big game.

⑧ **Marble** (*Detective Comics* #173). Batman and Robin have some pretty unique uses for an ordinary marble. If you roll it down steps, it simulates footsteps, and if you place it under your arm, it stops your pulse so that you can feign death. Don't question the logic of it—if Batman says it stops the pulse, it must!

⑨ Secret identity disc (*Detective Comics* #185). In this issue, Batman debuts a new addition to the belt—a small disc that, when treated with a special chemical, reveals Batman's true identity. Batman's theory is that if he is ever in a situation where he is near certain death, he would use the chemicals to let everyone know who Batman really was, to ward off anyone trying to take advantage of his death to impersonate him.

⑩ Shark repellent. Shark repellent has made not one, but two appearances in the world of Batman. In the 1966 *Batman* film, Batman uses "shark-repellent Bat-Spray" to dislodge a shark that attached itself to his leg while he was climbing down the Bat Ladder (yes, it is actually labeled "Bat Ladder") from the Bat-Copter to a yacht, after getting a tip that the owner of the yacht was in danger. Interestingly enough, the shark-repellent Bat-Spray did *not* come from Batman's utility belt: Robin tosses it to Batman, with excellent timing, too. Unbeknownst to Batman, the shark had a time bomb inside of it designed to blow up when Batman was nearby.

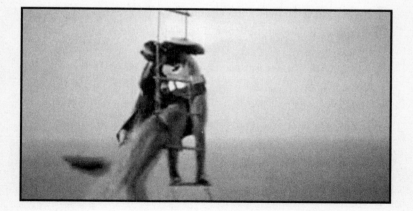

Amazingly enough, though, Batman actually used shark repellent in his utility belt eight years earlier, in *Batman* #117. While on a mission to another world, Batman used the shark repellent within his utility belt to distract an underwater monster.

FIFTEEN ALLITERATIVE COMIC BOOK NAMES CREATED BY STAN LEE

During the early 1960s, when Marvel began putting out superhero comics again after avoiding the genre for most of the 1950s, Stan Lee was scripting practically every series. Lee was also the only editor Marvel had, so he only had himself to rely on when it came to correcting errors in character names. Lee devised a trick to help himself remember the names of his characters: he would use alliteration. Here are thirteen of Stan Lee's most famous alliterative names from Marvel Comics during the 1960s, plus two he invented by accident.

1. Peter Parker (Spider-Man's alter ego)
2. J. Jonah Jameson (publisher of the *Daily Bugle* and Peter Parker's boss)
3. Betty Brant (Jameson's secretary at the *Bugle* and Peter Parker's first girlfriend)
4. Otto Octavius (*Spider-Man* villain Doctor Octopus's alter ego)
5. Curt Connors (friend of Spider-Man, also transforms into the evil Lizard)
6. Bruce Banner (the Hulk's alter ego)
7. Reed Richards (Mister Fantastic of the Fantastic Four)
8. Sue Storm (Invisible Girl of the Fantastic Four)
9. Doctor Doom/Victor Von Doom (the Fantastic Four's nemesis works either way!)

(10) Scott Summers (Cyclops of the X-Men)

(11) Warren Worthington (Angel of the X-Men)

(12) Matt Murdock (Daredevil)

(13) Stephen Strange (Doctor Strange, Sorcerer Supreme)

And the two accidental ones? They are:

(14) Peter Palmer (In the first printing of *The Amazing Spider-Man* #1, Lee twice accidentally called Peter Parker Peter Palmer—it was corrected in further reprintings of the issue.)

(15) Bob Banner (Lee accidentally referred to Bruce Banner as Bob on more than one occasion. This error led Lee to reveal that Bruce is Banner's *middle* name, and the name that he normally goes by. Clever, Stan!)

FIVE WEIRDEST MEMBERS OF THE GREEN LANTERN CORPS

When one of your primary members looks sort of like a chicken (Tomar-Re), the bar is pretty high to be considered one of the oddest members of the Green Lantern Corps. The following five members meet that challenge.

(1) **Apros.** Apros was one of the longest-serving and highly decorated members of the Green Lantern Corps. He also happened to be one of the weirdest looking, appearing to be some sort of cross between a jellyfish and a plant. Since he had no mouth, his primary method of communication was telepathy, which helped him be a sort of spiritual adviser to the corps.

(2) **Ch'p.** Ch'p, well, looked like a chipmunk. He served honorably with the corps for years, being one of the few Green Lanterns to main-

tain their ring when the central Green Lantern battery was destroyed during the 1980s. Sadly, Ch'p met his end when he was hit by a yellow tractor trailer (with all of its powers, the ring can't protect against anything yellow).

③ **Bzzd.** Bzzd is a current Green Lantern who is about the size of a housefly. However, don't let his small size fool you, like it has some villains.

④ **Gallus Zed.** Gallus Zed was a long-serving member of the Green Lantern Corps who was also one of the weirdest looking: just a giant head with arms and legs.

⑤ **Mogo.** In a short story by Alan Moore and Dave Gibbons, a bounty hunter spends years on a planet searching for the mysterious Mogo. After finally mapping out the planet, he is shocked: he knew where Mogo was all along—because he was literally standing on it.

Yep, Mogo was a Green Lantern *and* a planet! Sadly, he was recently destroyed in battle.

NINE GREAT NONWHITE
COMIC BOOK CHARACTERS
(PLUS ONE INTERESTINGLY
DIVERSE WHITE GUY)

GREG PAK

As a half-Korean, half-Caucasian writer and filmmaker, I've always had a special interest in seeing different faces on the big screen and on the comic book page. For those interested in exploring the history and potential of diverse casting in comics, here's a list of some of the greatest characters to get you started.

① **The Sub-Mariner, a.k.a. Namor McKenzie,** created by Bill Everett (*Marvel Comics* #1, 1939). I include Namor because he's half Atlantean and because his first story in *Marvel Comics* #1 ends with the words, "And so Namor dives into the ocean again—on his way to further adventures in his crusade against white men!" In 1939. And he's the *hero* of the story.

② **Joseph "Robbie" Robertson,** created by Stan Lee and John Romita Sr. (*Amazing Spider-Man* #51, 1967). As a kid, I was strongly impressed by Robbie Robertson, the even-keeled and warm-hearted managing editor of the *Daily Bugle*. Robertson was one of the first nonstereotypical African American men I saw in any media, and the unspoken but undeniable reality that he was a non-white man working in a position of authority in a largely white world seized my interest. Robertson's understated, everyday kindness and bravery felt *real* to me. He provided some valuable food

for thought and coping lessons for this particular kid of color. (Thanks, Stan and John!)

③ **Storm, a.k.a. Ororo Munroe,** created by Len Wein and Dave Cockrum (*Giant-Size X-Men* #1, 1975). Arguably the most famous of all nonwhite superheroes, Ororo Munroe is an African American orphan turned Cairo street thief who ends up worshipped as a rain goddess in the Serengeti before joining the X-Men. I love Storm for her epically huge backstory, her indomitable strength of character, and all her contrasts.

④ **The cast of *Love and Rockets*,** created by Jaime and Gilbert Hernandez (*Love and Rockets* #1, 1981). For thirty years, the Hernandez brothers have triumphed in one of the greatest world-building endeavors in comics history, telling stories ranging from quirky sci-fi to punk rock melodrama to magical realism, featuring a massive cast of diverse characters. Their success is proof that creators telling great stories featuring compelling nonwhite characters can win international acclaim and legendary status. (Side note: it helps that the Hernandezes are geniuses.)

⑤ **Marlys,** created by Lynda Barry (*Ernie Pook's Comeek*, 1987). Eisner Award–winning cartoonist Lynda Barry is a quarter Filipina, as is her most famous creation, a girl named Marlys. Marlys's awkward, funny, scary, beautiful life is depicted in the hilarious and occasionally heartbreaking strip *Ernie Pook's Comeek*. Marlys provides great support for the Spike Lee adage that the more specific something is, the more universal it becomes.

⑥ **Static, a.k.a. Virgil Ovid Hawkins,** created by Dwayne McDuffie and John Paul Leon (*Static* #1, 1993). While working as an editor at Marvel in 1989, *Static* cocreator Dwayne McDuffie infamously wrote a staff memo in the form of a fake pitch for "Teenage Negro

Ninja Thrashers," a book that would feature a group of "teen-aged negroes" with "cosmic-powered skateboards," "a smart white friend," circa 1974 hair and clothes, and "bizarre speech patterns, unrecognizable by any member of any culture on the planet." A few years later, McDuffie and the other creators behind Milestone Media put everything on the line by creating the Dakotaverse, a comic book universe featuring nonwhite superheroes, including Static, who went on to star in the *Static Shock* television show for four seasons. McDuffie, who tragically passed away in February 2011, remains an inspiration to anyone interested in diversity in comics and proof that individual creators can make a huge difference.

⑦ **Alex Wilder,** created by Brian K. Vaughan and Adrian Alphona (*Runaways* #1, 2003). As the brilliant leader and then betrayer of the young heroes known as the Runaways, Alex Wilder represents a broadening of opportunity for nonwhite characters. Back in the day, Robbie Robertson blew me away because he was the kind of human being I wanted to be. But Alex Wilder blows me away for a different reason: he is brilliant and funny and multidimensional— and a *villain*.

⑧ **Chin-Kee,** created by Gene Yang (*American Born Chinese*, 2006). I've described Gene Yang's *American Born Chinese* as possibly the greatest Asian American male coming-of-age story in any medium, and the character of Chin-Kee is critical to the book's success. As a deeply painful (and sometimes hilarious) combination of every horrific stereotype about Asian men, Chin-Kee represents Yang's willingness to directly grapple with stereotypes rather than just present alternatives.

⑨ **Miles Morales, a.k.a. Spider-Man** (Ultimate Universe), created by Brian Michael Bendis and Sara Pichelli (*Ultimate Fallout* #4, 2011).

I'll admit it—I haven't yet read *Ultimate Spider-Man* #1, the first issue of Miles Morales's starring vehicle, because it hasn't hit stores as I write this. But already Miles Morales has become one of the most important nonwhite characters in comics. Brian Michael Bendis, the biggest writer in mainstream comics, has just put a half-black, half-Latino kid into the costume of Marvel's most recognizable character. Plenty of comic fans have expressed reasonable opinions both for and against the move. But a shocking number of flat-out racists came out of the woodwork on the mainstream media sites when the news debuted, which is strong evidence that the world still desperately needs exactly this kind of storytelling. As a half-Korean kid, I had no trouble identifying with Peter Parker. Kids of all backgrounds will have no trouble identifying with Miles Morales. And in a small but real way, the world will be a little bit better of a place for us all to live.

And the interestingly diverse white guy?

Magneto, a.k.a. Erik Lensherr, a.k.a. Max Eisenhardt, created by Stan Lee and Jack Kirby (*X-Men* #1, 1963). Okay, yes, Magneto is white. But he's also a mutant, which many readers of Marvel comic books have interpreted as a stand-in for anyone discriminated against for race, ethnicity, or sexual preference. Even more interestingly, in the 1980s legendary *X-Men* writer Chris Claremont gave Magneto a backstory as a Holocaust survivor, and suddenly a fun villain became one of the greatest characters in comics, inspiring unending discussions about the thin line between hero and monster. (Full disclosure: I wrote the *Magneto Testament* miniseries in 2007, which tells Magneto's origin story as a German Jewish boy struggling to save his family from the rise of the Nazis and the Final Solution.)

Greg Pak is a filmmaker and comic book writer best known for directing the award-winning feature film Robot Stories, *writing the epic "Planet Hulk" and "World War Hulk" comic book storylines, and cowriting (with Fred Van Lente) the fan favorite* Incredible Hercules *series for Marvel Comics. He currently writes* Herc *(with Van Lente) and* Astonishing X-Men.

SIX CAMEOS BY CLARK KENT AND LOIS LANE OUTSIDE DC COMICS

Clark Kent and Lois Lane are very busy reporters—so busy that one comic book company is not enough for them! They pop up quite frequently in comic books by other publishers. Here are six cameos of Clark and Lois in comic books outside DC Comics.

① ***X-Men #98.*** In this Christmas issue, the X-Men are celebrating the holidays when they walk past Clark, Lois, and what appears to be longtime DC Comics editor Julius Schwartz.

② ***Marvel Team-Up #79.*** In another Christmas issue, Clark stops by the *Daily Bugle* to visit with his fellow reporters.

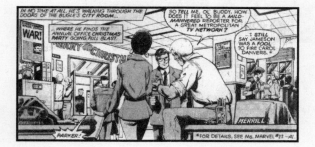

③ **_Thor #341._** Thor, now free of his human identity of Don Blake, needs to find a way to appear inconspicuous when on Earth. Nick Fury suggests that he slick his hair back and wear eyeglasses, as, after all, it works for "that other guy." That other guy then bumps into Thor on the next page.

④ **_WildC.A.T.s #8._** In the only Image comic on this list, Clark and Lois enjoy a cruise along with a few members of the WildC.A.T.s. Cyclops and Jean Grey of the X-Men are also on the same cruise, as are grown-up versions of Beavis and Butt-Head, oddly enough.

⑤ **_The Ultimates #3._** Lois, Clark, and Jimmy Olsen appear in this issue to interview Tony Stark about the introduction of the Ultimates superhero team.

⑥ **_Marvel Knights: Spider-Man #4._** An injured Peter Parker escapes from the hospital wearing just his hospital gown and he passes by a familiar-looking office, as Clark, Lois, and Jimmy watch him go.

TOP SIX CHARACTERS KNOWN FOR SITTING AROUND

PETER DAVID

① Charles Xavier

② Niles Caulder

③ Barbara Gordon

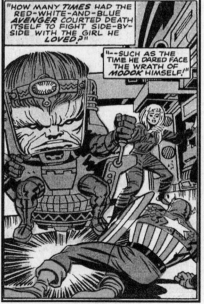

④ MODOK

⑤ Hector Hammond

⑥ Metron

A self-proclaimed "writer of stuff," Peter David has written acclaimed comic books, novels, TV scripts, screenplays, video games, and lists for books about comic books. You name it, Peter has written it. And likely won an award for doing so! His most famous comic book work is likely his run on The Incredible Hulk, *which he wrote for more than a decade. He currently writes X-Factor for Marvel.*

NINE GREAT SUPERHERO PETS

The old saying goes that dog is man's best friend, and we have to admit, sometimes that's true in the comic book world. But other times, superheroes' buddies are a little more unique—monkeys, aliens, dinosaurs . . .

① **Streak the Wonder Dog** (*Green Lantern* #33, February 1948). Streak was a German shepherd who was the sidekick to the original Green Lantern. He actually became so popular that he began starring on the cover of the comic *without* Green Lantern.

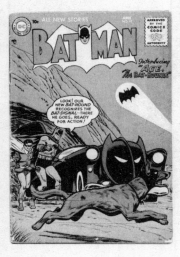

② **Krypto** (*Adventure Comics* #210, March 1955). Most likely created in response to the popularity of dog characters like Rin-Tin-Tin and Lassie as well as Superboy's pet dog, Krypto debuted in 1955. Little did readers know that this would spark a flurry of superpets. Decades later, Krypto even received his own cartoon series!

③ **Ace the Bat-Hound** (*Batman* #92, June 1955). Great minds think alike! The small amount of time between

Krypto's debut and Ace's debut likely suggests that it was a coincidence rather than one being inspired by the other. You have to love the idea of giving a dog a mask, because, you know, people might recognize him.

④ **Streaky the Super-Cat** (*Action Comics* #261, February 1960). Streaky was a normal Earth cat who was transformed into a supercat by a rare form of kryptonite. She was Supergirl's pet and sidekick.

⑤ **Comet the Super-Horse** (*Action Comics* #292, September 1962). Comet the Super-Horse has the weirdest origin of any of the pets on this list. He was born a centaur in ancient Greece, but the witch Circe offered him a chance to become entirely human. Unfortunately, the potion she gave him backfired and he instead became a horse. To make it up to him, she gave him immortality and superpowers. Centuries later, he met Supergirl and became her pet and sidekick. Weird, but it got weirder. On a mission in outer space with Supergirl, a magic spell was cast on Comet so that whenever a comet was in the solar system he was inhabiting, he would be transformed into a human. During one of these transformations, he took on the form of a cowboy . . . and Supergirl *fell in love with him.* Thankfully, this was never addressed again, and readers were spared from potential interspecies relations.

⑥ **Zabu** (*X-Men* #10, March 1965). Zabu is a saber-toothed tiger who is a pet and sidekick to the Marvel jungle adventurer Ka-Zar. They live together with Ka-Zar's wife in the mysterious hidden continent known as the Savage Land.

⑦ **Redwing** (*Captain America* #117, September 1969). Redwing is the pet and sidekick to the Falcon, who was the partner of Captain America for a number of years. Redwing is telepathically con-

nected to the Falcon, and eventually the Falcon realizes that he can actually see through Redwing's eyes.

⑧ **Lockheed** (*Uncanny X-Men* #166, February 1983). On a mission in outer space, Kitty Pryde saves a small purple alien from harm. The two quickly form a bond with each other, and Lockheed chooses to return to Earth with Kitty.

⑨ **Old Lace** (*Runaways* #2, August 2003). When a group of teenagers discover that their parents are actually supervillains, they decide to run away from home and become superheroes, using the powers they inherited from their parents. Gertrude Yorkes's parents are time travelers who genetically altered a small dinosaur to be tele-pathically linked with their daughter. They intended it to be her inheritance, but she stumbles across it early when the teens go on the run. Being a classic movie buff, Gertrude names herself Arse-nic and her pet dinosaur Old Lace, after the 1944 film, *Arsenic and Old Lace*.

TOP TWENTY-FIVE DC COMIC BOOK CHARACTERS

The results are based upon a survey of readers of Comic Book Resources for their favorite DC comic book characters of all time, arranged in ascending order. These are all characters that DC currently has the comic book rights to (for instance, DC no longer has the rights to Walter B. Gibson's Shadow).

㉕ Swamp Thing
㉔ Captain Marvel
㉓ Green Lantern (Guy Gardner)

㉒ Martian Manhunter
㉑ Aquaman
⑳ Rorschach
⑲ Black Canary
⑱ Power Girl
⑰ Superboy (Conner Kent)
⑯ John Constantine
⑮ Lex Luthor
⑭ Robin (Damian Wayne)
⑬ Booster Gold
⑫ Green Lantern (Kyle Rayner)
⑪ Green Arrow (Oliver Queen)
⑩ Oracle (Barbara Gordon)
⑨ Flash (Barry Allen)
⑧ Red Robin (Tim Drake)
⑦ Wonder Woman
⑥ Flash (Wally West)
⑤ Green Lantern (Hal Jordan)
④ Joker
③ Nightwing (Dick Grayson)
② Superman
① Batman (Bruce Wayne)

TOP TWENTY-FIVE MARVEL COMIC BOOK CHARACTERS

The results are based upon a survey of readers of Comic Book Resources for their favorite Marvel comic book characters of all time, arranged in ascending order. These are all characters that Marvel currently has the comic book rights to (for instance, Marvel no longer has the rights to Robert E. Howard's Conan the Barbarian).

㉕ Silver Surfer
㉔ Captain America/Winter Soldier (James "Bucky" Barnes)
㉓ Rogue
㉒ Beast
㉑ Storm
⑳ Jean Grey
⑲ Shadowcat (Kitty Pryde)
⑱ Punisher
⑰ Emma Frost
⑯ Iron Fist
⑮ Deadpool
⑭ Doctor Strange
⑬ Nightcrawler
⑫ Magneto
⑪ Thing
⑩ Hawkeye (Clint Barton)
⑨ Cyclops
⑧ Doctor Doom
⑦ Iron Man
⑥ Daredevil
⑤ Hulk (Bruce Banner)
④ Wolverine
③ Thor
② Captain America (Steve Rogers)
① Spider-Man

SIX AWESOME COMMIE VILLAINS FROM THE EARLY DAYS OF MARVEL

Even before the United States of America got involved in World War II, the comic books of the early 1940s were heavily anti-Nazi (the cover of Timely Comics' *Captain America Comics* #1 famously shows Cap punching out Adolf Hitler in 1940). Once World War II ended, comic books pretty much went back to just depicting gangsters and supervillains as the bad guys. One prominent exception was Atlas Comics (formerly known as Timely), which brought back Captain America—only now his enemy was "commies!"

The publication of *The Fantastic Four* #1 in 1961 really began the "Marvel Age" of superheroes, and during this period, editor in chief Stan Lee chose communists as his "go-to" villains. In fact, since *The Fantastic Four* #1 was the first Marvel comic, it is well worth noting what exactly drove the four adventurers into the dangerous space mission that ended up giving them their powers. You see, Ben Grimm originally was not going to go on the mission until Sue Storm called him a coward and said that they couldn't let the "commies" beat them to the moon! Since the Marvel Age was full of commie villains, let's take a look at six of the most awesome, evil ones.

① **Igor** (*Incredible Hulk* #1, May 1962). Just like the Fantastic Four, another Marvel mainstay's origin is directly connected to communism. Doctor Bruce Banner is working on a gamma bomb for the U.S. military with his associate, Igor, who is suspiciously curious about the technical aspects of how the bomb can detonate. When a teenager wanders onto the area where the bomb is set to

go off, Banner runs to save him, instructing Igor to hold off the bomb's detonation. As it turns out, though, Igor is a Russian spy who is eager to get rid of Banner, so he detonates the bomb. Instead of killing Banner, however, it transforms him into the Incredible Hulk!

② **The Chameleon** (*Amazing Spider-Man* #1, March 1963). This mainstay *Spider-Man* villain dresses up as Spider-Man to steal plans to sell to the Iron Curtain countries. Spider-Man, of course, defeats him (while shouting triumphantly, "This is the end of the line, commie!").

③ **Wong-Chu** (*Tales of Suspense* #39, March 1963). Famed weapons maker Tony Stark is visiting U.S. troops in Vietnam when he is wounded by a land mine. Stark is brought to the compound of the local communists, led by the evil Wong-Chu. Wong-Chu forces Stark (who has shrapnel in his chest and only days to live before it reaches his heart) to build him weapons. Instead, Stark and another captive, elderly Professor Yinsen, defy their captors by building instead a powerful suit of armor. Stark destroys the compound and kills Wong-Chu, thus beginning the superhero career of Iron Man, the #1 anticommunist superhero of the 1960s!

④ **The Radio-Active Man** (*Journey into Mystery* #93, June 1963). After watching Thor repel a Chinese attack while on a mission in India, a Chinese communist scientist is inspired to irradiate himself in an attempt to be able to match up with Thor. The scientist, who renames himself Radio-Active Man, travels to New York and almost defeats Thor, but he is really no match: Thor blows him all the way back to China, where his landing causes a nuclear explosion. The Radio-Active Man became a long-standing Marvel villain before reforming in recent years and becoming a respected

hero (as it turned out, the radiation had driven him mad—once he was given treatment, he was far more reasonable).

⑤ **The Crimson Dynamo** (*Tales of Suspense* #46, October 1963; *Tales of Suspense* #52, April 1964). The Soviets send their own armored agent, the Crimson Dynamo, to the United States to wreck Tony Stark's latest project and get rid of Iron Man. Instead, Iron Man defeats the Russian and convinces him to defect to America. Undaunted, the Soviets send a new Crimson Dynamo to the United States to kill the first Crimson Dynamo for defecting to America (and while he's here, he is also to kill Iron Man and Tony Stark). Naturally, Iron Man defeats him. The Crimson Dynamo becomes a regular part of Iron Man's rogues' gallery.

⑥ **The Black Widow** (*Tales of Suspense* #52, April 1964). Sent along with the second Crimson Dynamo, the Black Widow is the best Soviet spy around and a recurring Iron Man foe. In *Tales of Suspense* #57, she seduces a new superhero named Hawkeye and convinces him to fight Iron Man. Hawkeye's love blinds him into doing just that, but as soon as he discovers the Black Widow is a Soviet spy, he dumps her and reforms, joining Iron Man's superhero team, the Avengers. Eventually the Widow realizes she loves Hawkeye, and she defects as well. She becomes a superhero and joins the Avengers, too (eventually leading the team!—never doubt the power of communist transformations).

THREE BRITISH COMIC CHARACTERS YOU YANKS PROBABLY DON'T KNOW

KIERON GILLEN

When I was a proper kid, with chirpy optimism and undescended gonads, I read whatever comics I could find. I'd read anything, especially if it involved a dude's head exploding. Or emotions. Always up for head-exploding and emotions, me. Still am, which is why I'm writing this list.

Anyway, this is everything you need to know about three great British comic characters that you probably haven't heard of, unless you have, in which case, well done you.

① **Oor Wullie.** The eponymous character from *Oor Wullie* crashed into my life as a preschooler, thanks to my mum's Scottish relations. And these comic portraits of Scottish family life in the 1960s absorbed me. They were alien artifacts, in a setting stranger than Krypton or Asgard. Why does *glue* look like a chocolate bar? This haunts me to this day. More importantly, it was written in Scottish dialect, which made it my prepubescent *Trainspotting*. And educational (probably).

② **Johnny Red.** If you mention *Battle* to Americans, they'll mostly say "What?" If they fancy themselves multicultural titans, they'll probably say "Oh—*Charley's War*." But if you're me, you'll go for *Johnny Red*, because it prominently features a Hurricane fighter, and I have nothing but crazy love for the Hurricane. Johnny Red

is a British fighter pilot who gets sent in that lovable snub-nosed flying brick of a plane to fight on the Eastern Front. He meets the Huns! He shoots them! It's great fun!

③ **Hook Jaw.** The wonder of kids' comics is that they're offensive enough to thrill a kid with evil transgression but simultaneously not offensive enough for a horrified parent to tear it away and set fire to it. British comics always walk that line, and when they do . . . well, occasionally they overstep it. The infamous *Action* comic—what Mills did before *2000 AD* but after *Battle*—pretty much made a career out of straddling that line.

What was *Hook Jaw* about? For a brief time, it was a shameless remix of *Jaws*, starring a killer shark with a hook embedded in his jaw. But at its core, it was really about showing people being torn into pieces in the sort of loving detail that would make the average Avatar Comics devotee wince. And the writers were so imaginative! When rediscovering *Hook Jaw* recently, I became transfixed by how they managed to off someone smart enough to use a shark cage. One of the sharks gave birth, and the diver was torn into pieces by a shoal of tiny baby sharks, fresh from the womb, hungry for flesh. In summation, there is nothing that is not good about *Hook Jaw* (except ethically).

A longtime journalist in the world of games and music, Kieron Gillen broke onto the scene with his acclaimed independent series Phonogram *with artist Jamie McKelvie. Currently, Gillen is the writer for one of Marvel's flagship titles,* Uncanny X-Men, *as well as an acclaimed run on* Journey into Mystery.

SIX FELLOW SUPERHEROES WHO WOLVERINE HAS STABBED AT ONE POINT OR ANOTHER

What good are super-sharp unbreakable claws if you don't occasionally use them to stab your fellow superheroes?

① **Jean Grey.** In *New X-Men* #148, Magneto has trapped Wolverine and Jean Grey on an asteroid that is slowly approaching the sun. After exhausting every means of escape from the hunk of rock, they sit down to accept their fate. Wolverine can't bear to see Jean suffer, so he stabs her so she won't have to face the pain of being incinerated by the sun.

② **Northstar.** *Wolverine* #25 is the conclusion of the "Enemy of the State" storyline, where Wolverine is killed and resurrected as an evil servant of the Hand, a sinister ninja organization. In this

issue, Wolverine is set against his former friends in the X-Men and tries to kill his old sidekick, Kitty Pryde. When she becomes intangible, he goes through her and stabs the super-quick Northstar in the chest, killing him. Wolverine is then captured and S.H.I.E.L.D. breaks the Hand's brainwashing.

③ **Beast.** In *Astonishing X-Men* #16, the minds of both Beast and Wolverine have been manipulated. In Beast's case, he has been turned into a feral, well . . . beast. In Wolverine's case, his mind is stuck back to when he was a boy (before he learned of his claws and his mutation). It's quite hilarious to see Wolverine (a) pop the claws and then (b) freak out over the sight of said claws coming out of his hands. Wolverine knows enough to use them to stab the Beast when the Beast starts gnawing on Wolverine's leg.

④ **Spider-Man.** In *Marvel Knights: Spider-Man* #13, Wolverine and Spider-Man are training in the Avengers Tower when some hard feelings about an earlier conflict arise (Spider-Man was *not* happy with how Wolverine was talking to Mary Jane). Their fight leads Wolverine to accidentally stab Spider-Man in the stomach.

⑤ **Phoenix.** The second X-Man to go by the name Phoenix, Rachel Summers is the daughter of Cyclops and Jean Grey from an alternate future. In *Uncanny X-Men* #207, Wolverine tries to prevent Rachel from murdering the evil mutant Selene. Wolverine insists that he would just as soon kill her than let her kill Selene in cold blood. Ultimately, one dramatic "snikt" later, that's exactly what happened (although Rachel does survive her wounds)!

⑥ **Jean Grey . . . again.** After she died "for good" in *New X-Men* #150, the Phoenix Force tries to resurrect Jean Grey again. She doesn't want to be tormented by it anymore and begs Wolverine to kill her. He does what she asks, but the Phoenix Force keeps resurrecting her. This leads to an unsettling full page of Wolverine continually killing Jean Grey, only for the Phoenix Force to bring her back each and every time.

SIX AWESOME AND INCREDIBLY WEIRD POWERS OF SUPERMAN

We all know that Superman is super strong, practically invulnerable, can look through walls with his X-ray vision, and can burn things with his heat vision. But that's not the end of it—Superman has had some even more awesome (and crazy) powers over the years. Here are six of the oddest superpowers Superman has ever had (and we're not counting flying . . . he's a superhero, people; it comes with the territory).

① **Super-control over his facial features.** One of the most bizarre powers Superman has, this one has not been used very much in the last, oh, fifty years or so. But for the first decade of Superman's existence, he would frequently demonstrate the ability to contort

his face into all sorts of appearances. This was quite helpful, as you might imagine, for undercover assignments.

② **Super-yell.** Superman's shouts have been measured at roughly one million decibels and can be heard for a five-mile radius. His voice is strong enough to destroy diamonds!

③ **Super-hypnotism.** This one has been used almost entirely to keep his identity a secret, like hypnotizing Lois Lane into forgetting that she has knowledge of who he really is. In one early 1980s story, we discover that Superman has been subconsciously using Super-Hypnosis for all of these years to make people think Clark Kent looks different from Superman.

④ **Super–muscular control.** Superman uses this power to stop the beating of his heart, so that people will think he has died. He used this a number of times during the 1940s. You'd figure someone would have spread the word. "Don't trust it! Superman's faking!"

⑤ **Super-intellect.** Superman during the Silver Age not only had a brilliant intellect but also he had an almost obsessive ability to recall things that he learned. Once, he performed an eye operation simply by reading a few books about how to perform them. And after all, he *did* build a series of extremely lifelike Superman robots to serve him. That takes a pretty heady intellect!

⑥ **Super-Kiss.** In *Action Comics* #306, Lois and Clark are under the mistletoe, so Clark decides to give Lois a Super-Kiss. It almost literally blows her mind, it is that good. You really have to wonder what is involved in a "Super-Kiss."

FOUR GREAT CHARACTERS FROM GRANT MORRISON'S RUN ON *DOOM PATROL*

JOHN ROZUM

What most people remember about Grant Morrison's run on *Doom Patrol* is how deliriously weird it was. It was completely unlike any other superhero comic published at the time, and unlike most being published now. It had a lot of wild concepts in it, but no matter how outrageous they were, the concepts succeeded because the characters were engaging and relatable. This series had some very unusual characters, too. Made up of a group of variously challenged people with strange powers, *Doom Patrol* under Grant Morrison's care was made up of Cliff Steele, a.k.a. Robotman, a human brain contained in a robot body with a big chip on his shoulder; Rebis, a white man and a black woman alchemically fused with a negative energy spirit, all wrapped in specially treated bandages; the Chief, a callous supergenius in a wheelchair; Joshua Clay, a former costumed superhero able to emit energy blasts; and Dorothy Spinner, an ugly girl who could make imaginary beings real. They were all well realized, but were often overshadowed by a succession of offbeat characters who came and went as the series progressed. Here are my four favorite characters from the run.

(1) **The Brotherhood of Dada.** Every superhero or superhero team is best defined by its villains, and *Doom Patrol* is no exception. Like the nonsense-based art movement they were named after, the Brotherhood of Dada isn't out for money or power, but to transform the world into a place open to new ideas and ways of think-

ing. Led by Mr. Nobody, who appears as if you're seeing him out of the corner of your eye, the Brotherhood came in two incarnations. The first includes Frenzy, a pyromaniac who can transform into a whirling tornado; the Fog, a man who can turn into a psychedelic death cloud that absorbs people; Sleepwalk, a woman who has superstrength but only when she is asleep; and the Quiz, a Japanese woman with a pathological fear of dirt who possesses every superpower (until a person thinks of one of them, which makes her lose that power).

The second incarnation of the team is even more delightfully inventive. Joining Mr. Nobody is the Love Glove, a man who woke up from a dream about a tree with gloves for leaves to discover that his arms were gone and, in replacement, a powerful hovering glove now operates as his right "hand" of his phantom limb. Alias the Blur is a mirror that was damaged by battery acid thanks to a narcissistic actress who couldn't stand the sight of her aging reflection. Alias is able to eat time, aging its victims. Agent "!" is a garishly dressed man with a birdcage for a torso whose power is that "he comes as no surprise," meaning that he is always unnoticed. Number None is anybody and anything who can get in a person's way—whether it's a loose floorboard, or a woman with a shopping cart who blocks your way by moving precisely down the center of an aisle so you can't get past.

The "crimes" they commit are equally trippy: the first incarnation of the Brotherhood of Dada sucks all of Paris into a painting whose recursive layers represent every art movement through history, and the second incarnation sets out to transform America using a psychedelic school bus, powered by the Bicycle of Albert Hofmann, for Mr. Nobody's campaign to become the president of the United States.

② **Crazy Jane.** Grant Morrison's new addition to the team began life as Kay Challis, a girl who was sexually abused by her father. This

Valley Community Library
739 River Street
Peckville, PA 18452-2313

caused her mind to fracture and disassociate, leading to the development of sixty-four different personalities, each with its own superpower. These aren't your typical superpowers, though. Sun Daddy appears as a giant version of Crazy Jane, only with a sun for a head, which shoots out balls of fire. Scarlet Harlot is a nymphomaniac who absorbs psychosexual energy and can create ectoplasmic constructs with which to fulfill her sexual needs. Crazy Jane is a terrific character who becomes the heart of the Doom Patrol and helps Cliff Steele find his humanity.

③ **Flex Mentallo.** Anyone who grew up reading comic books in the 1960s and 1970s is no doubt familiar with the Charles Atlas ads featuring a comic book narrative in which a bully on the beach kicks sand on skinny Mac and his girlfriend, leading a fed-up Mac to send away for a series of fitness books that transform him into a man. Flex Mentallo *is* Mac. He sent away for a book on muscle mystery and built his physique so that he could accomplish all sorts of astonishing feats simply by flexing his muscles. His hero halo is the label "Hero of the Beach," which appears above him in shimmering form when he flexes.

④ **Danny the Street.** The cover of *Doom Patrol* #42 may have declared Flex Mentallo the sensational character find of 1991, but I think Danny the Street deserves to be declared the sensational character find of all time. There's never been anything like Danny before or since, and it's unlikely we'll ever see any thinly veiled knockoffs, either. Danny the Street is, in fact, a street. He's a sentient, transvestite block of commercial real estate with the ability to travel from place to place by teleporting and pushing existing real estate aside so that he can squeeze in between a row of buildings. How do we know he's a transvestite? Because the stores that occupy him are all manly stores that sell hardware, sporting goods, and guns but are decorated with lace curtains and floral displays, as

well as the Peeping Tom's Cabaret, which offers a revue of drag shows and campy comedy bits. Danny also has a wonderfully charming personality and communicates through smoke, typewriters, refrigerator magnets, and window signs. He's also a welcoming home to an assortment of odd characters and street people, and during the course of this run, the Doom Patrol's mobile headquarters.

From The X-Files *to more than one hundred issues of* Scooby-Doo *to his creator-owned series,* Midnight, Mass., *John Rozum has written a lot of comic books about people investigating weird phenomena. Best known for the critically acclaimed* Xombi, *which has been called "the spiritual successor to Grant Morrison's* Doom Patrol," *Rozum has also written for television and wrote* Static Shock *for DC Comics.*

THREE MEMORABLE CHARACTERS WHO HAVE WIELDED THOR'S HAMMER

When he was first introduced, one of the main concepts of Thor was that his hammer, Mjolnir, would work only for him. For the first two decades of Thor's existence, that was true, but when Walter Simonson began writing and drawing Thor's comic in 1983, things went a little haywire when a new character, Beta Ray Bill, shocked Thor by being "worthy" enough to wield Mjolnir. Since then, a few other memorable characters also have been able to lift Thor's hammer.

① **Captain America.** In *Thor* #390, Captain America is visiting the Avengers, but Thor is concerned about whether he can trust his old friend. At the time, Captain America was stripped of his title by

the U.S. government for refusing to become an official employee of the U.S. military, so he is calling himself "the Captain." This seems a little suspicious to Thor, but his concerns are lifted later in the issue. When Thor is incapacitated by the henchmen of one of his enemies, the Captain picks up Mjolnir and saves the day. Friendship restored; all doubts cast aside.

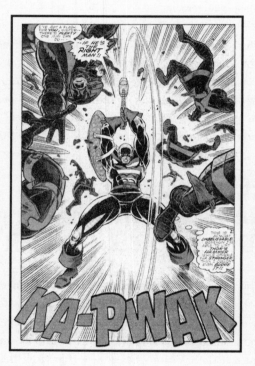

② **Wonder Woman.** During the *DC versus Marvel* crossover, Thor is separated from his hammer after defeating Captain Marvel in battle. Wonder Woman picks it up and is transformed into a female version of Thor. Eventually, when matched up against Storm of the X-Men, Wonder Woman discards the hammer, as it gives her too big of an advantage. (She then loses the matchup against Storm—stupid Amazonian ethics!)

③ **Superman.** During the *JLA/Avengers* crossover, the Justice League and the Avengers are forced to team up against a powerful cosmic entity named Krona, who threatens reality itself. In the final battle against Krona and the legions of supervillains he has summoned to defend him, a small yet powerful attack force is put together featuring the most powerful members of the Avengers and the Justice League, with Captain America commanding the operation. Since he cannot fight in the battle himself, Captain America lends Superman his famous unbreakable shield. Later in the fight, with Superman close to breaking through Krona's shields, Thor lends Superman his hammer to make the final difference. Interestingly enough, Thor later notes that Odin lifted the enchantment off of the hammer to allow Superman to lift it, so we will never know if Superman is actually worthy enough to lift Mjolnir. (Then again, considering he's, you know, *Superman*, the odds are probably pretty good that he is.)

SIX TRAGIC SUPERHERO ROMANCES

Girlfriends of superheroes are arguably some of the most threatened characters in comics. Danger follows them everywhere, sometimes leading to tragic circumstances. The following are six notable superhero girlfriends that met an untimely demise.

① **Gwen Stacy.** The girlfriend of Peter Parker, she is killed by Parker's enemy the Green Goblin, who actually knows Gwen in his alter ego of Norman Osborn. Years later, in the "Sins Past" storyline in *The Amazing Spider-Man*, J. Michael Straczynski wanted to reveal that Peter accidentally got Gwen pregnant and she gave birth to the kids in the story secretly. These kids would be artificially aged and then confront Peter. However, Marvel editor in chief Joe Quesada would not approve the storyline, so Straczynski was forced to change the man Gwen had the affair with to Norman Osborn, the Green Goblin. Besides being a bizarre story (secret children who age extra fast?), it also gave us an image that will be seared into our brains forever—Norman Osborn's "O" face.

② **Alexandra DeWitt.** The girlfriend of Green Lantern Kyle Rayner, Alexandra is killed by a rogue government agent who is trying to gain hold of Kyle's Green Lantern ring. In a most gruesome turn, she is stuffed inside a refrigerator and left for Kyle to discover. This led to the term "women in refrigerators" to describe the device of

killing off women in comic books to advance the plot of their male counterparts.

③ **Mariko Yoshida.** Wolverine's fiancée, Mariko, is forced to renounce him when she assumes the leadership of her father's Yakuza crime family. She is soon poisoned and faces a slow and painful death. Unable to bear her misery, Wolverine ends his lover's life.

④ **Silver Fox.** Another tragic end for one of Wolverine's lovers. Every year on Wolverine's birthday, his old rival Sabretooth hunts him down and fights him. One year, Sabretooth discovers Wolverine's girlfriend, Silver Fox, and makes a pass at her. When she rejects him, he murders her.

⑤ and ⑥ **Karen Page and Elektra.** Daredevil's girlfriends might be some of the most vulnerable. His nemesis Bullseye kills both Karen Page and, later, Elektra. (Although Elektra herself is an assassin, so it's not like death is a shocking result in her line of work.) In addition, Daredevil later marries a woman named Milla Donovan, who is subsequently driven insane by another of Daredevil's enemies. Daredevil should likely just omit his dating history for future dalliances.

SIX GREAT YOUNG HEROES
MARC SUMERAK

① **Spider-Man.** Many of us grew up in a time when Peter Parker was already an adult, so it's easy to forget that he was one of the first teen heroes to star in his own title. He was also one of the first young characters in comics whose life seemed genuinely "real." He had problems at school, problems at home, problems with girls. In

fact, nothing ever seemed to go smoothly for poor "Puny Parker"—a feeling with which almost every young reader can relate.

② **Bucky.** What could possibly be nobler than fighting for your country? How about serving alongside the living embodiment of freedom as his handpicked sidekick? That's what young James Buchanan Barnes did when he strapped on a mask and took to the battlefield with Captain America as the kid-hero called Bucky. And when he sacrificed his own life to save his country, Bucky was instantly upgraded from hero status to legend.

③ **Robin.** At first Batman faced the dark streets of Gotham alone. But it wasn't long before a plucky orphan in bright-colored tights joined the fight, and the Caped Crusader became part of the world's most famous duo. Robin infused a splash of color (and a bit of fun) into the gritty crime-filled world that he and his mentor patrolled each night. As Batman's protégé, Robin learned firsthand what it truly meant to be a hero and, over the years, evolved into much more than a sidekick: Robin became a superhero legacy.

④ **Kitty Pryde.** The original X-Men started their careers as teen heroes attending Xavier's School for Gifted Youngsters, but living in a world that hates and fears mutants is enough to age any character before his or her time. By the time the "All-New, All-Different" X-Men roster came around, Xavier's first class was all grown up—and their stories matched in maturity. Thankfully, the introduction of an intangible girl named Kitty Pryde helped reintroduce a youthful innocence that the title had long been missing. Kitty not only provided a fresh perspective on the mutant condition, she also served as the perfect foil to the most popular X-Man, the gruff Wolverine.

⑤ **Captain Marvel.** With just one word, young Billy Batson transformed from an ordinary boy into one of the most amazing heroes ever, Captain Marvel. His was a magical world where childhood fantasies came to life—not just talking tigers and evil worm geniuses, but the idea that a normal boy could find the power to save the day. As Captain Marvel, Billy had abilities equal to some of the greatest "supermen" in comics. This unique formula made Captain Marvel a character with whom every kid could connect . . . and one they dreamed they, too, could become with just a simple yell of "*Shazam!*"

⑥ **The Runaways.** Discovering you're actually a teenage superhero? Awesome. Discovering your parents are actually supervillains? Not so awesome . . . unless, of course, you happen to be a reader along for the ride. When the children of the super-secret criminal organization known as the Pride discovered the truth about their sinister lineage, it was only the beginning of one of the greatest adventures of the last decade. Their journey was less about fighting bad guys and more about self-discovery, learning that their family history didn't dictate who they would become.

Marc Sumerak has been writing and editing stories of young heroes for more than a decade. He has had memorable runs on Power Pack, Franklin Richards: Son of a Genius, *and* Marvel Adventures: Superman. *His most recent book,* All-Ghouls School, *continues his exploration of teen characters in extraordinary worlds.*

PART II

COMIC BOOK

WRITERS
AND ARTISTS

FIVE COMPLAINTS COMIC BOOK CREATORS SNUCK INTO THE COMICS THEMSELVES

Comic book creators tend to be a vocal group, so when they feel strongly about something, you better believe they'll find a way to work it into the comic itself.

① **Mike Sekowsky shows his displeasure with *The Brute* #1.** Mike Sekowsky had been working in comics for more than two decades when he ended up doing the art for a new comic book company started by former Marvel publisher Martin Goodman. *The Brute* was not a particularly good comic book, and Sekowsky let everyone know he thought so, as well, when he put the model number on a plane at one point in the issue: SH17. In other words, SHIT.

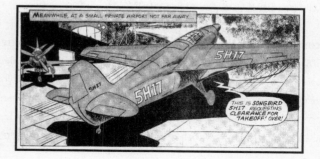

② **Byrne wants more respect for Doctor Doom.** In *Uncanny X-Men* #146, by Chris Claremont and Dave Cockrum, Doctor Doom guest-stars, and his fellow villain, Arcade, lights a match on Doom's armor. Soon after, John Byrne spotlighted the famous Fantastic Four villain in *The Fantastic Four* #258 and revealed that the Doctor Doom from that particular X-Men story was a robot, as the real Doctor Doom never would have stood for such an affront. When queried by the real Doom, the robot suggests that he thought they might need Arcade in the future. Doom's response? Blow the robot up.

③ **Petty Larsen-y.** In 1992's *Spider-Man* #19, writer-artist Erik Larsen got the Sinister Six back together, but he wanted to high-light how much more powerful Doctor Octopus was now that he'd upgraded to fancier robotic arms; he demonstrated this by having Doctor Octopus beat up the Hulk. Well, later in 1992, in *The Incredible Hulk* #396, writer Peter David and artist Dale Keown had a response to that fight: Hulk claims that he was robbed by "petty larceny" and then knocks Octopus out with one finger.

④ **They don't call him Joe Mad for nothing!** In *Uncanny X-Men* #325, superstar artist Joe Madureira decided to voice his complaints over how much fellow artist Roger Cruz was swiping his drawings (that is, essentially copying Madureira's artwork and calling it his own). In a scene in a crowded subway, Madureira has a newspaper with the headline, "Cruz swipes again!"

⑤ **Just counting down the hours.** *Weapon X* was a series that debuted in 2002 that detailed the latest version of the Weapon X project (which was the name of the group that had experimented on Wolverine decades earlier). It was basically a team of bad guys, with no clear focus, and the series was canceled with issue #28. In the last issue, in the background of a panel, someone has written on a

notepad, "I want this issue to be finished and over with. I don't like slogging through the last issue of a dead book." The artist then continues to note that he'll do it, though, because he's a pro.

THREE UNDERRATED (AND INFLUENTIAL) COMIC BOOK ARTISTS OF THE 1960s

GABRIEL HARDMAN

The 1960s were a time of huge social and artistic change. Old standards were upended in all popular media and comics were no exception. I'd like to point out a few comic book artists whose contributions to the craft remain influential to this day.

① **Bruno Premiani (1907–1984).** Known primarily for collaborating with writer Arnold Drake on the original *Doom Patrol* series, Italian artist Bruno Premiani was one of the finest draftsmen to work in the American comics industry. The story of three oddball heroes gave Premiani the opportunity to bring a beautifully crafted weight and realism to the bizarre stories. While his linework bears a superficial resemblance to that of earlier comic strip artists like Milton Caniff, the underlying structure and craft of his work are unsurpassed. His ability to draw expressive faces, animals, and crazy creatures of all kinds with absolute confidence makes Premiani the best artist you've never heard of.

② **Pat Boyette (1923–2000).** Texan Pat Boyette turned to comics, in his words, "on a lark." He worked primarily for Charlton, cranking out a huge volume of work for books like *The Phantom*, *Ghost Manor*, and *Space Adventures*. Boyette had a deceptively simple drawing

style that was always expressive if not consistent. He used popular storytelling techniques of the time, such as diagonal panel layouts, with more success than many of his better-known contemporaries.

③ **Frank Thorne (1930–).** While best known as the artist of *Red Sonja* in the 1970s, Frank Thorne produced quite a bit of outstanding work in the 1960s. Though it's easy to see the influence of Joe Kubert on Thorne's work, I think he brings something unique to the equation. His work on *The Mighty Samson* is a standout. While beautifully drawn and imaginative, his inks have a raw quality to them. His art takes you into the world of the story—and that's the definition of the job of comic book artist.

After debuting in the comics industry in the early 1990s, Gabriel Hardman has gone on to have an extremely successful career as a storyboard artist in the world of film, working on Inception, Tropic Thunder, X2: X-Men United, *and others. He has since returned to mainstream comics as the artist on an acclaimed run on* Hulk *with writer Jeff Parker and colorist Bettie Breitweiser and is currently drawing* Secret Avengers.

TOP FIVE COMIC BOOK CREATOR RUNS

A "run" is when a comic book creator writes a significant number of consecutive issues of an ongoing comic book series. The following are the top five results of a survey of Comic Book Resources readers for their favorite creator runs of all time, listed in ascending order.

⑤ **Alan Moore's Swamp Thing** (*Saga of the Swamp Thing/Swamp Thing* #20–58, 60–61, 63–64, Annual 2). Swamp Thing was already a

popular character when Alan Moore became the writer of the series in 1984—it had even starred in its own film. However, within two issues, Moore had turned the whole concept of Swamp Thing (a man who was mutated into a mossy creature during a lab explosion) on its head. He revealed that Alec Holland, the man who seemingly became Swamp Thing during the lab explosion, actually *died* in that explosion, and instead the chemicals gave life to swamp matter to make it *think* that it was Alec Holland. This mind-blowing revelation was the first sign that this series was not going to be your standard comic book fare. Moore soon took the character into areas where comic books normally did not go, including an issue where Swamp Thing and his love interest, Abigail Arcane, have sex (in a stunning visual issue where the actual sexual act involves Abigail eating a tuber created by Swamp Thing). Moore revitalized the character and made it a major part of the DC Universe. And it couldn't hurt that Moore was blessed with two stunning art teams on *Swamp Thing*. Penciler Stephen Bissette and inker John Totleben gave the book a dark, noirish feel, and later Rick Veitch, who ended up succeeding Moore as the writer on the series, gave the series his own unique spin.

④ **Frank Miller and Klaus Janson's Daredevil** (*Daredevil* #158–191). Klaus Janson was the inker on *Daredevil* when Frank Miller joined the book as the penciler in *Daredevil* #158. (Roger McKenzie was the writer at the time.) Within ten issues, Miller was one of the most popular pencilers at Marvel Comics and was allowed to take over as the writer on the series. In his very first issue, Miller introduced an old girlfriend of Matt "Daredevil" Murdock—Elektra, who was now a professional assassin. During Miller's run, the sexual tension between Daredevil and Elektra intensified, as did the enmity between Daredevil and a one-time Spider-Man villain, Wilson Fisk, the so-called Kingpin of Crime. Janson began the run as Miller's inker, but over time he began penciling and inking

Miller's breakdowns, and by the end of the run, he became the sole artist on the series.

③ **Stan Lee and Jack Kirby's Fantastic Four** (*Fantastic Four* #1–102; *Fantastic Four Annual* #1–6). This was the run that started the "Marvel Age" of comics, as Stan Lee and Jack Kirby's hit title (which Marvel dubbed "the World's Greatest Comic Magazine") formed the framework of the entire Marvel Universe. Without Mister Fantastic, the Human Torch, Invisible Girl, and the Thing, there would be no Spider-Man, no X-Men, no Iron Man, no Hulk, and no Thor. The success of *The Fantastic Four* showed that comic book audiences were ready to embrace superheroes once again, and the very human relationships of the Fantastic Four were early signs of the approach Stan Lee would take with Marvel's super-heroes. Beyond the sheer creativity of Lee and Kirby's run (in one stunning twelve-issue span, they introduced the Inhumans, Silver Surfer, Galactus, and the Black Panther), they created stories that would reverberate in the Marvel Universe decades after they were finished.

② **Chris Claremont and John Byrne's X-Men** (*X-Men/Uncanny X-Men* #108–109, 111–143). Writer Chris Claremont and artist Dave Cockrum had already made *X-Men* an up-and-coming book when John Byrne joined the title with issue #108 to replace Cockrum, who was having trouble with deadlines. After a fill-in issue that had already been produced to aid Cockrum's schedule (#110), Claremont and Byrne (and inker Terry Austin) settled in to a stun-ning streak of issues that took the series from bimonthly status into one of Marvel's top-selling comics. The combination of Clare-mont and Byrne (who eventually contributed to the writing as well) brought the series to new heights of excitement. Perhaps the most notable aspect that Byrne brought to the table was increas-ing the spotlight on Wolverine. Under Cockrum, Wolverine was

more of a background character, but Byrne (who was a Canadian) took a liking to the Canadian Wolverine and made him a major focus of the series. Fans went for it in a big way, with Wolverine soon becoming one of the most popular characters in all of Marvel Comics. The "Dark Phoenix Saga" (one of the top comic book story-lines of all time) took place during their run, and one of the last stories they did together, "Days of Future Past," about a mutant coming from a postapocalyptic future to get the X-Men to change the future, influenced hundreds of later comic book stories. Eventually Byrne wanted more freedom to control the stories himself (since Claremont, as the scripter, would ultimately get the last say on what would actually get printed), so he left to write and draw *The Fantastic Four*, while Claremont would stay on the title (with a host of different artists) for another decade.

(1) **Neil Gaiman's Sandman** (*Sandman* #1–75, plus one special). *Sandman* stars Morpheus, otherwise known as Dream of the Endless (the Endless are siblings who personify natural forces, such as dreams, desire, and death itself). After reestablishing himself as the ruler of the Dreaming, the land where all dreams exist, Morpheus became involved in a number of stories involving both this mystical land and other areas of the supernatural, even including the gates of Hell. (Gaiman's Lucifer was such a compelling figure that he eventually had his own spin-off, also lasting seventy-five issues.) Since the book was about dreams, Gaiman was able to write whatever stories he wanted to tell, and he tended toward tales of religion, myth, and fantasy. A wide variety of artists drew *Sandman* in its run, as Gaiman would gear each story to fit the style of the artist he was working with on that issue. One of the most famous issues is *Sandman* #19, "A Midsummer's Night Dream," where Gaiman and artist Charles Vess show Morpheus interacting with William Shakespeare. By the time the series ended, *Sandman* had won *eighteen* Eisner Awards and Neil Gaiman

had been solidified as one of the most popular and acclaimed fantasy authors of his generation.

FOUR ARTISTS WITH BIZARRELY UNIQUE STYLES

SKOTTIE YOUNG

(1) **Bill Sienkiewicz.** Bill's frantic inks and melting colors all come together to form something that doesn't sound like it should work in comic book storytelling. His depiction of the Kingpin in *Daredevil: Love and War* was enough to cement my love for his art forever.

② Ashley Wood. Ashley's recklessness with ink is simultaneously frightening and exciting. There are not many artists who will push that far outside the boundaries of tradition, but Wood is one of them. Jump over to his oil paintings and his depictions of robots and you'll be lost for days.

③ Jim Mahfood. Jim is one of those guys who never even faked being a part of the traditional style of superhero comics. He was injecting his love of hip-hop and art culture into his work from day one. You can almost hear the music when you look at a Mahfood comic.

④ Sergio Toppi. Sergio has a way of laying out a page or a panel that is all his own. He'll throw a horizon line high on the page and then weave other images in and out of his insane textures. Simply put, it's hypnotizing.

Skottie Young is, himself, a bizarrely unique artist. One of the most dynamic sequential artists and designers around, Young is an in-demand cover artist and an even more in-demand interior artist. He has been working on a multi-award-winning adaptation of L. Frank Baum's Oz novels for the past few years.

THREE UNUSUAL WAYS THAT A CREATOR HAS BROKEN INTO COMICS

Typically, comic book creators break into the industry by either doing independent comics that get attention from the larger comic book companies, showing their portfolios to editors at conventions, or going to work for comic book companies in another role and working their way into writing. Some creators, though, have taken the road less traveled. Here are three particularly peculiar routes.

① **Jerry Robinson.** Jerry Robinson had just graduated from high school and was about to play a game of tennis on the day he got his big break. An older man was admiring Robinson's jacket, which he had decorated with all sorts of cartoons (a popular sort of style for high schoolers at that time). The man asked Robinson if he knew who the artist was, to which Robinson replied that it was him, and that he was his high school newspaper's cartoonist. On the spot, the man offered him a job as his assistant back in New York City. The man who offered him the job? Bob Kane, who had recently created Batman in *Detective Comics*. To say that they had a fruitful collaboration is an understatement, as Robinson helped to create Robin, Catwoman, and the Joker as *Batman* took off as a national sensation.

② **Elliot S. Maggin.** As a junior at Brandeis University, Maggin took an American history course that involved mass media. Maggin wanted to demonstrate to his classmates how a comic book story could be useful as an ideological tool, so he wrote his own Green

Arrow story to illustrate his point. Maggin got a B+, but felt that his story and his concept should have gotten an A. He sent the paper to DC Comics editor Julius Schwartz to prove his point to his instructor. In a crazy twist of fate, DC actually *bought* the comic and published it in *Green Lantern* #87, with art by Neal Adams. Sadly, though, it was too late to change the grade, as the semester had ended, but no doubt Maggin got over that pretty quickly, given his new job.

③ **Steve Epting.** Steve Epting had just graduated with a BFA in graphic design and was working as a designer when he read about a contest that First Comics was holding at the Atlanta Fantasy Fair. The winner would get his or her six-page story published in the back of one of First Comics' series—a pretty nice prize for a new artist. However, that contest? Not even real. It was a rumor that had somehow spread in the Atlanta comic community! With a few submissions unexpectedly in hand, however, First Comics figured, hey, might as well give these artists a quick look for their time, not expecting anything to come of it. But Epting's entry caught their eye, so much so that the art director offered him the chance to do some work for them. Epting slowly worked his way up in the business until he became one of Marvel Comics' top artists, working on *The Avengers*, *Captain America*, and most recently *The Fantastic Four/FF*. All from a contest that did not even exist!

THREE VERY, VERY STRANGE COMICS WRITTEN BY ALAN MOORE

Alan Moore is likely the most acclaimed comic book writer in comic book history (and he has some stiff competition in guys

like Neil Gaiman, Grant Morrison, and Stan Lee). However, once upon a time Moore was a struggling young creator like everyone else, so he did some bizarre projects. Very, *very* bizarre.

① ***BJ and the Bear Annual.*** In the 1982 *BJ and the Bear Annual* (based on an American TV series about a trucker and his pet chimpanzee named the Bear), Alan Moore contributed not just one, but two special features. First was a story called "CB? That's a Big Ten-Four!" where Moore explains the various slang terms that CB users used. Next was a story called "Bear's Monkey Business." Both features were illustrated text pieces, and obviously quite off the wall.

② ***Not the World Cup Special.*** Alan Moore was not exactly the world's biggest sports fan, but he managed to put together a three-page parody of football in this satire special that Marvel UK did for the 1982 World Cup.

③ ***Violator vs. Badrock.*** In the early 1990s, Moore was looking to do some freelance work outside of Marvel or DC. Luckily, the fellows at Image Comics had plenty of work for him. Moore went to work for Todd McFarlane, Rob Liefeld, and Jim Lee on a number of projects. A few were particularly strange, including a teaming between Liefeld's hero Badrock and McFarlane's villain the Violator, where you could barely recognize that it was written by Moore.

THREE AWESOME AND UNUSUAL USES OF COLOR BY AN ARTIST

FRAZER IRVING

① **John Higgins in *Watchmen*.** Comics have often been described to me as "pamphlets with the same four garish colors" by illustrators who are unfamiliar with anything beyond the classic imagery of superheroes from the '60s. With *Watchmen* that view is both proved and debunked. Are these colors garish? Hell, yes: retina-searing reds and vomit-inducing yellows dance on the page and assault our visual senses like a polychromatic wolverine on amphetamines . . . yet these are not the same four hues that characterize the comics of the swinging '60s. John Higgins gripped a generation with some of the oddest color choices back in the '80s, when he was tasked with adding depth and mood to Dave Gibbons's sterling, solid line work, breaking the trend for color-coded consistency and easily recognized chromatic landmarks for a nice safe read.

② **Barry Windsor-Smith in *Uncanny X-Men* #205.** This dude painted with the standard four-color process as if it were watercolor. Layers of yellow and magenta and cyan created shades of purple with highlights of white, in a field where such things were generally represented with broad areas of flat color. He brought complexity and realism to a world that was dominated by almost abstract colors. This was the first time I had seen hues within skin tones, the holy rule of "flesh tone" utterly broken down into its constituent parts and laid bare for the world to enjoy. It brought a grace to the

page that was almost hinting at the future, a world we now live in where if you want realistic watercolored art in your superhero comics, you can have it.

③ **Richard Corben's *Den*.** The color choices in Richard Corben's *Den* are simple, almost basic, yet they are harmonious even when contrasting. The colors wouldn't actually work in the real world: in reality, there would be far more reflected colors all over the place. But it is that incongruity that makes *Den* special. It is like watching an early Technicolor motion picture epic on paper. As a youth, I was turned off by the strangeness of this story, yet as an adult I shed my fear of the flesh and embraced the colors that seemed so clearly to define this story and, later, the majority of his painted output.

Frazer Irving is a popular British artist who broke in by drawing for 2000 AD. He was handpicked to be one of the artists on Grant Morrison's acclaimed Seven Soldiers *series. Irving illustrated* Klarion the Witchboy *and has worked with Morrison on* Batman and Robin, *as well. He also drew an issue of the best-selling* Return of Bruce Wayne. *Recently, Irving drew high praise for his recent DC Comics series* Xombi *with writer John Rozum. Irving is currently developing a creator-owned comic book project.*

TOP TEN COMIC BOOK WRITERS OF ALL TIME

The following are the results of a survey of the readers of Comic Book Resources asking for their favorite comic book writers, along with some of their best-known works; they're listed in ascending order.

⑩ Geoff Johns (*Flash, Green Lantern, JSA, Blackest Night, Infinite Crisis*)

⑨ Ed Brubaker (*Captain America, Sleeper, Daredevil, Criminal, Incognito, Catwoman*)

⑧ Garth Ennis (*Preacher, Hellblazer, Punisher, Hitman*)

⑦ Brian Michael Bendis (*Ultimate Spider-Man, New Avengers, Powers, Alias, Torso*)

⑥ Frank Miller (*Batman: The Dark Knight Returns, Sin City, 300, Daredevil, Batman*)

⑤ Stan Lee (*Fantastic Four, Amazing Spider-Man, X-Men, Captain America, Hulk, Thor*)

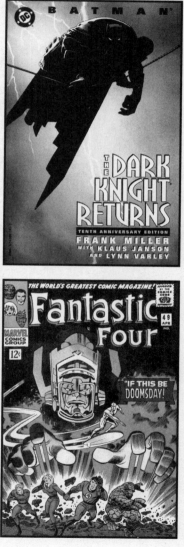

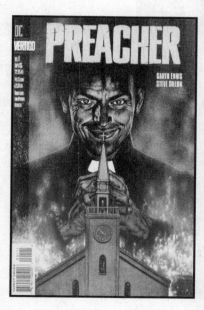

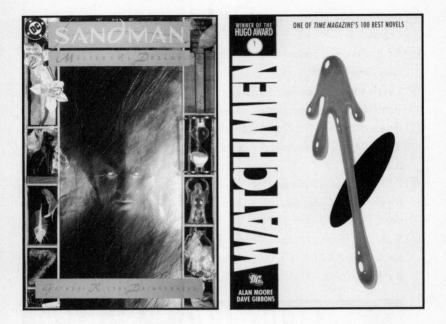

④ Warren Ellis (*Authority, Planetary, Transmetropolitan, Nextwave, Red, Hellblazer*)

③ Neil Gaiman (*Sandman, Death: The High Cost of Living*)

② Grant Morrison (*JLA, New X-Men, We3, Doom Patrol, Animal Man, Batman*)

① Alan Moore (*Watchmen, V for Vendetta, Marvelman, Swamp Thing, Promethea*)

TOP TEN COMIC BOOK ARTISTS OF ALL TIME

The following are the results of a survey of the readers of Comic Book Resources asking for their favorite comic book artists,

along with a few of their most notable works; they're listed in ascending order.

⑩ Alex Ross (*Marvels*, *Kingdom Come*, *Justice*, *Superman: Peace on Earth*, *Uncle Sam*)

⑨ John Romita Jr. (*Amazing Spider-Man*, *Uncanny X-Men*, *Daredevil*, *Thor*, *Avengers*)

⑧ Frank Miller (*Batman: The Dark Knight Returns*, *Daredevil*, *Ronin*, *Sin City*, *300*)

⑦ John Byrne (*Uncanny X-Men*, *Fantastic Four*, *Superman*, *Alpha Flight*, *Next Men*)

⑥ Jim Lee (*X-Men*, *WildC.A.T.s*, *Batman: Hush*, *Superman: For Tomorrow*)

⑤ Neal Adams (*Batman*, *Green Lantern/Green Arrow*, *Deadman*, *X-Men*, *Superman*)

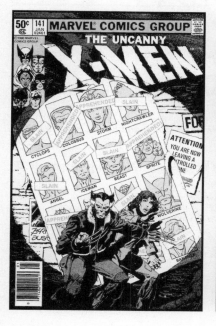
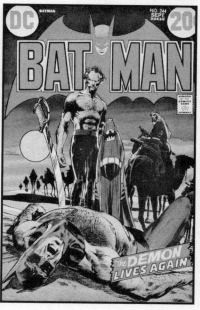

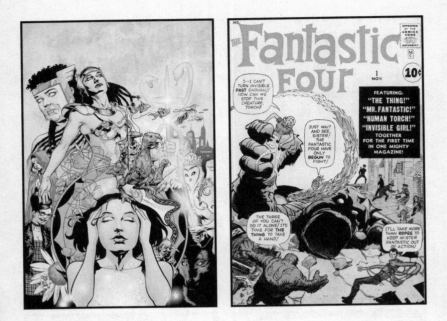

④ George Perez (*New Teen Titans, Avengers, Crisis on Infinite Earths, Wonder Woman*)

③ J. H. Williams III (*Promethea, Batman, Batwoman, Chase, Seven Soldiers*)

② Frank Quitely (*We3, New X-Men, Batman and Robin, Flex Mentallo, Authority*)

① Jack Kirby (*Fantastic Four, X-Men, Captain America, Avengers, Hulk, New Gods*)

FOUR THINGS NOT TO DO WHEN TRYING TO BREAK IN AS A COMIC BOOK ARTIST

MIKE DEODATO

I've had the good fortune to do comic book conventions all over the world. One constant, beyond mutual love for comics, is that every comic book convention has fans that want to be professional comics artists. When I sit at various publisher and agent booths, I see the interactions between fans and pros. Once in a while, I see a great meeting and bright smiles all around, but more often, I see would-be artists walking away, dejected. But! I *also* hear what those editors and publishers and agents have to say *after* the people leave. Here are four rules of what to avoid doing, based on my experiences.

① **Don't announce that you kick ass.** At one con, an artist, girlfriend in tow, came up to an editor, threw open his portfolio, and announced, "I kick ass!" I was sketching nearby and glanced over, curious to see precisely what ass-kicking art should look like. Little did I realize it should look a bit like stick figures surrounded by rubbery lines. The editor started to explain what type of art this fellow would need to submit, basic advice the guy clearly needed, yet the next words from the guy's mouth were, "You're not what *I* need!" And he scooped up his ass-kicking stick figure work and stormed off to the next booth.

② **Don't make excuses for your work.** One sunny Sunday at a con, an artist handed his portfolio to an agent, who carefully looked through every piece to get a feel for the work before commenting.

I could see the guy on edge, dreading the words to come. When the agent finally began commenting, the artist interrupted with excuses about every piece. "I didn't have the reference." "I broke up with my girlfriend that week." "The storytelling's weak because I didn't have a real script to draw from." "That's an old piece." Finally, the agent asked, "So you're saying nothing in this portfolio reflects the work you can really do right now?" "That's right," the artist replied. The agent closed the portfolio, handed it back, and said to the line of artists, "Next?"

③ **Don't compare yourself with the worst guy working.** "I saw the latest issue!" an artist proclaimed to the book's editor. "I can draw better than that." "Yes, you can," said the editor, paging through the kid's portfolio, an amused look on his face. "But *everybody* I have working for me draws better than he does. I don't need somebody better than my worst guy; I need somebody better than my best guy."

④ **Don't lie about your credits.** "I'm working on *Wolverine: Origins* #29 right now," said the artist showing his stuff to my agent as I did sketches nearby. "No, you aren't," I said without looking up. "I'm drawing that issue right now." "Ummm . . . I mean, I was supposed to draw it but I was too busy." "Maybe you're mistaken," said my agent, "because that was always part of Deodato's scheduled run." "No, I mean it was a sample." "So you're telling me your best recent *credit* is a sample that you didn't do?" Sometimes the truth can be merciless.

Understand that editors *want* to discover the next top talent. Fake credits, poor comparisons, sad excuses, and overselling your skills do nothing to make those sample pages better. For better or for worse, the quality of the work will speak for itself. So make it great!

One of Marvel's top exclusive artists for many years, Mike Deodato started working in the American market twenty years ago, making his first splash with such titles as Beauty and the Beast, Lost in Space, *and* Quantum Leap. *From there he went on to* Wonder Woman, Batman, Wolverine, Spider-Man, X-Men, *and various Avengers titles. His latest art book,* The Marvel Art of Mike Deodato, *premiered in 2011.*

FOUR INSTANCES OF COMIC BOOK CREATORS BEING LAMPOONED BY ANOTHER CREATOR

When you work in an industry as insular as comic books, there are bound to be some bruised egos and grudges carried. Occasionally these feelings even make their way out onto the pages of the comic books themselves. Most of the time, you presume that the teasing is meant good-heartedly, but you never know. . . .

① **Funky Flashman and Houseroy.** After leaving Marvel for DC, Jack Kirby decided to use the pages of *Mister Miracle* #6 to take a shot at his former coworkers—specifically, Stan Lee and Roy Thomas. The Lee riff is understandable, especially from Kirby's side of things, as he felt that Lee took too much credit for their work together at Marvel and that Lee got more attention because he had a better image. The knock on Roy Thomas (as the excessively demeaning "Houseroy") is strange, though. Kirby didn't appear to have had much interaction with Thomas at Marvel, so such a harsh criticism seems a little out of bounds.

② **Thundersword.** In the pages of *Secret Wars II* #1, Jim Shooter gave a little grief to a former notable Marvel writer, Steve Gerber, who was at the time writing for the *G.I. Joe* cartoon series. In the comic, Gerber is depicted as a bloating hypocrite who feels that he is better than "the masses" while continuing to sell them bloody gore by the bucketful ("Of course I'm against violence, you idiot! That's the point!").

③ **Sunspot.** Soon after Shooter did his Gerber take, so, too, did John Byrne, Len Wein, and John Ostrander on Jim Shooter in the pages of DC's *Legends* #5. In the comic, Shooter is depicted as a raving power freak, constantly harping about the "New Universe" (Shooter had just launched a new line at Marvel Comics called the New Universe—his Sunspot persona is also a send-up of the main character of the New Universe, the Starbrand).

④ **Johnny Redbeard.** Byrne, in turn, was lampooned in an issue of Erik Larsen's *Savage Dragon*. Johnny Redbeard was a power-mad fellow who experimented on characters and gave a number of them superpowers and then abandoned them all when he became disinterested in them. The characters all match characters that John Byrne had, at one point or another, worked on—including riffs on She-Hulk, Superman, and Namor the Sub-Mariner. These now-ignored characters call themselves Johnny Redbeard's Nixed Men, in reference to Byrne's series for Dark Horse Comics at the time, *John Byrne's Next Men*.

FOUR WRITERS WHO BROKE BOUNDARIES (AND HOW THEY INSPIRED ME TO DO THE SAME)

J. M. DeMATTEIS

① **Stan Lee.** Contemporary comic book readers can't possibly understand how different the 1960s Marvel comics were from everything else on the stands. DC's comics—for all their imagination and artistic flair—were pristine and sculpted, all-American and squeaky clean to the point of being nearly antiseptic: no rough edges, no raw emotions, nothing messy at all. If you looked at the Marvel books, especially in the early days of the line, it was *all* mess. The covers said it all: lurid colors. Captions screaming for your attention. Oversize word balloons with thick black borders around them. Artwork so primitive it was frightening. The Marvel Universe was everything an adolescent boy in love with superheroes and science fiction could ever ask for. It exploded my imagination—and I've been picking up the pieces ever since.

There's been much debate, down through the decades, about the relative contributions of Stan Lee (who was Marvel's editor, art director, and head writer in that formative era) and his collaborators. From my perspective, Stan's contribution was incalculable. Even if, hypothetically, Jack Kirby and Steve Ditko (both of whom were absolutely essential to the company's success) plotted every single one of those stories on their own, Stan created the vibe and the mythos of Marvel Comics. He did it with cocky cover copy and the warmth of the "Bullpen Bulletins" pages, the hilarious footnotes and scripts that managed to be absurdly pseudo-Shakespearean and yet utterly down-to-earth at the same time.

Most important were the absolutely relatable characters (especially to a boy on the verge of adolescence), constructed of equal parts angst and humor and, above all, heart. Stan put his passion into those pages. They clearly mattered to him, and so they mattered to us, as well.

② **Jack Kirby.** With Stan Lee, Jack Kirby took mainstream comics and turned them inside out, upside down, and left his mark forever. But, as his later Marvel work too clearly showed, he was bored. If his collaboration with Lee brought Kirby to new levels, those levels had now been attained, a plateau had been reached, and it was time to move on—without collaboration. Artists, *real* artists, tend to burn. When they've burned long enough, the smoke starts pouring through their lips and they've got to spit the fire out.

In 1970, Kirby jumped from Marvel to DC and started spitting fire. The fire was called *New Gods*, *Mister Miracle*, *Jimmy Olsen*, and *Forever People*. Books that opened new doors, set new standards, did things that comics had never dared to do before. True, the dialogue in those stories was sometimes awkward—but dialogue was never Kirby's forte. *Storytelling* was. *Spirit* was. *Vision* was. And those stories had them all. They ran, they rambled, they surprised, and they *exploded*.

The word "genius" is one that's often overused, and cheapened by that overuse, but if the comic book business has ever produced a genius, Jack Kirby was it. A genius who taught me that keeping my eyes wide, focused both on the limitless heavens and the infinite universes within the human heart, is the surest way to create stories that matter.

③ **Steve Gerber.** Steve Gerber was a mold breaker. He had an individual voice at a time when many of Marvel's writers—even the very best of them—were burying their individuality beneath a layer of Stan Lee–isms. He stepped into the Marvel Universe,

looked around at the towering structures that Lee, Jack Kirby, and Steve Ditko had erected, bowed in deference to their collective genius, and then started kicking those towers down with ferocious glee. His work on *Defenders* (where he injected a Monty Python–esque lunacy into the superhero genre), *Howard the Duck* (the first overground underground comic book), *Man-Thing* (his most impassioned and compassionate writing) ranks among the best work of the 1970s. Hell, it ranks among the best mainstream comics work by *anybody ever*. I wouldn't be the writer I am today if I'd never encountered Steve Gerber's work.

④ **Harvey Pekar.** Harvey Pekar and I met at a convention in the 1980s and had a brief, spirited correspondence debating the merits of realism versus fantasy in fiction. It was then–Marvel editor Denny O'Neil who turned me on to *American Splendor*, a series that helped explode the limits of what a comic book could or couldn't be. Pekar's writing was absolutely naked—brutal and hugely funny—in its honesty. In its wonderfully odd and idiosyncratic way, it was also wise. Harvey brought an outsider's eye to comic book art as well: the *American Splendor* strips taught me the value of the static image, how something as simple as a single talking head, repeated panel after panel after panel, could gather in emotional power. Harvey's work gave me the courage to keep following my *own* odd and idiosyncratic creative urges, to be true to myself and the visions in my head: a gift of immeasurable value.

Born and raised in Brooklyn, New York, J. M. DeMatteis was a professional musician and music journalist before entering the comic book field. Although he's written almost all of the major DC and Marvel icons—including memorable runs on Spider-Man *and* Justice League—*DeMatteis's greatest acclaim has come for his more personal work. The autobiographical* Brooklyn Dreams *was picked by the American Library Association as one of the ten best graphic nov-*

els, and Booklist, *in a starred review, called it "as graphically distinguished and creatively novelistic a graphic novel as has ever been . . . a classic of the form."*

THREE POP CULTURE ICONS WITH CONNECTIONS TO JACK KIRBY

J ack "the King" Kirby is probably the most famous comic book artist in the history of the medium. Along with Stan Lee, Jack Kirby was the face of Marvel Comics during its breakout success in the 1960s. Kirby's art style became the "house style" at Marvel Comics for years and even today, many artists pattern themselves after him. Kirby's influence was not just restricted to the world of comic books, though. Here are three other pop culture icons whose paths have crossed with Kirby's over the years in unusual ways.

① **Johnny Carson.** In 1982, Kirby drew a 3-D comic called *Battle of the Third-Dimensional World* that included 3-D glasses with the tagline "Jack Kirby, King of the Comics" printed on them. At some point that year, legendary *Tonight Show* host Johnny Carson came across these glasses, and did a bit of riffing on the tagline, saying he was put off that this Kirby guy was calling himself the "King of the Comics" when nobody had ever heard of him. As you might imagine, Kirby was quite displeased about this whole debacle. Ultimately, Kirby's status in the comic book community was explained to Carson and the matter was resolved amicably, with Carson devoting time in his show to apologize to Kirby for his mistaken comments. Talk about the King—not too many people ever received an on-air apology from Johnny Carson!

② **Paul McCartney.** On Paul McCartney's 1975 Wings' album, *Venus and Mars*, there is a song called "Magneto and Titanium Man" about three Marvel villains who commit a robbery. The inspiration for the song came from McCartney's kids, who would read comics when the family went on vacation. When Wings went on tour to support the new album, Gary Sherman, brother to Jack Kirby's assistant Steve Sherman, thought that Kirby and McCartney should meet, so he concocted a story that Kirby had a drawing that he wanted to give to McCartney. McCartney's people agreed and Gary had to tell Jack that he had to do a drawing for McCartney— and quickly! Kirby, with his typical awesomeness, whipped up a great drawing of Magneto, Paul, Linda, and the band in less than an hour. McCartney thanked Kirby for the drawing and for helping to entertain his kids, and gave him free tickets to his concert that night. At the concert, McCartney introduced Kirby—"In the audience tonight, we have the creator of Magneto and lots of other comic characters, and I'd like to dedicate this song to Jack Kirby"— and then played "Magneto and Titanium Man."

③ **Frank Zappa.** The late, great Frank Zappa was a big comic book fan and even put advertisements for his albums in Marvel comic books in the 1960s. Later in life, Zappa and Jack Kirby lived near each other and became friends. In fact, after the great success of Zappa's 1982 song "Valley Girl," Zappa tried to convince Kirby that he should adapt the song for a comic strip—and Kirby actually went along with the idea! The strip that Kirby drew was never published, but the fact that Jack Kirby actually managed to do a comic strip based on a Frank Zappa song only further confirms how awesome he is.

FOUR COMIC BOOK CREATORS WHO HAVE RECEIVED DEATH THREATS OVER THEIR WORK

In a world packed with so much violence and anger, it probably should not surprise us to know that comic creators receive death threats over their work (especially thinking about how . . . shall we say, dedicated, certain fans are). Here are four examples of how the act of writing comics nearly turned into something a little more serious.

① **Joe Simon and Jack Kirby.** When *Captain America Comics* #1's iconic cover (featuring Cap punching out Adolf Hitler) was released, it was a year before the United States was drawn into the war. As crazy as it might sound now, there was still a faction of Americans in the United States who were vocal in their support of the Nazis—and these two young Jewish guys having their character punch Hitler out on the front cover? It caused quite a sensation. Things got so bad that New York City police officers were assigned to guard their offices. They even received a phone call from Fiorello La Guardia, the mayor of New York, who told Joe Simon, "You boys over there are doing a good job. The City of New York will see that no harm will come to you." Can't beat an endorsement like that, huh?

② **Marv Wolfman and George Perez.** Wolfman and Perez were the creative team behind *New Teen Titans*, a popular 1980s series from DC Comics (for the first few years of the 1980s, it was even outselling *X-Men*). One of their most famous plots was the "Judas Con-

tract," where the Titans learn that their teammate Terra is a mole sent to infiltrate the group by their old enemy Deathstroke the Terminator. Terminator captures the team and after their plan is thwarted at the end of the story, Terra dies as a result of her own powers. Despite the fact that the reveal that Terra was working with Deathstroke had occurred nearly a year earlier, fan outrage was palpable, including, yes, a death threat.

③ **Ron Marz.** In 1994, Ron Marz was brought on as the new writer of *Green Lantern* to do one thing—have Hal Jordan, the longtime star of the book, go insane and become a villain, and then introduce a new Green Lantern. That was *solely* the plotline that Marz was hired to write—it wasn't even his idea. That said, he still received a tremendous amount of negative fan feedback, with some fans going as far as to threaten Marz's life.

④ **Ed Brubaker.** In a 2010 issue of *Captain America*, there was a political rally in the comic that was *basically* modeled after Tea Party protests, but wasn't intended to be any specific political group. The letterer of the issue, who was in charge of adding the words to the signs in the background, used Google Images for research and ended up unknowingly modeling the signs after trademark Tea Party slogans. Once that was discovered, attention was called to the dialogue of the superhero Falcon in the issue, who remarks that he does not feel comfortable at an antitax rally—an ironic coincidence that took Tea Partiers over the edge. Writer Ed Brubaker began to receive death threats over the comic book, receiving so many negative and threatening emails that he had to close his account. All because a letterer picked the wrong two signs from Google Images to add to the background. Yikes.

THREE UNDERRATED COMIC BOOK RUNS

JAY FAERBER

① *Avengers* **#355–375** (1994–1996). There have been a number of classic runs on *The Avengers* over the years, but one that never gets mentioned (except by me) is the run by Bob Harras and Steve Epting in the mid-'90s. This is what's often derisively referred to as "the leather jacket era," since the Avengers sported team jackets for part of this run. The arc that I'm talking about involves the Gatherers, a group of mysterious villains led by the even more mysterious Proctor, who is hunting alternate versions of the Avengers on parallel worlds. The entire story hinges on a love triangle between the Black Knight, Sersi, and Crystal. None of these characters are exactly A-listers, but the result of their interactions is a superhero book that literally has everything: action, drama, high stakes, humor, and yes, romance. While Steve Epting is a well-respected A-list creator today, he was just finding his groove on *The Avengers*, and it's a real treat to watch him develop here.

② *New Defenders* **#125–152** (1983–1986). Marvel's long-running title *The Defenders* underwent a bit of a revamp in issue #125 and was retitled *The New Defenders*. The series no longer featured the classic *Defenders* characters of Hulk, Namor, Silver Surfer, and Doctor Strange, and instead featured the diverse lineup of the Beast, Iceman, Angel, Gargoyle, Valkyrie, and Moondragon. The majority of the run was written by Peter B. Gillis and penciled by Don Perlin and featured the Defenders working out of Angel's mansion in the mountains of New Mexico. To say this book was weird would be a severe understatement. The Defenders were still

superheroes, but they rarely fought actual costumed supervillains. Instead, they fought various monsters and freaks and demons. The series kinda felt like a Vertigo book . . . before Vertigo books had been invented. Really quirky stuff to be found in a C-list Marvel title in the mid-1980s.

③ *Aquaman* **#16–22** (2004). Writer Will Pfeifer and penciler Pat Gleason took over *Aquaman* in 2004 and launched the series into a great, short-lived direction: part of the city of San Diego was submerged after an earthquake and all of its inhabitants somehow gained the ability to breathe underwater, with Aquaman reigning. The idea of an underwater city full of people who were struggling to adjust to their new lot in life was one that was rife with potential, and Pfeifer made great use of it.

Jay Faerber currently writes Near Death, *a monthly from Image Comics, and is on the writing staff of* Ringer, *airing on the CW Network.*

FOUR NOTEWORTHY ART SWIPES BY BOB KANE

In relation to art, "swiping" is the practice of taking another artist's drawing and copying it into your own work. Bob Kane, cocreator of Batman, was no stranger to swipes. He even swiped an Alex Raymond drawing for the cover of *Detective Comics* #27, the first appearance of Batman. In addition to that famous swipe, Robby Reed of the website Dial B for Blog and DSK of the Vallely Archives website discovered the following notable art swipes by Kane.

① *Detective Comics* **#33.** Kane swiped the following layout that Hal Foster used in the *Tarzan* comic strip.

Kane later did a Batman poster using an enlarged version of this panel.

DSK, who runs a website about 1930s artist Henry Vallely, came across a particularly shocking collection of swipes. Vallely drew a 1938 "Big Little Book" called *Gang Busters in Action*, written by Isaac McAnally. That one book was used by Kane in two different stories, including one of the most famous panels from early Batman history!

② ***Detective Comics* #33.** From the first origin of Batman, we see Bruce Wayne note that criminals are a cowardly and superstitious lot. The panel is clearly lifted from the *Gang Busters* panel by Vallely.

③ **Detective Comics #27.** From the first appearance of Batman and Commissioner Gordon in 1939, you can see how Gordon in this panel is patterned after the following *Gang Busters* panel.

Olson, Captain of the Police

④ **Detective Comics #27.** Of all the *Gang Buster* swipes, this might be the most amusing. Kane swipes a car, for crying out loud, from Vallely. A *car*! You don't have the time to draw a *car*?

They Drove Along the Highway

SIX STANDARD-RAISING COMIC BOOK ARTISTS

JIMMY PALMIOTTI

① Darwyn Cooke (*Jonah Hex* #50)

② Alex Toth
③ Frank Franzetta

④ Jim Steranko (*Nick Fury, Agent of S.H.I.E.L.D.* #2)

⑤ Amanda Conner

⑥ Jaime and Gilbert Hernandez (*Love and Rockets* #23—Jaime's art in this example)

Jimmy Palmiotti is an Eisner Award nominee who has written many popular and well-received series, such as Jonah Hex, Power Girl, Monolith, *and* 21 Down. *He is currently writing* All Star Western *for DC Comics with his longtime writing partner, Justin Gray. He is also working on a number of independent comic projects, including an original graphic novel,* Queen Crab.

FIVE COMIC BOOK CREATOR EASTER EGGS

An "Easter egg" is a recurring in-joke or hidden reference in a pop culture work that you have to search for to find (hence the name). Here are some notable Easter eggs in comic books.

① **Popeye.** Legendary inker Terry Austin is a huge Popeye fan, so much so that he sneaks Popeye into the background as often as he can.

② **Felix the Cat.** At a local comic book store that Todd McFarlane frequented, he knew a fellow who carried a Felix the Cat doll with him at all times. The man was friendly enough, but would often tell McFarlane how he did not pick up any of his books because he was not a fan of superhero comics. Finally one day McFarlane asked him, "If I put Felix the Cat in my comics, would you buy them then?" He said yes, so McFarlane put Felix the Cat into his comics from that point on.

③ **Jon Day.** Jon Day was a childhood friend of Erik Larsen. When Larsen was just starting out, he drew Day into a small independent comic book that he was drawing. Jon apparently got the impression that Larsen was going to put him into *every* comic Larsen drew. Larsen figured, what the heck, and Day has appeared in pretty much every comic Larsen has drawn since then. He is a slight, balding fellow with glasses and a mustache. Keep an eye out for him in any given issue of Larsen's *Savage Dragon* comic book!

④ *Mystery Science Theater 3000.* Artist Todd Nauck is a big fan of the television series *Mystery Science Theater 3000,* and he tries to work in a reference to the show whenever he gets a chance, even if it is as simple as writing "MST3" on a sign in the background of a panel. When he can, he'll sneak the robots from the show into the background, too.

⑤ **Barney Rubble.** John Byrne is probably the king of sneaking little hidden jokes into his comic books. Perhaps his most famous Easter egg is the tiny drawing of Barney Rubble he would make whenever he had to draw actual rubble. Eventually, when the gag became too well-known (and therefore no longer a "hidden joke"), Byrne stopped drawing Barney in rubble. I would not be surprised if there are new jokes that Byrne is hiding in his current work that no one has discovered yet!

PART III

COMIC BOOK
STORYLINES

NINE GOOFIEST MOMENTS IN THE FIRST TWENTY ISSUES OF *BATMAN*

When Batman's ongoing series debuted, there were four separate Batman stories in each quarterly issue. As you might guess, that leaves a lot of room for the Caped Crusader to get a *little* bit goofy.

① **Is Robin going to have to slap a Batman?** In *Batman* #3, Batman becomes hypnotized, and Robin knows just what to do.

The sight of Robin dropping Batman with one punch? Hilarious.

② **Surgery made simple.** In *Batman* #11, Bruce Wayne and Dick Grayson are on vacation in Florida when they stumble across a crooked gambling operation run by the Penguin and three new associates. One of the gang is a beautiful singer (the Canary) who performs in the casino's nightclub. After Batman saves her life, she warns him of an attack planned on him, but it's too late. Not only does Batman get shot, but the poor guy gets *trapped in a hurricane*. Needless to say, Batman is in baaaad shape, and all of the hospitals are too full to heal this superhero. Luckily, Canary once worked as a doctor's assistant, so she successfully performs a (very advanced) surgery on Batman! She is inspired enough to leave the world of crime to become a Red Cross nurse.

③ **Batman on speed.** In *Batman* #10, it is Dick's birthday and yet it is Bruce who is hyperactive as he wakes Dick, gives him birthday spanks, shows him his cake, then takes him to see his present—all in a matter of seconds.

④ **Remember, kids, lobotomies are always the answer!** In *Batman* #2, Batman discovers that the Joker escaped his apparent death in *Batman* #1 and is being kept under armed guard at a hospital. He sets off to do something about this and comes up with an excellent strategy: "My plan is to abduct the Joker from the hospital before he becomes strong and wily enough to slip through the hands of the police. Then we'll take him to a famous brain specialist for an operation, so that he can be cured and turned into a valuable citizen." So you're going to break in, kidnap a guy, and then *give him a lobotomy*? That's your plan? Good luck with that, Batman!

⑤ **In the Golden Age, this was all quite routine.** In *Batman* #19, Batman and Robin discover that the Nazis have uncovered the lost city of Atlantis and are now using it as a submarine base. That is amazing in and of itself, but the writers couldn't just stop there!

No, the king of Atlantis is a boy who looks just like Robin, to the point that Robin is able to impersonate him to save Batman's life. Remember, comic books teach us that you will meet your exact double at least once a week!

⑥ This is a weird time for a demonstration, Batman. In *Batman* #1, Batman and Robin board a yacht to stop some crooks. For some reason, even though Batman knows there's a jewel thief on the boat, he decides to take some time to demonstrate to readers about how cowardly bad guys are! After a couple of pages of Robin beating the bejeesus out of the crooks, Batman turns to the reader and states: "Well, kids, there's your proof! Crooks are yellow without their guns! Don't go around admiring them . . . rather do your best in fighting them and all their kind!" Then they end this PSA about bad behavior and go about, you know, actually stopping the jewel thief they went there to catch.

⑦ Don't turn this Bat-Plane into a den of lies! In *Batman* #10, Batman and Robin are flying in the Bat-Plane when they get lost in a storm. They end up flying by an island and Robin sees what he thinks is a dinosaur. Batman replies, "Don't get gay! You know as well as I do dinosaurs lived millions of years ago! Give me those glasses!" After they land and are walking through the jungle, Robin again insists that he saw a dinosaur. While he tells Batman this, he slips on a log and falls down. Batman retorts, "A dinosaur in the twentieth century! See what you get for telling lies!" Yes, Robin, see what you get? Of course, Robin is basically correct (there are dinosaurs there, but they are mechanical ones for a movie being filmed on the island). Batman never admits he was wrong, of course.

⑧ Not now, Robin, my stories are on! In *Batman* #1, the Joker makes his debut killing a rich Gotham citizen and stealing his expensive

diamond. When news of the murder and theft air over the radio, Dick and Bruce are sitting in the parlor reading. Dick says, "But Bruce, why don't we take a shot at this Joker guy?" And Bruce replies: "Not yet, Dick. The time isn't ripe." What do you mean the time isn't ripe? The guy just *murdered* someone. I suppose Batman doesn't even get out of bed in the morning unless the body count is in the double digits.

⑨ **Batman sure is smooth with the ladies.**
In *Batman* #1, Batman captures a jewel thief in disguise as an old woman. In order to find out her true identity (the Cat, later known as the infamous Catwoman), he orders the thief to remove her old woman makeup. She struggles in Batman's grasp, but he is firm and he lets her know what will happen if she doesn't reveal her true self.

Papa spank, indeed, Batman. Papa spank, indeed.

FIVE SUCCESSFUL RETCONS
(PLUS THE WORST RETCON OF ALL TIME)

A "retcon" is when a writer *retro*actively changes *con*tinuity. Retcons typically get a bad name because people worry about writers changing concepts too much, but the fact of the matter is that a number of very important comic book stories would not have been possible if it were not for them. Here are five retcons that were successful (and one that absolutely bombed).

① **Captain America did not make it out of World War II.** This retcon is one of the most important ones around, and a perfect example as to why fans should not be so quick to judge new retcons too

harshly. Originally, *Captain America Comics* lasted until the late 1940s, well after the end of World War II. Later, there was a revival during the 1950s (where Cap's new enemies were the communists). When Stan Lee introduced the new Marvel Universe of superheroes, he decided to bring Captain America into the fold. However, he also decided to ignore all the stories that had happened after World War II. Instead, in *The Avengers* #4, Captain America is awoken from a suspended animation he had been in since the tail end of World War II. The "man out of time" element worked wonders for years and is still a strong element for adaptations of *Captain America*.

② **Alec Holland is dead.** For years, Swamp Thing was a straightforward concept: a scientist named Alec Holland was caught in a chemical explosion in the swamp that caused him to turn into a, well, swamp thing. That was the case until Alan Moore took over the character with *Saga of the Swamp Thing* #20. The next issue, in a story called "The Anatomy Lesson," Moore revealed that Alec Holland died that day. The chemicals did not turn Alec Holland into a mass of plants; it turned a mass of plants into a being that *thought* it was Alec Holland! Once people put together the pieces of their brains after Moore just exploded them all, they got ready for an excellent run of stories by Moore, now free to do whatever the heck he wanted to do with this plant that thought it was a man.

③ **Magneto is not a sociopath.** One of the most controversial figures in comics is Magneto. For years he was one of the greatest villains in all of comics; however, when Chris Claremont began writing the character, he slowly added backstory to Magneto that made him a much more sympathetic figure. First, we learned that he survived a concentration camp during World War II. The idea of a Holocaust survivor also being part of *another* subjugated group (mutants)? That's fascinating, especially when you contrast it against some of

the extreme actions he proposes in support of mutantkind. Claremont also established an old friendship between Magneto and Professor X that fell apart because of their philosophical differences. Claremont established that Xavier and Magneto were, in essence, the Martin Luther King and Malcolm X of the mutant rights movement. These changes to what was once a one-note villain helped present a much more complex, interesting, and ultimately, more likable Magneto than what we had seen before. It is this version that has been adapted into multiple films now.

④ **Bucky was a commando.** It never really made sense that a soldier like Captain America would go into battle with a teenage sidekick, which is just what Bucky was in the Golden Age *Captain America Comics*. Writer Ed Brubaker addressed this when he took over writing *Captain America* in 2005. As it turned out, Bucky was actually a dangerous commando who would sneak off and slice some throats and otherwise neutralize the bad guys before the next day's public battle. So, yes, Bucky essentially was Rambo, not a teenager, making his presence in battle scenes a lot more comfortable.

⑤ **Bucky did not die.** For years there were two constants in the Marvel Universe: both Spider-Man's Uncle Ben and Captain America's partner, Bucky, would stay dead. However, Ed Brubaker ignored that second rule and brought Bucky back to life. And he somehow made it *cool*! You see, after the same explosion that had left Captain America in suspended animation and Bucky seemingly killed in action, Bucky was rescued (what was left of him—he lost an arm in the explosion) by the Russians, who then brainwashed him into becoming the perfect assassin. Bucky then went on missions for them and when he was finished, they would put him into cryogenic storage. That way, a killing he did in 1948 would not be able to be pinned on him when he shows up in 1955 at the same age as

he was seven years earlier. After decades of this (and Bucky aging only into adulthood), Captain America finally comes face-to-face with his old partner. Eventually he snaps Bucky out of the brainwashing, and when Captain America is killed, it is Bucky who steps in and takes over as the new Captain America. A successful retcon indeed: Brubaker took an idea that nobody wanted to see and made it something that pretty much everybody could enjoy.

And now for the worst retcon of all time. . . .

Flash got his powers from Mopee. The Silver Age Flash had a pretty typical Silver Age origin. Lightning hit some chemicals that splashed on him and he gained superpowers. However, in 1967's *Flash* #167, Flash meets Mopee, a short, balding fellow in a robe with big thick glasses who was a magical "heavenly help-mate." Mopee reveals that it was *he* who gave the Flash his powers, not a "one in a ten quadrillion billion chance" like the chemicals doing it. This origin must have set a record for the fastest time that a new origin was ignored, as it was never mentioned again after Mopee's first appearance.

SIX WAYS THAT AQUAMAN'S FINNY FRIENDS HAVE HELPED HIM OUT

People often overlook Aquaman's powers, but let's be honest: the ability to get a whole army of sea life to do stuff for you is pretty darn cool. Here are just six ways (among many hundreds) that Aquaman's finny friends have helped him out over the years. (Thanks to my pal H at the Comic Treadmill for spotlighting finny friend stories for years.)

① **An octopus serving as umpire.** In *Adventure Comics* #206, a group of kids get stranded on a deserted island. Aquaman stops by and decides to entertain them by playing baseball with them in the water, during which an octopus friend serves as home plate umpire.

② **A whole group of fish performing surgery on Aquaman.** In *Adventure Comics* #262, Aquaman constructs a fish hospital underwater. The fish repay his generosity when he is shot later in the issue. They team up to perform surgery on him (talented swordfish do the actual surgery—lantern fish provide the light).

③ **An octopus searching eight pockets at once.** In *Adventure Comics* #264, a U.S. city becomes partially submerged and becomes "New Venice." Aquaman and his finny friends become the police force in town. When someone has his pocket picked, an octopus searches the pockets of eight nearby people to see who stole the man's wallet. Eight civil rights violations at once! A new record!

④ **Topo the octopus rocking out.** In *Adventure Comics* #266, Aquaman's pet/sidekick, Topo the octopus, helps save a birthday party on a boat from being a disaster by rocking out as a one-octopus five-man band!

⑤ **Whales forming a runway.** In *Adventure Comics* #271, a plane is about to crash into the ocean, so Aquaman commands a group of whales to form a runway for the plane. But wait, Brian, you might say . . . wouldn't the plane just tear the whales apart? Of course not; the plane would just land safely on them! Perfectly plausible!

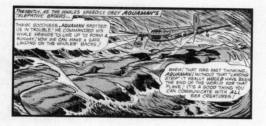

⑥ **Various fish helping Aqualad cheat.** In *Adventure Comics* #278, Aqualad is trying to get accepted into a local school. He's quite bright, but right before his big test, he gets hit in the head and can't remember what he learned. Aquaman does not think this is fair, so he gathers a bunch of fish outside the window of Aqualad's school to basically help Aqualad cheat his way through the test. Aquaman's plan works and Aqualad passes with flying colors. That's some judicious usage of your powers, Aquaman!

FIVE MOST ICONIC COMIC PANELS IN MARVEL COMICS HISTORY

A survey of Comic Book Resources readers came up with these five panels, shown in ascending order, as the most iconic in Marvel Comics history.

⑤ From *Amazing Spider-Man* #121, story by Gerry Conway, artwork by Gil Kane and John Romita Sr.

④ From *X-Men* #132, story by Chris Claremont and John Byrne, artwork by John Byrne and Terry Austin.

③ From *Amazing Spider-Man* #50, story by Stan Lee, artwork by John Romita Sr. and Mike Esposito.

② From *Daredevil* #181, story by Frank Miller, artwork by Frank Miller and Klaus Janson.

Ⓕ From *Amazing Spider-Man* #42, story by Stan Lee, artwork by John Romita Sr.

FIVE "WTF?" MOMENTS IN COMIC BOOK HISTORY
MARK MILLAR

Ⓕ **Captain America's Stark armor.** Cap's been through some weird stuff in his career. He fought Hitler, got frozen in ice, and briefly became a werewolf. But the thing that really sticks in my head as the weirdest Captain America idea has to be the Stark armor he was given in the '90s. It's not that the idea was especially ridiculous. He'd been poisoned by his own supersoldier serum and immobilized in a hospital bed, prompting his dear friend Tony Stark to build him a cybernetic suit that would allow him to keep fighting crime. But the fact that this suit that *lets the crippled walk*

again has been retired to Stark's personal collection is beside the point. The thing that makes this weird for me is that Cap still carried a shield despite wearing bulletproof armor. What the #@*&?

② **Supermobile.** The weirdest moments in comics always seem to come when superheroes lose their powers and need some kind of technical assistance. Spider-Man got the Spider-Mobile under such circumstances back in the '70s. The Supermobile had buttons for heat vision, microscopic vision, and even superbreath. And just in case the man needed to beat the shit out of someone, there were two big fists at the front, literally intended for pounding people. As a kid, I had no idea that these storylines were crude tie-ins with toys being released and the concepts forced upon the otherwise brilliant creative teams. We didn't get the toys here in Scotland and so it just seemed like, very briefly, the writers and artists had lost their minds.

③ **Green Lantern as a toy salesman.** Spider-Man is a photojournalist and Daredevil is a lawyer. But, really, who does the same job their entire life, never mind wearing the same blue suit and red-striped tie Clark Kent has been wearing since about 1945? In real life, we change jobs all the time and some of them are crap. I like the fact that as well as being a cool, Chuck Yeager–style test pilot, Hal Jordan has been a truck driver, insurance adjuster, and toy salesman. I guarantee that if he had been a toy salesman in the Ryan Reynolds movie it would have made more money than *Harry Potter* and sucked exactly 18 percent less.

④ **The Spider-Man/Power Pack Child Abuse Special.** Nothing could possibly match the madness of the now-legendary Marvel sex abuse special, paid for by a children's charity in a bid to reach victims of child sex abuse. This comic was a master class in how to

have the best of intentions and yet somehow turn it into something schoolboys would read aloud in class to impress their friends. The Power Pack segment featured an attractive babysitter trying to touch up a boy with the line "You know what you have to do if you want to see *Star Wars*," a piece of dialogue my friends and I still use in the pub at least once a week to this day. But the most insane moment surely belongs to Spider-Man and his disclosure to a young boy that he was nipped by a creepy teenage neighbor long before any radioactive spiders got their teeth into him. Flashback to an inexplicably white-haired boy named Snowy, who interrupts a game of pool with some porn mags, suggesting he and young Parker touch each other "like the people are touching each other in the magazines." It's bona fide bonkers and how anyone cleared this storyline is a mystery beyond even the pyramids. Surely, it's only a matter of time before Marvel brings him back as a new villain in *The Amazing Spider-Man*. The Buggernaut, anyone?

⑤ **Lex Luthor beating Superbaby to death.** Superman's probably had more "What the %$#*?" moments than any other character in history. Before you and I were born, Red Kryponite had turned him into King Kong, an insect god, a small, mobile rock formation, and the former senator Jesse Helms (only one of these facts is made up). In the '90s, they made him fat and gave him a ponytail. But surely the biggest WTF moment in comic book history is *Action Comics* #466 and Lex Luthor's brilliant plan to finally destroy his hated enemy. Frustrated at not being able to beat Superman, Batman, and the Flash as adults, he turns them all into children . . . and beats them to death with a power glove. Just in case his bare fists *weren't enough* against the superbabies. This was quite possibly the first DC comic anyone ever bought me and I'm still haunted by the image of Batman and the Flash as dead toddlers among wreckage, Superbaby screaming as Luthor laughs and

donkey-punches him across the back of the head. It's the most messed-up idea for a story in the history of the medium and, reading it at six years old, I was hooked for life.

If you want to be impressed, just check out what Mark Millar has been up to in just the current century: The Authority, The Ultimates, Marvel Knights: Spider-Man, Ultimate Fantastic Four, Civil War, Wanted, *and* Kick-Ass. *That's not even counting his new hits like* Nemesis *and* Superior, *or his work on* Wolverine: Old Man Logan *and* Wolverine: Enemy of the State, *or his acclaimed runs early in his career on* Superman Adventures *and* Swamp Thing.

FOUR STRANGE MOMENTS IN *STAR WARS* COMIC BOOK HISTORY

*S*tar Wars and comic books have been linked for decades (and I'm not even talking about those people who believe that the "Dark Side" and the "Force" are riffs on Jack Kirby's Darkseid and the Source). First, Marvel had a long and fruitful relationship with *Star Wars*, and for the past two decades, Dark Horse has been putting out some really great comic books based on the *Star Wars* characters. Lucasfilm has done very well with its properties in the world of comics, but that does not mean some weird things did not happen over the years, of course. Here are four of the strangest moments.

① *Splinter of the Mind's Eye*, released in 1978, is often thought to be the first "expanded universe" *Star Wars* story (a story that built upon the stories *from* the films rather than a comic book adaptation of the movie). However, it was actually beaten to the punch

by a story that appeared in the same year *Star Wars* came out, 1977, in the pages of—of all places—*Pizzazz*!

Pizzazz was a weird mishmash of a magazine that Marvel produced for a few years that mixed comic-related content with games and articles about entertainment and sports. It also had, for the first eighteen issues, original *Star Wars* stories—including the very first expanded universe *Stars Wars* comic!

② Writing for *Star Wars* in the 1980s was weird, because writers were constrained by the plots of the movies being released. To wit, you couldn't have plots with Luke and Darth Vader, and without Vader, let's be honest, things get a little boring. One plot that *was* available was "the search for Han Solo." So long as they did not actually *find* Han after the events of *The Empire Strikes Back*, comics were free to spend issues *looking* for him. In issue #46, Lando Calrissian got his

first solo issue, written by J. M. DeMatteis, where he goes on the hunt for Han. During their search, Lando and Chewbacca meet an old Rebel warrior named Cody Sunn-Childe, who decided not to get involved in the intergalactic war. Lando really rides him, telling him pacifism is for chumps. He gets Cody to rise in anger, but then Cody realizes that his pacifistic views have no real strength if they are not challenged. Well, they are very challenged when the Imperials show up and Cody refuses to fight. He is killed, but DeMatteis's idea was to say, "Hey, there's nobility in choosing to die for a cause or a belief." The folks at Lucasfilm felt otherwise, though, and had Marvel change the ending of the comic so that Lando specifically points out that what Cody did was *wrong*! DeMatteis was angry enough that he took his name off of the issue.

③ As you know, *Star Wars* is very popular all across the globe, so it's only natural that the comic book adaptations would also be popular. However, sometimes when things get translated, the meaning gets lost, as it did in a particular Danish translation of *Star Wars* #77. In that issue, "Chanteuse to the Stars" (called such because Leia, while hiding from the Imperials, has to impersonate a lounge singer), we get an issue where Leia, Luke, and Plif (a new character created for the Marvel *Star Wars* comic) are on the planet of the Zeltrons, humanoid aliens who sometimes give off pheromones that make them appear even more attractive than they already are. While there, Luke and Plif (who is pretending to be an alien ambassador, with Luke as his assistant) are accompanied by some Zeltrons. In one panel, a Zeltron asks, "Gee, are you little fellows any fun?" In the Danish translation, though, that line is translated as, "Can I please take you to bed with me?" I've heard some Danish folk suggest that the connotation from the translation is like "I want to take you to bed like a little teddy bear," but either way, it is a *weird* translation.

④ In 2000, Randy Stradley was writing *Jedi Council: Acts of War*, in which he introduced a new Jedi Master named Soon Baytes. Stradley said he came up with the name because the comic editor for Lucasfilm, Sue Rostini, would always correct character names so that when a Jedi Master was addressed, "Master" preceded the Jedi's last name. For instance, if Stradley wrote "Yoda," she would correct it to "Master Yoda." Stradley figured that when she did that to Soon Baytes, the joke would become clear to her and Stradley would then come up with a "real" name. Only she did not get back to him, so the character made it into comic book history. Get it? Master. Bates? Anyone? Gotta love high school humor.

TOP FIVE COMIC BOOK STORYLINES

Based on a survey of readers of Comic Book Resources, here are the top five favorite comic book storylines of all time, in ascending order.

⑤ ***The Dark Knight Returns.*** Written and penciled by Frank Miller, inked by Klaus Janson. When this four-book series begins, it has been ten years since Batman retired and Gotham City has become a much worse place, with violence flooding the streets. Batman is compelled to return, but as soon as he does, so too does his Rogues (as Miller makes the suggestion that perhaps it is Batman who *draws* people like Joker to Gotham City). Complete with a new female Robin, Batman takes a different approach to helping Gotham, by attempting to assimilate the gangs of Gotham rather than destroying them. This brings Batman into conflict with his old friend Superman, in a memorable final conflict between the two heroes.

④ **"Batman: Year One."** Written by Frank Miller and drawn by David Mazzucchelli. In this four-issue story in the *Batman* series, Miller and Mazzucchelli redefine the origins of Batman. The story cleverly mixes Bruce Wayne telling his side of the story versus the version reported by Gotham's new police captain, James Gordon. The strong story and the striking artwork heavily inspired Christopher Nolan's current *Batman* films.

③ **"Born Again."** Written by Frank Miller and drawn by David Mazzucchelli. This six-issue storyline in the ongoing *Daredevil* series unfolds as Matt "Daredevil" Murdock's former lover Karen Page is now a drug addict. In desperate need for a fix, she reveals Murdock's true identity to fuel her drug addiction. The information makes its way to Wilson Fisk, the Kingpin of Crime and a recurring enemy of Daredevil, who goes on to systematically destroy Murdock's life (getting him disbarred, freezing his assets, and blowing up his home among these actions). With his life in ruins, Murdock manages to slowly build it back up (to be "born again"). In the process, he helps redeem Karen Page's life, as well, while turning the tables on Fisk. Mazzucchelli was already impressing readers as the regular artist on *Daredevil* when Miller returned to the title, and they both delivered one of the most defining storylines in Marvel history.

② **"The Dark Phoenix Saga."** Written by Chris Claremont and John Byrne, penciled by John Byrne and inked by Terry Austin. In this epic saga, Jean Grey of the X-Men had been reborn as the powerful new hero known as the Phoenix. As time went by, though, the maxim "all power tends to corrupt and absolute power corrupts absolutely" became quite true as Jean's powers reached a cosmic level and her mind was warped into a new, malevolent entity known as the Dark Phoenix. Her teammates on the X-Men are

forced to fight against her, during which they seemingly cure her of her affliction. But her powers are still present, and stronger than ever, leading a number of alien races to form a coalition to eliminate Phoenix for fear of her universe-destroying powers. While her teammates defend her, Jean realizes that the alien coalition is right—her power is truly dangerous—and she ends her own life for the good of the universe. She dies as she lived: a true hero.

① **Watchmen.** Written by Alan Moore and drawn by Dave Gibbons. This twelve-issue series changed comic books dramatically, as it showed the sophistication that could be achieved from the medium. Moore and Gibbons fill the series with depth and nuance, showing the devolution of superheroes until we get to the world where heroes can no longer be trusted, leading to the question used in promos for the series—"Who watches the Watchmen?"

FIVE COMIC BOOK DEPICTIONS OF THE VIETNAM WAR
JASON AARON

Jason Aaron studied the depiction of the Vietnam War in comic books while working on his Vietnam comic book series, *The Other Side*, and came up with these highlights and lowlights of the war's portrayal in comic book form.

① **Iron Man in *Tales of Suspense* (1963).** Throughout the 1960s, several prominent superheroes signed up for tours of duty in Indochina, but only one originated in Vietnam. In 1963's *Tales of Suspense* #39, millionaire industrialist Tony Stark is injured by a

booby-trap in the jungles of Vietnam while demonstrating his high-tech "transistor-powered" weapons to the U.S. military. He is then captured by Wong-Chu, the "red guerrilla tyrant" of Vietnam, who orders Stark to build weapons for the commie cause. Instead, Stark builds a suit of armor he uses to blast the commie bastard back to the Stone Age. And thus, Iron Man is born.

② *Blazing Combat* **(1966).** The first truly memorable portrayal of the Vietnam War in comics came courtesy of Warren's short-lived *Blazing Combat* magazine. Most of its stories were written by the late, great Archie Goodwin and drawn by such luminaries as Gene Colan, Russ Heath, Alex Toth, and John Severin. Unfortunately, some of the book's imagery (most notably a scene where Vietnamese peasants are burned to death) proved too inflammatory for audiences in 1966, and the series lasted just four issues. These days, the original issues of *Blazing Combat* command high prices.

③ *Sgt. Fury and His Howling Commandos King Special* **#3 (1967).** In its bid to become "the most talked-about work of war-mag wonderment ever published," this fifty-page travesty features a cameo by President Lyndon Johnson (who speaks like a bad version of a Mark Twain character), Viet Cong fighters who look like Mexican banditos (and, like most other comic book VC of the era, speak fluent English, their favorite phrases usually being "Die, American swine!" and "Death to all Yankee imperialists!"), and a ridiculous plot to sabotage North Vietnam's creation of a hydrogen bomb. Nick Fury's well-formulated plan consists of the Howlers disguising themselves as Vietnamese refugees (a ploy that's perpetrated merely by donning different hats), infiltrating the city of Haiphong, and detonating the bomb. "There she blows!" the Howlers joke as their plane soars above the mushroom cloud. Stan Lee presents . . . Nick Fury executing thousands of civilians! Excelsior!

④ *Super Green Beret* **(1967).** Tod Holton, all-American teenager, is given a magic, glowing beret by his uncle. Whenever he dons the beret . . . *Shazam!* Young Tod is transformed into an adult super-soldier, much like Captain Marvel in fatigues. As Super Green Beret, Tod is able to use his magic powers to aid the American troops in Vietnam by making "magic monkeys" appear to throw coconuts at the Viet Cong or by turning hand grenades into pine-apples. Published by Lightning Comics, *Super Green Beret* only lasted for two issues in the spring of 1967. So unfortunately for all the GIs in Vietnam, Super Greenie Beanie was nowhere to be found come Tet 1968. Probably could've used some of those magic monkeys in Saigon or Hue City.

⑤ *Vietnam Journal* **(1987).** *Vietnam Journal* #1 was unleashed upon an unsuspecting populace in November 1987, courtesy of little-known Apple Comics. Borrowing a phrase from *Full Metal Jacket*

screenwriter Gustav Hasford, Don Lomax's vision of Vietnam had come to "mangle frail civilian sensibilities." Comicwise, I've still never seen anything so horrific as the horribly burned chopper pilot from *Vietnam Journal* #7, whose leg comes off in a medic's hands; the meticulously pockmarked landscape and the bullet-riddled bodies of Viet Cong in issue #4; the tangled mass of soldiers clinging desperately to a chopper's rope ladder in #5; the poor grunt who's been shot in the face on the opening page of #6; the bayoneted baby in #13; or the last three issues, #14–16, which are, without a doubt, the most brutal and disturbing comics I've ever read. Even today, *Vietnam Journal* is one of the most gritty and brutally honest war stories ever published.

One of the most popular writers at Marvel Comics, Jason Aaron is the current writer of Wolverine, The Incredible Hulk, Wolverine and the X-Men, *and* The Punisher. *He also writes the critically acclaimed series* Scalped *for DC Comics' Vertigo line of comics, about an FBI agent sent back undercover in the reservation where he grew up.*

FIVE STUPIDEST SUPERHERO ORIGINS

There are only so many radioactive spiders and exploding planets out there, so over the years, some characters have gotten the short end of the stick when it comes to their origins. Here are five of the lamest superhero origins in comic book history.

(1) **Bouncing Boy.** Bouncing Boy is Chuck Taine, who might be the only superhero whose origin entirely revolves around him being incredibly incompetent. You see, Chuck was working as the errand boy of a famous scientist when he was ordered to deliver a special

new fluid to the science council. Chuck, naturally, decided to stop and watch some robots fight first (the Legion of Super-Heroes era's equivalent of a baseball game). While at the game, Chuck accidentally drank the fluid instead of his soft drink and, voilà, superpowers! He has continued to be one of the lamest superheroes ever since.

② **Flash.** Jay Garrick, the Golden Age Flash, gained the ability of superspeed when he fell asleep one night and inhaled a lot of hard water vapor. Yes, hard water vapor. So, in effect, he inhaled steam. He inhaled steam and gained superpowers out of it. Very quickly, they changed it to being *heavy* water vapors that he inhaled. It still does not make any sense, but it makes a lot more sense than inhaling magical steam.

③ **Ultra Boy.** Ultra Boy is a longtime member of the Legion of Super-Heroes and one of its most powerful members. He was a bit of a tough guy before he became a hero, but then his space speedster was swallowed by a space whale (yes, a space whale), which exposed him to radiation that gave him his powers. Guess what Ultra Boy's real name is. Just guess. Okay, I'll tell you. It is Jo Nah. Jo Nah, who got swallowed by a space whale. I guess Jerry Siegel (who created him) was flipping through *Picture Tales from the Bible* that day!

④ **Black Condor.** Black Condor appeared during the Golden Age for Quality Comics (DC eventually purchased him with the other Quality characters like Plastic Man). When he was a young boy, Richard Grey was traveling with his parents on a caravan in Mongolia. They were attacked by marauders, and Richard alone survived. He was then taken in by superintelligent condors who taught him how to fly. Eventually, a local hermit discovered him and taught him how to speak English. He arrived in the United

States upon catching wind of an assassination attempt on Senator Thomas Wright. He showed up too late to save Wright, but coincidentally, Wright was his exact double, so he assumed Senator Wright's identity by day and was the Black Condor by night! Raised by condors and assuming the identity of an exact double who is a senator—that's quite a powerful combo!

⑤ **Whizzer.** Young Robert Frank was on a trip to Africa with his father, Dr. Emil Frank, when he was bitten by a cobra. Fearing for his son's life, Dr. Frank gave his son a blood transfusion from a mongoose. This somehow gave his son the power of superspeed. Hey, it's better than inhaling steam, right? The better question is—what's sillier? His origin or his superhero name?

THREE AMAZING POST-APOCALYPTIC COMICS
JEFF LEMIRE

Jeff Lemire currently writes the acclaimed monthly series *Sweet Tooth* (DC Comics' Vertigo), a postapocalyptic adventure about a little boy with antlers who travels across America with a dangerous bounty hunter in search of the secrets of his own origin and of a plague that decimated humanity. In keeping with that theme, here are Lemire's choices for three of his favorite postapocalyptic comic books.

① *Vic and Blood: A Boy and His Dog,* **by Harlan Ellison and Richard Corben (1969).** The graphic novel *Vic and Blood*, by sci-fi great Harlan Ellison and Richard Corben, is actually a continuation of Ellison's 1969 short story "A Boy and His Dog." The novel follows a boy named Vic and his telepathic dog, Blood, across a devastated

American wasteland searching for food. The twist here is that Blood is a leftover from government experimentation in telepathy, animal intelligence, and extrasensory perception, and may in fact be the single most intelligent being left on Earth. Corben's irradiated vistas are dark and striking, but it's the unique relationship between Vic and Blood that drives this story and makes it linger.

② *Kamandi*, by Jack Kirby (1972). The legend goes that then–DC Comics publisher Carmine Infantino approached Kirby in 1972 and asked him to create a comic similar to the wildly popular film *Planet of the Apes*. Kirby answered this call with *Kamandi*, the story of the last human boy on Earth in a postapocalyptic world ruled by highly intelligent animal factions. Talking apes, tigers, rats, and dogs fill Kirby's dynamic pages. As always, Kirby's vast imagination took the story well beyond that initial concept and created a fully fleshed-out world. Kamandi's adventure is truly epic, paced like greased lightning and completely intoxicating.

③ *Scout* and *Scout: War Shaman*, by Tim Truman (1985). Timothy Truman was one of the many great talents to emerge from the early days of the Joe Kubert School. While some of his classmates, like Steve Bissette and John Totelben, went on to do great work for the likes of DC Comics in the mid-1980s, Truman mostly seemed to find work with fledgling independent companies like First Comics and Eclipse Comics, where he produced a lot of well-regarded comics like *Grimjack* and *Airboy*. But it was his creator-owned series, *Scout*, which debuted in 1985, that is his masterpiece.

Scout follows an Apache named Emanuel Santana, or Scout, as he sets out to rid the world of "the Four Monsters," mythic beasts inspired by Native American folklore, who are disguised as corrupt politicians. *Scout* ran for twenty-four issues, and a year later,

Truman launched a follow-up series entitled *Scout: War Shaman*, which jumped ahead ten years into the future and followed Santana and his two young sons in this chaotic landscape. These later adventures take the book from a fun, well-crafted pulpy adventure comic into truly inspired territory. Truman's depiction of Santana and his two boys are equally heartwarming and heart wrenching. It's so real at times I am still brought to tears when rereading it, and the epic conclusion of the fifteen-issue *War Shaman* series is one of the single greatest and most emotional scenes I have ever encountered in the comics medium. Do yourself a favor and hunt down *Scout* and *Scout: War Shaman*.

Canadian cartoonist Jeff Lemire is the creator of the award-winning graphic novel Essex County, *published by Top Shelf. He also writes* Animal Man *and* Frankenstein, Agent of S.H.A.D.E *for DC Comics. In 2008, Jeff won the Schuster Award for Best Canadian Cartoonist and the Doug Wright Award for Best Emerging Talent. He also won the American Library Association's prestigious Alex Award, recognizing books for adults with specific teen appeal. In 2010,* Essex County *was named one of the five Essential Canadian Novels of the Decade!*

EIGHT WEIRD TRANSFORMATIONS SUPERMAN UNDERWENT DUE TO RED KRYPTONITE

Superman never knows what kind of strange effect red kryptonite will have on him, so a lot of hijinks ensue when he is exposed to it. Here are eight of the weirdest transformations Superman has undergone due to red kryptonite exposure (thank goodness they were only temporary).

(1) His hair and nails grew uncontrollably. (*Superman* #139)

(2) Flames shot out of his mouth. (*Action Comics* #283)

(3) He was turned into an infant with the mind of an adult. (*Action Comics* #284)

(4) He was given the head and antennae of a giant ant. (*Action Comics* #296)

(5) He was driven insane. (*Superman* #163)

(6) He morphed into a giant Kryptonian creature known as Drang. (*Action Comics* #303)

(7) His face became a sort of mood ring: it started to change colors depending on his emotions. (*Action Comics* #317)

(8) His wishes came true. (*Action Comics* #283) Aww, well at least this one makes up for the whole shooting-flames thing.

EIGHT SIGNIFICANT LIES AND DECEPTIONS BY PROFESSOR X

One of the things that *X-Men: First Class* really got right was the way that James McAvoy's Charles Xavier, while an idealist, was not exactly a Boy Scout. He could (and did) do a number of Machiavellian things in the film, which is good because at the end of the day, that's really what Charles Xavier is all about—a guy who wants to do good and will do whatever it takes to achieve that good. Although, at times, it does seem like he is *pleased* to have the chance to deceive people. . . .

(1) **Brainwashing Wolverine into joining the X-Men.** Recently it was discovered that Xavier and Wolverine met before Wolverine ever joined the X-Men. Wolverine had been brainwashed to kill Xavier, and Xavier lifted the elaborate brainwashing—but not without leaving in a suggestion of his own. Xavier planted the command in Wolverine to agree to join the X-Men should Xavier ever ask him

to. Xavier figured he could use an assassin of his own, if need be. Of course, Wolverine became a valued member of the team, but initially, it was all about trickery.

② **Joining the Illuminati.** The Illuminati were a group of some of the most powerful men on Earth (Mister Fantastic, Iron Man, Namor, Black Bolt, Doctor Strange, and Professor Xavier), who would meet in secret to help keep an eye on the world. The very idea of an Illuminati cabal was, in and of itself, a betrayal, but it was particularly bad in Xavier's case, as nothing ever seemed to happen to benefit mutantkind while he was involved with them.

③ **Lying to yourself counts!** An early X-Men idea that writer Stan Lee had that was quickly dropped was this bit from #3 where Professor Xavier reveals that he is pining away . . . for his student Jean Grey?!? Even better is the fact that when he thinks about why it couldn't work out, he convinces himself that it is because he is the leader of the X-Men and he is in a wheelchair. Not, you know, that she is sixteen, you're more than twice her age and her teacher! But no, it's the wheelchair that makes it not a good idea.

④ **Learning the Danger Room is sentient and still using it.** Years ago, Xavier discovered that the Danger Room, the advanced computer that develops different holographic tests for the X-Men's training, had become so advanced that it was sentient! And yet Xavier kept this fact to himself until the Danger Room ended up killing a student in its attempt to escape from the school, which it did as a new sentient being known as Danger. Nice job, Xavier.

⑤ **Pretending to be dead.** In *X-Men* #42, Professor X is seemingly killed. However, in *X-Men* #65, it is revealed that Xavier struck a deal with a shape-shifting former villain, Changeling: Xavier helped Changeling (who was dying of a rare, life-threatening dis-

ease) redeem his misspent life and Changeling in turn pretended to be Xavier while the *real* Xavier prepared for an upcoming alien invasion. Only Jean Grey knew he wasn't really dead.

⑥ **Tricking the X-Men into killing one another in their minds.** In *Uncanny X-Men* #375, Wolverine has been replaced by a Skrull (a shape-shifting alien). Xavier is not sure if there are other Skrulls on the team, so he decides the only logical way to figure this out would be to enter all of the X-Men's minds at once and trick them into thinking that they were in a fight to the death against one another. The reasoning: if they were fighting for their lives, they would not be able to guard their thoughts from him, so he could check to make sure they weren't Skrulls. If he determined they weren't, they would be "killed off" in the mental scenario. Eventually, he clears every one of the X-Men. If that sounds abhorrent, hey, this is how Charles Xavier does business. There are no ethics in Xavier's world!

⑦ **Keeping a whole separate team of murdered X-Men secret.** X-Men Cyclops and Havok were brothers, but they actually had *another* brother they were never aware of because he was raised on an alien planet. This brother was eventually taken to Earth on a mission and escaped. He was found by Moira MacTaggert, a geneticist friend of Xavier's, who took him on as a pupil. Xavier realized the connection between Cyclops and Havok and this boy, but he decided not to tell them about their long-lost brother . . . for no apparent reason, really. Bad move #1, Xavier, but it gets worse. Soon afterward, the original X-Men were captured by a powerful mutated island. Readers familiar with X-Men history will know that this is when Wolverine and the "All-New, All-Different" X-Men made their debut. These new X-Men were recruited by Xavier to rescue the *original* X-Men and then stuck around after they suc-

ceeded. What Xavier never told the new X-Men, though, was that their team was the *second* team he sent to rescue the original X-Men. The first team consisted of Cyclops's brother (code-named Vulcan) and some other students of MacTaggert's, and they were all brutally murdered by the island. Xavier just sent the next group in there, not letting them know that their predecessors were murdered doing exactly what they were trying to accomplish. Xavier decided it was best to keep this a secret for years (until a resurrected Vulcan showed up years later looking for revenge), and he never told Cyclops and Havok about their other brother.

⑧ **Telling the X-Men he didn't name the team after himself.** Clearly the biggest deception of all, though, took place in *X-Men* #1 when Xavier is asked why the team is called the X-Men. "It's because of the '*ex*tra power' you all have! What's that? My name's Professor X and the team is called the X-Men? What a total coincidence!"

THREE UNDERAPPRECIATED SCI-FI AND FANTASY COMICS
ERIC TRAUTMANN

Given that comics are, in filmic terms, operating with an "unlimited special effects budget," I find it both puzzling and sad that pop-lit genres like sci-fi and fantasy are grossly under-represented on comic shelves. Certainly, there are science-fiction or fantasy elements in the majority of superhero comics, but pure space opera, speculative fiction, and fantasy are exceedingly rare. Here are three of the best (and underappreciated) comics in this area.

① *Runners*, **by Sean Wang.** Wang's entertaining serial is pure space opera, centered on the adventures of a crew of aliens operating a smuggling operation. Blending the feel of *Star Wars* and the interpersonal dynamics of *Firefly*, there's a lot to love about *Runners*. The tone is cheerful, the art is crisp and detailed, and best of all: it's free. The original story arc, "Bad Goods," is available in a black-and-white print collection, but the adventures of the crew of the *Khoruysa Brimia* are updated every week as a webcomic.

② *Orbiter*, **by Warren Ellis and Colleen Doran.** It is exceedingly difficult to select material from Ellis's body of science fiction work, as he is one of the genre's few practitioners in comics. *Orbiter* is the tale of a failed NASA reawakened to human possibility when the space shuttle *Venture*—which vanished in orbit a decade prior, bringing down NASA in the process—returns. All but one of the crew is missing, and other mysteries unfold. Why is there soil from Mars in *Venture*'s wheel housings? And why is the shuttle now wearing skin? Ellis's introduction—which discusses how, as he finished the graphic novel, the *Challenger* disaster occurred—is worth the price of admission all by itself.

③ *We3*, **by Grant Morrison and Frank Quitely.** Originally released as three issues by DC Comics' Vertigo, *We3* is the tale of a military bioweapons experiment gone awry. The project—augmenting common animals to act as remote control soldiers—is about to be shut down, and one of the team scientists, feeling pangs of guilt, frees the three primary subjects before they can be destroyed. The "projects" are a dog, a cat, and a rabbit (poignantly identified as "Bandit," "Tinker," and "Pirate," respectively, on the series' covers, which were rendered as missing pet posters). Morrison's work is occasionally prone to excess, but *We3* is tightly focused, precisely written, and incredibly emotional. In many ways, *We3* follows the pattern of a Disney film: three animals, lost and far from home,

teaming up to find their way. In the hands of Morrison and Quitely, it is a much darker affair.

Eric Trautmann is a comic book writer, editor, and graphic designer. He wrote a number of comics for DC Comics (as both writer and cowriter), including Final Crisis: Resist, JSA vs. Kobra: Engines of Faith, The Shield, Mighty Crusaders, Adventure Comics, *and others. He currently writes the continuing adventures of classic sword-and-sorcery heroine Red Sonja for Dynamite Entertainment as well as a revitalized* Vampirella *and* Flash Gordon *series. Eric is also a graphic designer and marketing consultant, through his Fedora Monkey Studio.*

FOUR GOOFIEST MOMENTS IN THE FIRST TWENTY ISSUES OF *THE FANTASTIC FOUR*

When Jack Kirby and Stan Lee created *The Fantastic Four*, the intent was that comics would be disposable pieces of entertainment for children. They did not expect anyone to still be reading them fifty years later, and they *certainly* did not expect anyone to be paying attention to their "fly-by-the-seat-of-their-pants" style of plotting. Which is exactly what I'm going to do now. . . .

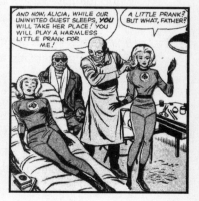

⟨**1**⟩ **We walk alike, we talk alike. . . .** In *The Fantastic Four* #8 we are introduced to the blind sculptress Alicia Masters, who will become the

Thing's longtime girlfriend. We also learn that, as luck might have it, Alicia is somehow the exact double of Sue Storm, the Invisible Girl (with a wig on, of course)! If Silver Age comic books were to be believed, there would be an exact double of you on every other block.

② **How convenient!** In *The Fantastic Four* #5, the Thing, the Human Torch, and Mister Fantastic are sent back in time. When they arrive, they look for disguises, and as luck might have it, they stumble upon two pirates arguing . . . over a large bag of stolen clothes. I wonder how long that took Stan Lee to figure out.

③ **Dumb aliens.** Here's a genius plot to stop evil invaders. When Earth is threatened by the evil Skrulls, the Fantastic Four brilliantly decide to cut out pages from monster comics and give them to the Skrulls. The Skrulls are clearly not very intelligent, either, as they think that the comic illustrations are actually photographs, so they ship off from Earth to avoid these dangerous "monsters." Now, as absurd as that is (and it is really absurd), the even crazier thing is that the Fantastic Four had just one issue earlier *been to Monster Island*. So if monsters were all they needed to convince the Skrulls not to invade, they had *actual* monsters they could have shown them and not had to cut out pages of a comic book. This is the best example of "Lee and Kirby did not think anyone but a kid would ever *really* read this comic, so why worry about the ending too much?"

④ **The "Lincoln's Mother" defense.** *The Fantastic Four* #11 was a perfect indication of how different Marvel Comics was from DC Comics during the 1960s. Stan Lee knew how to hook an audience and this was a great example of that. You see, readers used to write in complaining about how useless the Invisible Girl was.

Fans went as far as to call for her to be killed off. In #11, using the voices of the Thing (who is temporarily in human form as Ben Grimm) and Mister Fantastic (Reed Richards), Lee directly addresses the readers and defends the Invisible Girl. And what is the defense? Why, it is the Lincoln's mother defense! You see, Abraham Lincoln once said that all that he was—all that he ever hoped to be—he owed to his mother. Therefore, if you are telling the story of Lincoln, you have to include his mother, right? Similarly, if it were not for the Invisible Girl's inspiration to Mister Fantastic, Human Torch, and the Thing, there wouldn't be a Fantastic Four! Yes, that is his actual argument. Reed then goes on to list the few times in the first ten issues that Sue was actually useful. It is amazing to see a fictional character have to be "defended" like that. Interestingly enough, even after that passionate defense, within a year Lee changed Sue's powers to give her invisible force fields that eventually made her one of the most powerful members of the team.

SIX NEAR-DEATH INCIDENTS FOR AUNT MAY

Poor Aunt May. Peter Parker's lovely old aunt never catches a break—she's been on the verge of death countless times. The fact that she keeps getting sick and almost dying either means that she will live forever or else that every time she gets out of bed she should count her blessings, because one day she may run out of luck. Either way, here are a few of her run-ins with death.

① **Unnamed illness.** Aunt May's first notable brush with death was in *The Amazing Spider-Man* #8, when she contracted an unknown illness. By issue #9 she had to have an operation, but luckily, it was

a success. In the next issue, though, the doctor informs Peter that May will need a blood transfusion, which Peter gladly supplies for her.

② **Radiation poisoning.** Of course, this being a *Spider-Man* comic, the very blood that Peter gave to Aunt May to save her life ended up poisoning her (due to Peter's radioactive blood). Through the help of friendly scientist Curt Connors, Peter discovers that they can cure Aunt May with a special serum—a special serum that Doctor Octopus recently stole! Spider-Man goes to Doc Ock's underwater base to retrieve it, but it's just his luck that tons of machinery fall on him, pinning him to the floor. This is the classic "Spider-Man lifts tons of machinery" bit from *The Amazing Spider-Man* #33. He eventually escapes and delivers the serum in time to save Aunt May's life.

③ **Heart attack.** In *The Amazing Spider-Man* #176, May is protesting for elderly rights at city hall when she has an altercation with a police officer. During the fracas, May has a heart attack. She once again needs an operation, but she pulls through, much to readers' relief.

④ **Seemingly a heart attack.** In *The Amazing Spider-Man* #196, Peter is called by a doctor to inform him that Aunt May has died of a heart attack. Peter is distraught over the next few issues until learning in #200 that the "doctor" in question was none other than his old foe Mysterio, master of illusions. You see, Mysterio teamed up with the burglar from Spider-Man's very first appearance (the one Spidey let get away and who then ended up killing Uncle Ben). Writer Marv Wolfman wanted to explain why a burglar who committed a crime in Manhattan during the day would then show up trying to break into a house in Queens later that

night. So he revealed that there was some sort of hidden treasure in the Parker home. Mysterio faked May's death so that they would have free rein to search her house for the treasure. May is tied up in the basement. Spider-Man shows up and puts an end to the plot and, ironically, the burglar dies of a heart attack at the end of the issue as Spider-Man reminds him that the burglar will never be free, since Spider-Man will follow him everywhere.

(5) **Seemingly heart failure.** In *The Amazing Spider-Man* #391, Aunt May suffered a severe stroke that left her in a coma until #400. In that issue, she comes out of the coma and spends a few days with Peter before she passes away at home, surrounded by Peter, Mary Jane, and May's best friend, Anna (Mary Jane's aunt). It was a lovely issue by writer J. M. DeMatteis, in which he also revealed that Aunt May had known that Peter was Spider-Man for years but never let on that she knew. While the issue was very well done, later writers felt that Aunt May was too important to the title to kill off, so they revealed that the "Aunt May" who died was an actor that the evil Norman Osborn had hired (and done plastic surgery on) to make Peter think (a) that his aunt had died and (b) that she died knowing (and accepting) his identity. One of many, many times when Norman Osborn retroactively caused major problems.

(6) **Shot in the gut.** In *The Amazing Spider-Man* #538, Peter, Mary Jane, and Aunt May are on the run after Peter revealed his secret identity on national television in support of the Superhero Registration Act. The Kingpin of Crime, Wilson Fisk, sends a sniper to shoot Peter, but his spider-sense instinctively causes him to move out of the way of the bullet. Instead, it hits poor old Aunt May in the gut. Over the next few issues, Aunt May goes into a coma and her condition slowly deteriorates (while Spider-Man's psyche, too, deteriorates because of his guilt over what happened). After nearly

killing the Kingpin with rage, Spider-Man goes to different scientific and magical sources to find a cure for May. Finally, one appears in the unlikely person of the demon Mephisto. He would cure Aunt May, but in return, Peter and Mary Jane would have to give up their marriage. Peter initially says no, but Mary Jane understands that Peter's guilt would ruin him if Aunt May died, so she convinces him to take the bargain. So Aunt May is back among the living once again . . . until the next time, of course.

TOP TEN COMIC BOOK BATTLES OF ALL TIME

The readers of Comic Book Resources voted on what they felt were the top comic book battles of all time. These are the results for the top ten, in ascending order.

⑩ **Elektra vs. Bullseye** (*Daredevil* #181, written by Frank Miller and drawn by Miller and Klaus Janson)

⑨ **Avengers vs. the Masters of Evil** (*Avengers* #273–278, written by Roger Stern and drawn by John Buscema and Tom Palmer)

⑧ **Spider-Man vs. the Juggernaut** (*Amazing Spider-Man* #229–230, written by Roger Stern and drawn by John Romita Jr., and Jim Mooney)

⑦ **The Ultimates vs. the Hulk** (*Ultimates* #4–5, written by Mark Millar and drawn by Bryan Hitch and Andrew Currie)

⑥ **The Sinestro Corps war** (July–November 2007, all *Green Lantern* titles, written by Geoff Johns, Dave Gibbons, and Peter Tomasi,

with art by Ivan Reis, Ethan Van Sciver, Patrick Gleason, and many inkers)

⑤ **Thanos vs. every Marvel superhero** (*Infinity Gauntlet* #4, written by Jim Starlin and drawn by Ron Lim and Joe Rubinstein)

④ **Miracleman vs. Kid Miracleman** (*Miracleman* #15, written by Alan Moore and drawn by John Totleben)

③ **The Final Battle in *Kingdom Come*** (*Kingdom Come* #4, written by Mark Waid and painted by Alex Ross)

② **Superman vs. Doomsday** (October–November 1992, all *Superman* titles, written by Dan Jurgens, Jerry Ordway, Louise Simonson, and Roger Stern and drawn by Jurgens, Tom Grummett, Jon Bogdanove, Jackson Guice and many inkers)

① **Batman vs. Superman** (*Batman: The Dark Knight Falls*, written by Frank Miller and drawn by Miller and Klaus Janson)

FIVE BEST STORIES STARRING PETER DAVID'S VERY BADASS GRAY HULK

ZEB WELLS

Peter David took over the writing duties on *The Incredible Hulk* with issue #328, and I took over reading duties with issue #357. Upon reporting for said duty I was surprised to find that the Hulk was gray, a dick, and the best comic book character ever written. The

rest of my summer was spent tracking down every appearance of the gray Hulk that Peter David had written. I became so obsessed that I asked my eighth grade English teacher if I could do a report about him in front of the class. No report in front of the class was being asked for, mind you—I wanted her to take time out of her lesson plan so I could talk to her class about the Hulk. She chuckled nervously, I got the hint, and we both pretended it never happened. Now, twenty years later, when all learning is done by way of lists, I present my favorite gray Hulk moments of Peter David's genius run.

1. *Incredible Hulk* **#333, "Quality of Life."** When this new improved Hulk leaps into a small town to avoid the authorities at the beginning of this issue, we're still learning what he's all about. But Mr. David rings the school bell and teaches us exactly what we're dealing with when the Hulk *drinks an entire liquor store* just to ruin his alter ego's day. Let's see puny Banner call the feds with a level ten hangover. But we also see his heroic side when the Hulk turns the tables on a wife-beating sheriff. He's a dick who targets other dicks! The Dexter of dicks! Of course, when the abused wife accidentally shoots her husband in the stomach, the Hulk comforts her by laughing in her face, but I never said he was marriage material.

2. *Incredible Hulk* **#339, "Native Son."** Probably not father material, either. In this issue, the Hulk travels across country with a merry band of rogue government agents. When he's accused of eating through their food budget, he happily offers to knock over as many convenience stores as necessary to finance their endless summer. I can't overstate how cool I thought this was when I was thirteen. Then we meet a young boy with laser hands and his father, a S.H.I.E.L.D. agent and first recipient of the innovative "Hulk handshake" (i.e., Hulk takes his gun away by breaking all of

his fingers around said gun). When the boy shows concern for his father's maiming, the Hulk, as is his custom, starts cracking jokes. The kid blasts him through a wall and in a classic "That's our Hulk" moment, the gray one declares that he plans on murdering *the boy*. What's so badass about Peter David is that he brought Hulk to a place where this was absolutely possible. Luckily (for the boy, not readers), the Hulk is reminded of his own childhood abuse and decides he'll be the kid's "big brother" instead. Cooler heads prevail, but the Hulk doesn't leave without threatening to level the town if the kid's dad doesn't give him what he wants. I'm sure that didn't create the world's most spoiled brat.

③ *Incredible Hulk* #340, "Vicious Circle." In some cultures, boys have to read this issue ten times before they can call themselves a man. McFarlane. David. Hulk. Wolverine. How do you write an adventure starring Marvel Comics' two walking bad attitudes? You don't, rookie, you write a massacre where they hack and rend at each other for twenty-two pages. What's genius about this issue is that Wolverine keeps trying to end the fight, but Hulk just won't let it go. Let me run that by you again . . . *Wolverine* has to be the reasonable one. Now I can write whatever I want because you're just staring off into space trying to wrap your mind around what you just read. Good luck.

④ *Incredible Hulk* #347–358, "Mr. Fixit." This is the Hulk I fell in love with. You like blue pinstripes and fedoras? Well, guess what, the Hulk doesn't care because that's how he gets his Mr. Fixit on. That's the name of his no-nonsense (or any sense, really) Las Vegas alter ego. A bouncer at a swank casino who just wants to retire from the grind and live it up for a while. Gray Hulk looks better in a fedora than Humphrey Bogart, and I'll fight any woman or child who says different. If his boss hadn't fired him after eleven issues,

The Incredible Hulk would be outselling *Harry Potter* right now, it was that good. I'm surprised a fascist dictator hasn't kidnapped Peter David and forced him to continue Mr. Fixit's adventures.

⑤ ***Incredible Hulk* #373, "Mending Fences."** The gray Hulk's days were numbered at this point. The green Hulk had made his return and we all knew ol' "Mr. Fixit's" days were numbered. Let's not talk about that, though. Let's talk about the last page of this issue, when the gray Hulk *straight runs game on Banner's wife*. After protecting Betty Ross from the U.S. Army in an impressive show of force (i.e., pretending to be blinded by a grenade long enough to get some sucker punches in. My boy!), the Hulk delivers her safely to a rooftop. There she says thanks by suggesting that they should all join a support group for people dealing with gamma radiation mutations. The Hulk blows her off with an impression of what such a group would be like, which melts her like a stick of the Abomination's face. I mean, this woman's just come from a monastery and he's got her doubled over laughing. How is she not in love with this guy?! Come on, if she's not going to marry him, I will. And I mean that. I will be marrying him if I'm ever allowed to write *The Incredible Hulk*.

Zeb Wells is an Emmy Award– and Annie Award–winning writer and actor for the TV show Robot Chicken, *including the Emmy-nominated* Robot Chicken: Star Wars Episode II. *He has written a number of series for Marvel Comics, including* The Amazing Spider-Man. *He recently launched an ongoing Spider-Man spin-off called* Avenging Spider-Man, *with artist Joe Madureira.*

TOP TEN MOST MEMORABLE MOMENTS IN DC COMICS HISTORY

Based on a survey of Comic Book Resources readers, here is what they came up with as the ten most memorable moments in DC Comics history, in ascending order.

⑩ **Bane breaks Batman's back** (*Batman* #497 by Doug Moench and Jim Aparo). Bruce Wayne is replaced temporarily as Batman by another costumed vigilante after the villainous Bane succeeds in seemingly permanently crippling Bruce Wayne. (Wayne gets better and becomes Batman again shortly thereafter.)

⑨ **"One Punch!"** (*Justice League* #5 by Keith Giffen, J. M. DeMatteis, Kevin Maguire, and Al Gordon). For the first few issues of the 1987 *Justice League* relaunch, Green Lantern Guy Gardner had been riding Batman hard over who should lead the team. In this issue, Batman agrees to have the fistfight Gardner was clamoring for. Batman then knocks Gardner unconscious in "one punch."

⑧ **Jason Todd is beaten nearly to death by the Joker** (*Batman* #427 by Jim Starlin and Jim Aparo). Fans were allowed to vote to decide if Jason Todd, the second Robin, would survive an explosion he was caught in—the fans voted no. However, the reason why he was unable to avoid the explosion was because he was beaten nearly to death by the Joker in a memorably shocking scene.

⑦ **Green Arrow's ward is a junkie?!** (*Green Lantern* #85 by Denny O'Neil and Neal Adams). In this classic issue, Green Arrow discov-

ers that his ward, Speedy, is addicted to drugs. Suffice it to say that this comes as quite a shock for the Emerald Archer.

⑥ **Ozymandias's plan goes into effect** (*Watchmen* #11 by Alan Moore and Dave Gibbons). After the other heroes have figured out Ozymandias's plan—that he will unite the world by creating what looks to be an alien invasion—they plan to stop him. After all, his plot involves millions of New Yorkers dying when the "aliens" initially show up. When his former teammates tell him that they plan to stop him, he shocks them by informing them that he actually did it thirty-five minutes ago, while they were talking.

⑤ **Death of Supergirl** (*Crisis on Infinite Earths* #7 by Marv Wolfman, George Perez, Dick Giordano, and Jerry Ordway). Superman's cousin receives a heartfelt good-bye after she sacrifices herself to save him during the Crisis on Infinite Earths.

④ **Baby Superman speeds away from his dying home planet in a rocket ship** (*Action Comics* #1 by Jerry Siegel and Joe Shuster). This is the moment that, in effect, started the DC Comics universe.

③ **Barry Allen makes the ultimate sacrifice to save the Multiverse** (*Crisis on Infinite Earths* #8 by Marv Wolfman, George Perez, and Jerry Ordway). As dramatic as Supergirl's death was, to kill off the hero that launched the Silver Age was a good deal more dramatic. The evil Anti-Monitor appears poised to destroy the universe with a powerful device. The Flash must outrace the beam of the device to save the universe. He pulls it off, but essentially races himself to death in the process.

② **Superman dies** (*Superman* Vol. 2 #75 by Dan Jurgens and Brett Breeding). A classic moment: the whole country tuned in to hear

Superman's last words after his dramatic victory over the malicious behemoth Doomsday.

(1) **Joker shoots Barbara Gordon** (*Batman: The Killing Joke* by Alan Moore and Brian Bolland). The comic world was shocked by this graphic novel from two of the top comic book creators. When the Joker rings Commissioner Gordon's doorbell and his daughter, Barbara, answers, she is shot and paralyzed. Recently, Barbara returned to her role as Batgirl in her own ongoing series.

PART IV

BEYOND THE PANELS (COMIC BOOK COVERS, ADS, AND OTHER EPHEMERA)

FOUR STRANGE COMIC BOOK ADS FROM THE 1950s

The 1950s were a bit like the Wild West when it came to ads in comic books. It was a boom period for consumerism but it was also fairly unregulated, so this decade probably had more examples of "false advertising" than all other decades combined (the 1960s are close). Here are four interesting ads from comic books during the 1950s.

① **Boy, kids sure are dumb.** The following "miniature dog" ad is a prime example of an advertisement designed to prey upon the relative stupidity (or at least the naïveté) of young kids. First off, nowhere in the ad does it actually say anything about how to get the dog. You "[j]ust mail me your favorite snapshot, print or negative NOW and pay the postman only 19c plus postage when your treasured enlargement arrives and I'll include the 'Movietone' frame at no extra cost" and later, "I'm so anxious to send you a miniature dog that I hope you will send me your name, address and favorite snapshot, right away and get your 20 enlargement coupons to hand out." In addition, do note the other ad at the bottom of the page—it is for a studio with a different name that has the same address as the studio in the main ad! They really did not think much of their audience. Luckily for easily duped children

everywhere, the Federal Trade Commission eventually did shut this ad down for false advertising.

2 Know your audience, advertisers!

I don't know exactly who the people at Fabric Frocks, Inc., thought they were pitching their dress-based pyramid scheme to, but putting ads in comic books was probably not going to get their scam (sorry, *valuable service*) to their intended audience. Unless their theory was that some mother would be putting her child to bed, and notice the comic open to this page and think to herself, "Hey, I would wear a $10.98 dress if I could get it for less than one cent!"

③ **Manipulating Your Parents 101.**
One of Daisy's most popular ad types was the kind designed to help a kid manipulate his father into buying him a BB gun. If you thought Ralphie from *A Christmas Story* knew of ways to get his parents to buy him a BB gun, you have not seen what happens when an entire company gets behind the idea. In this 1958 ad, not only does Daisy thoughtfully print out four separate cutout reminder cards, it even has a system on how to deliver the reminders, starting

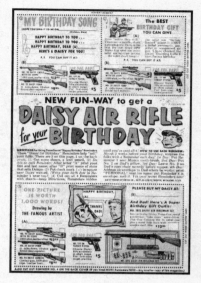

from two weeks before your birthday. "1st Day: Put Reminder 1 near Mom's tooth-brush. 2nd Day: Put No. 2 on Dad's pillow. 3rd Day: Leave No. 3 on Dad's easy chair secretly before supper. 4th Day: Address an envelope to Dad where he works: print 'PERSONAL' near his name: put Reminder 4 in envelope: mail it." I am sure parents everywhere loved this ad.

④ **Truly in the dark?** I am going to assume that the folks at the Glow in the Dark Company were, in fact, "in the dark" about the rather phallic shape of their glow-in-dark flashlight-esque product in this comic book ad. Such an assumption allows me to simply be amused by their instructions regarding the

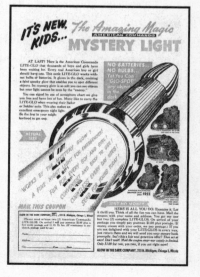

device at the end of the ad rather than be creeped out by the instructions that tell you to "Examine it. Let it thrill you. Think of all the fun you can have."

SIX AWESOME ROY LICHTENSTEIN PAINTINGS BASED ON COMIC BOOK PANELS

Roy Lichtenstein (1923–1997) was one of the most famous Pop artists, modern artists who appropriated mass-produced items of popular culture into their work. In the case of Lichtenstein, some of his most famous (and most valuable) works of art were those done in a period between 1963 and 1965, when he adapted panels from comic books of the era into large paintings. Lichtenstein would even paint the "Ben-Day dots" that made up the cheap color-printing process of comic books of that time (if you look very closely at a comic book page, you can see that the colors are formed by the placement of tiny multicolored dots). A painting from this era sold for more than $40 million in 2010! Here are six comic book panels and the Lichtenstein paintings based on them.

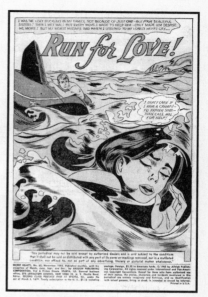

Ⓡ Tony Abruzzo's opening page of *Secret Hearts* #83 from 1962.

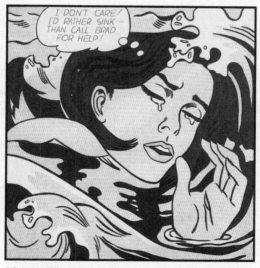

ROY LICHTENSTEIN, *DROWNING GIRL*, 1963 (PERHAPS
LICHTENSTEIN'S MOST FAMOUS PAINTING, IT
CURRENTLY HANGS IN THE MUSEUM OF MODERN
ART IN NEW YORK CITY.)

② A panel by Irv Novick (who had actually been in the military during World War II and reportedly got Lichtenstein a job with him, using their art abilities for the military) in *All-American Men of War* #89 from 1961.

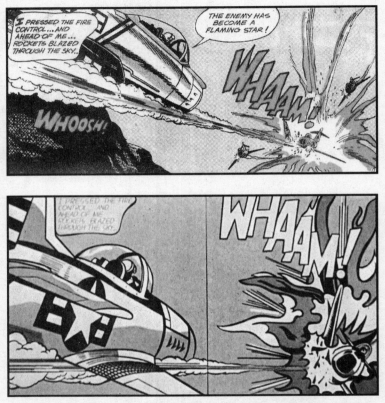

ROY LICHTENSTEIN, *WHAAM!*, 1963 (IF *DROWNING GIRL* IS NOT LICHTENSTEIN'S MOST FAMOUS PAINTING, *WHAAM!* CERTAINLY IS.)

③ Another panel by Tony Abruzzo in *Secret Hearts* #83 from 1962.

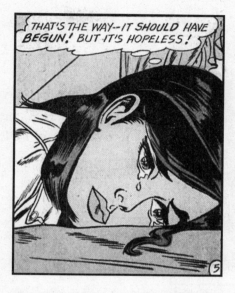

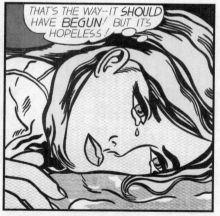

ROY LICHTENSTEIN, *HOPELESS*, 1963

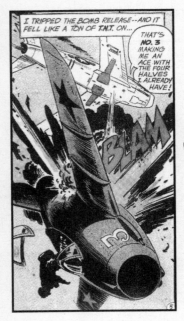

④ A panel by Russ Heath in *All-American Men of War* #89 from 1961.

ROY LICHTENSTEIN, *BLAM!*, 1962

⑤ A panel by Dick Giordano in *Strange Suspense Stories* #72 from 1964.

ROY LICHTENSTEIN, *BRUSHSTROKES*, 1965

ⓖ A panel by Jack Kirby in *X-Men* #1 from 1963.

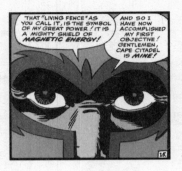

ROY LICHTENSTEIN, *IMAGE DUPLICATOR*, 1963

FIVE STRANGEST RESPONSES TO *SUPERMAN* FAN MAIL

Mort Weisinger was the editor for the *Superman* titles for more than twenty years, from the late 1940s through the late 1960s. He was not a man to shy away from readers; in fact, he often asked the readers themselves what they would like to see. Occasionally

Weisinger's direct style could lead to some rather, shall we say, interesting replies to letters sent in by readers. Here are five odd responses Weisinger gave to readers over the years. (Thanks to Mark Engblom of the website Comics Coverage for finding some of these letters.)

(1) **Note to self: don't ask Mort Weisinger about people from Atlantis.** In *Adventure Comics* #264 in 1959, reader Jon Beach wrote in to ask, "In your May issue, in the story about Aquaman's mother, it clearly showed her with legs, like a normal human being. Yet, [in] the story, 'The Girl from Superman's Past,' published in Superman Comics, the girl [Lori Lemaris] had the tail of a fish. If both these girls came from Atlantis, wouldn't they look alike?" Weisinger replied, "Are you serious? We're publishing fiction, not documented history. Different stories present different conditions on different worlds. If not, all stories would be monotonously alike. The Atlantis Aquaman's mother came from has a different set-up than the Atlantis presented in the Superman story. We try to be consistent in our 'ground rules' for each of our characters. For example, Ma and Pa [Kent] own a general store in every issue. It isn't a general store this month and a bowling arena the next. If we show the Green Arrow visiting Mars, it is entirely likely he'll meet inhabitants and creatures different from those encountered by Jimmy Olsen and Batman. If writers didn't use their imaginations to vary conditions, all comic book stories and science fiction movies would become so repetitious you'd soon lose interest." Yikes. Oddly enough, exactly a year later another fan asked pretty much the same exact question. Weisinger figured it must be something he was going to keep getting asked, so he came up with an actual answer: "Lori has a fish-tail because she is descended from a merman and mermaid race. While Aquaman's mother came from Atlantis, his father was an ordinary Earthman—and Aquaman inherited his legs from his father."

② **Metropolis Mailbag—your place to learn the birds and the bees.**
In *Superman* #136, we meet a man from the future who says he is
destined to marry Lois. Superman seems to think that sounds
logical—"I guess if it's destined, it's destined"—but Lois changes
her initial "no way" tune when she sees the weird-looking guy (who
turned green and alien-looking due to comet radiation in the
future) revert to a good-looking guy. So they go through with the
marriage, but when they go back to the future, they both become
green. Lois is despondent, so her husband sacrifices his own life to
send her back in time. A few months later, in *Action Comics* #266,
an alien named Jena the Space Girl blackmails Superman into
marrying her and then tries to use a special love potion to make
him love her. He uses the opportunity to fake being in love, but an
overbearing boorish type of love. He becomes so annoying that
she breaks up with him. So young Tony Armalis writes in to say,
"As a faithful reader of the Superman 'family' of magazines, I can't
help but notice that many of your readers are clamoring for Super-
man and Lois Lane to get married. Well, I have news for them,
they ARE married! But not to each other. Lois married X-Plam
in the July 1960 issue of Superman Comics and Superman wed
'Jena the Space Girl' in Action Comics No. 266." Weisinger sets
him straight by pointing out to him, "You're quite right—except
that neither one of these marriages were ever consummated." I bet
the parents who needed to give a definition of that word that day
were quite pleased with Weisinger.

③ **More than kissing cousins?** In 1960's *Action Comics* #303, Bruce
Cutler of Huntsville, Alabama, wrote in to say, "Recently I sent you
a letter suggesting that Supergirl would be the most likely candi-
date to marry Superman. You answered that she is too young. This
is absurd! She is older physically and mentally than any regular
human. She is pretty, and goes with Superman on missions any-
time she wants to. Also, being invulnerable, it would be difficult

for Superman's enemies to harm her. So why not have a wedding?" Now, you would think that there were all sorts of reasons Weisinger could give for why Superman shouldn't want to marry his cousin, but instead, he just goes with, "Even if Superman were interested romantically in Supergirl, she is still a minor, and would have to wait at least three years to be eligible for a wedding license. And who knows who Supergirl will meet during the next three years?"

④ **Weisinger 1, Detail-Oriented Fan 0.** In 1968's *World's Finest* #173, reader Fred Haynes writes in to vent a little bit: "I consider myself an expert on Batman. In fact, I probably know more about him than anyone else short of Bob Kane. And I don't like some of your recent issues, which have had Robin popping corny puns. Until that 'camp' stuff started on TV, Robin never made with the puns when he was fighting crooks. I especially dislike those 'Holy this' and 'Holy that' expressions. What's so 'holy' about these stories anyway?" Weisinger then puts a beat down on the kid: "If you were a *real* Batman expert, you'd know punning was part of Robin's personality from the day he first donned that red vest of his. And we sometimes think the 'hole-iest' things about our mags are the heads of certain self-styled 'experts.'" Ouch!

⑤ **That's my story and I'm sticking to it.** In 1964's *Superboy* #110, reader Claude Diamond wrote in with his displeasure: "Shame on you! You've often stated that it is against Superboy's code to destroy life. However, in the recent story, 'The Mystery of Sorcery Boy,' you show the Boy of Steel snatching up a trout from a stream and bringing it to his friends. Obviously they weren't going to put it in a fish pond, but feast on it. Isn't that a goof?" Weisinger calmly just made up a "fish tale" of his own: "We received many other protests from readers about this apparent violation of Superboy's code. What was not shown was that the trout was already dead,

having been struck by lightning and was just floating in the water when Superboy found him." Riiiiight.

FOUR STRANGE COMIC BOOK ADS FROM THE 1960s

In a lot of ways, the 1960s were the glory days of comic book advertisements, with a great deal of utterly bizarre ads.

① **So *that's* how to be attractive!** We're all familiar with the basic formula of the comic book ad featuring a bodybuilder telling readers how he can turn them from scrawny pipsqueaks into muscle-bound hunks. This 1966 ad, though, goes even further, with its booklet "The Secret to Being Attractive." It tells you Mike Marvel's secret method for developing a new, almost *magnetic* way of being attractive and popular! At parties, dances, at the beach—you will have women clustering around you breathlessly, while other guys watch enviously and say, "What does *he* have that *we* don't?"

② **If you can predict the future, why are you working as a telephone psychic?** Once you get past the unsettling idea of a bunch of prepubescent boys controlling people's minds, ponder the concept of a company selling "hypnocoins." I also like the idea of them being sold by the Hypnotic Aids Supply Co. How would you like *that* on the top of your letterhead?

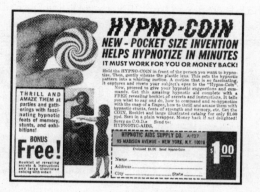

③ **I know that it was the sixties, but still.** I suppose that, eventually, model kit companies just run out of new model cars to sell to kids, but this particular kit from 1968? A customized garbage truck, mod musicians, and surfboards? I don't know if this scene actually existed anywhere on Earth during the 1960s, but if it did, I'm terribly disappointed at being five decades late for it!

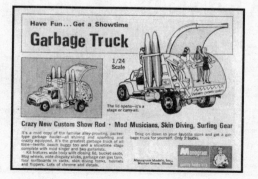

④ **Truth in comic book ads!** One of *the* go-to ads throughout comic book advertisement history has been the X-Ray Spex. The idea of seeing through objects (and, let's face it, most young male readers were thinking "ladies' clothes") is fascinating. However, what's even more fascinating is to see how someone must have been forced to step in to clarify the product for readers, because compare the X-Ray Spex ad from 1966 to the X-Ray Spex ad from 1967.

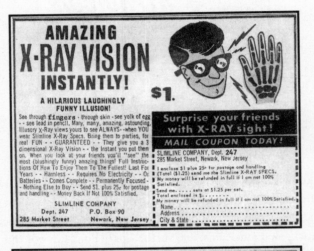

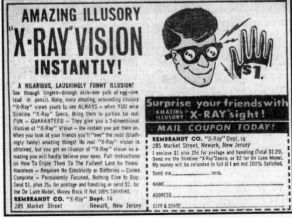

Amazing X-Ray Vision! Oops, wait, I mean, Amazing *Illusory* X-Ray Vision! It's hilarious to see how many extra qualifiers they were forced to include in the advertisement.

NINE ICONIC *GREEN LANTERN* COVERS

GEOFF JOHNS

Brian here for a moment. I asked *Green Lantern* writer Geoff Johns his choices for the most iconic *Green Lantern* covers. Here is what he suggested, along with some notes from me as to who did the artwork and the significance of a particular cover.

① *Showcase* #22 (Gil Kane). First appearance of Hal Jordan.

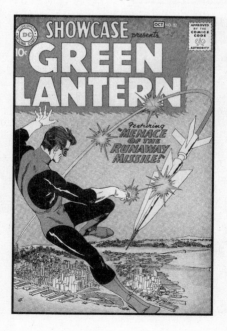

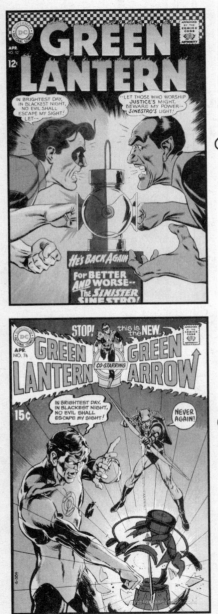

② *Green Lantern* (2nd Series) #52 (Gil Kane and Murphy Anderson).

③ *Green Lantern* (2nd Series) #76 (Neal Adams). Beginning of the *Green Lantern/Green Arrow* series of team-ups by Denny O'Neil and Neal Adams.

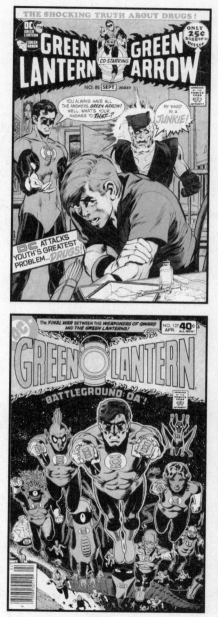

④ *Green Lantern* (2nd Series) #85 (Neal Adams). Johns notes that this is more known as a *Green Arrow* cover, but it *was* in an issue of *Green Lantern*!

⑤ *Green Lantern* (2nd Series) #127 (Brian Bolland). The first time Hal wore more than one ring.

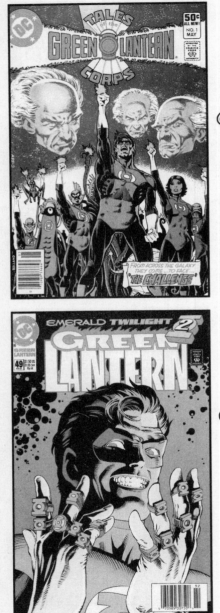

⑥ *Tales of the Green Lantern Corps* #1 (Brian Bolland). This one has been homaged a number of times, including most notably on the cover of *Green Lantern* #200 by Walter Simonson.

⑦ *Green Lantern* (3rd Series) #49 (Darryl Banks and Romeo Tanghal). This was part of "Emerald Twilight," when Hal Jordan seemingly went insane and began killing other Green Lanterns.

⑧ *Green Lantern* (4th Series) #29 (Ivan Reis). The first part of the "Secret Origin" story that was essentially the basis for the 2011 *Green Lantern* film.

⑨ *Green Lantern* (4th Series) #39 (Ivan Reis and Oclair Albert). Introduction of the Orange Lantern, Larfleeze.

After first working as Richard Donner's assistant for four years, Geoff Johns began to transition into a full-time comic book writer around 2000. He opened up with a critically acclaimed five-year run on the The Flash. *Since then, he has quickly become one of the most popular and prolific comics writers today, working on such titles as a highly successful reimagining of* Green Lantern, Action Comics *(cowritten with Richard Donner),* Teen Titans, Justice Society of America, *and* Infinite. *Geoff has received numerous awards for his comic book writing. Geoff has also written some acclaimed episodes for the TV series* Smallville. *In 2010 Geoff was appointed chief creative officer of DC Entertainment. In addition to writing the best-selling* Blackest Night *series, he is a consultant on DC film properties, including* Green Lantern, *starring Ryan Reynolds.*

SIX NOTABLY RECALLED COMIC BOOKS

Over the years, a number of comic books have been recalled for a variety of reasons. Sometimes it's due to printing errors, and other times . . . let's just say they were *inappropriate*. Here are six of them.

① *Wolverine* **#131** (1998). In this issue, the script referred to Wolverine's enemy Sabretooth as "the assassin Sabretooth." Someone, presumably the editor, crossed out the word "assassin" and wrote (in pen) the word "killer" instead. When the letterer went to letter the issue, he reportedly could not make out what the editor had written, so he just lettered what he thought it said. Which was the word "kike." So Marvel published an issue of *Wolverine* where someone refers to a character as "the kike Sabretooth." Marvel quickly recalled the issue, for obvious reasons.

② **Elseworlds 80-Page Giant** (1999). In this issue, there is a story about Clark Kent's babysitter, who naturally has trouble with the little superpowered tyke. He gets into all sorts of mischief, including microwaving himself. The president of DC objected to the depiction of baby Clark being put into harm's way, so nearly all copies of the one-shot were pulped. (Some made their way to England, however, and the story later won its writer-artist, Kyle Baker, an Eisner Award for Best Short Story.)

③ **The League of Extraordinary Gentlemen #5** (2000). At the back of this issue, which is set in the Victorian era, creators Alan Moore and Kevin O'Neill reprinted an actual ad from the early 1900s for a brand of douche called Marvel. DC felt that this might lead to a lawsuit from Marvel Comics, so the issue was pulped right away. Only one hundred or so were ever made.

④ **Universe X: Spidey #1** (2001). In this issue, one of the inkers snuck an insult to the recently fired editor in chief of Marvel Comics, Bob Harras. On the spines of books in the background of a panel, he wrote: "Harras, ha ha, he's gone, good riddance to bad rubbish he was a Nasty s.o.b." The issue was recalled and pulped.

⑤ *All Star Batman and Robin, the Boy Wonder* **#10** (2008). In this issue, the black bars that DC used to cover up profanity in the comic book did not *quite* cover up what guest-star Batgirl said, leaving a few readable curse words. The issue was recalled and pulped.

⑥ *Action Comics* **#869** (2008). On the cover of this issue, Clark Kent (with his Superman costume just barely noticeable under his shirt) and his father, Jonathan Kent, are relaxing and drinking what appears to be beer. DC recalled the issue and asked retailers to destroy any copies with the original cover. They reprinted the issue the next week with a new cover with the bottles clearly marked "soda pop."

THREE GREAT PRE-EISNER GRAPHIC NOVELS FROM BEFORE 1950

FRED VAN LENTE

Most folks credit Will Eisner with coining the term "graphic novel" and producing the first actual one, *A Contract with God*, back in 1978. But while researching my history-of-comics-as-a-comic comic, *Comic Book Comics* (cocreated and drawn by Ryan Dunlavey), I stumbled across some worthy examples that show, just as Columbus didn't quite "discover" America, Eisner was working from an obscure, but nonetheless preestablished tradition. Here are three that existed before 1950, even!

① *Histoire d'Albert,* **by Rodolphe Töpffer (1845).** A lot of snooty academic types (not to mention a few of today's, ahem, more *opin-*

ionated graphic novelists) will tell you that the true father of the graphic novel *and* the comic book *and* the comic strip is Swiss schoolmaster and part-time cartoonist Töpffer, who penned several satiric picture-stories for the amusement of his friends, publishing to a wider audience only when encouraged to by, of all people, Goethe. However, this claim is undermined by the fact that Töpffer's work has no dialogue balloons, the back-and-forth "imitation of life" that revolutionized the medium with Outcault's *Yellow Kid* at the end of the century. And while there are a very few panel-to-panel transitions, most of the action is narrated in captions, leading Töpffer's work to come across more like picture books for adults than comics. Don't take my word for it, though; you can download *d'Albert*, one of his best-known works, for free as a PDF (in French) off Wikipedia Commons (http://commons .wikimedia.org/wiki/File:Toepffer_Histoire_Albert.pdf).

② *God's Man*, by Lynd Ward (1929). Though you can often find a few of these wordless early-twentieth-century woodcut-panel-per-page "comics" in the remainder bin at your local art museum's gift shop, Ward's original effort—he was the first American to attempt a "pictorial narrative" (his words)—is quite moving. It shows the tragedy of an impoverished artist who sells his soul for commercial success at far greater cost than he suspects. Recently six of Ward's "novels in woodcuts" were collected in a two-volume edition by Library of America with introductions by Art Spiegelman.

③ *He Done Her Wrong*, by Milt Gross (1930). *God's Man* sold nearly twenty thousand copies when it debuted and earned the surest sign of success: a parody, in this case by newspaper gagmeister Milt Gross. Specializing in silent movie gags (unsurprising, since it's a silent comic) *He Done Her Wrong*'s tale of an Alaska strongman venturing to the Big City to rescue his seduced girlfriend holds up pretty well today (there's an extended gag involving a job

interview that makes me giggle every time I think of it). Fantagraphics recently reprinted Gross's book in a handsome trade paperback edition.

Fred Van Lente is the #1 New York Times *best-selling author of* Marvel Zombies, Incredible Hercules *(with Greg Pak), and* Odd Is on Our Side *(with Dean Koontz), as well as the American Library Association award–winning* Action Philosophers. *His original graphic novel* Cowboys & Aliens *(cowritten with Andrew Foley) is the basis for the major motion picture starring Daniel Craig and Harrison Ford. Van Lente's other comics include* Comic Book Comics, Taskmaster, X-Men Noir, The Amazing Spider-Man, *and* Alpha Flight *(also with Pak).*

FOUR STRANGE COMIC BOOK ADS FROM THE 1970s

The era of eight-tracks, Afros, and disco saw itself reflected in the comic book ads of this generation, as advertisers in general responded to the gradual age increase of the comic book audience with ads for slightly older readers. The decade also saw the debut of one of the most iconic series of comic book ads of all time, as we all learned the crime-fighting abilities of Twinkies! Here are four interesting ads from what Tom Wolfe referred to as the "Me Decade."

① With a name like Masculiner Co., it *has* to be good! What kind of a person reads a comic book ad about glue-on sideburns and says, "Hey, that sounds like something that could work for me!" Perhaps the best part

about this ad is that along with the six-dollar payment, they want you to send in a piece of your hair! Can't you imagine some office with piles of teenage boy hair just collecting dust in the corner? Yeesh.

② **Well, if it is the biggest rock event of the decade, how could I pass?** What is the only thing cooler than a rock album devoted to Marvel superheroes? Why, a rock opera album devoted to Spider-Man with a cartoon image of Stan Lee endorsing the product! Lee also narrated the rock opera, titled *Spider-Man: Rock Reflections of a Super-Hero*. The album credits the instruments to various Marvel superheroes (Thor on trumpet, Hulk on drums, the Fantastic Four on background vocals, Luke Cage on bass, etc.). Sadly, this did not begin a trend of superhero rock operas.

③ **Did you really think this would work, Chiquita?** You really have to question the folks in Chiquita's marketing department for thinking that producing banana-shaped walkie-talkies and banana-shaped compasses would go over well with children. How does something like that even occur to you? I suppose it makes some sense to try to diversify your brand, but banana-shaped toys seems a little inexplicable.

④ **Once again, Hostess pies save the day!** The most famous series of comic book ads during the 1970s (and possibly the most famous series of comic book ads ever) was the Hostess superhero ads of the late 1970s and early 1980s. These ads starred Marvel and DC superheroes fighting villains, with the end results in the ads showing that Hostess snack cakes would save the day (usually by the villain being distracted by the snacks—"I am robbing this bank, but I can't help but go for those cupcakes! Oh, no, now Batman has captured me!"). These ads were typically written by the editorial staff of DC and Marvel and drawn by actual Marvel and DC artists. The ad I'm sharing here is famously one of the earliest professional comic book works by none other than Frank Miller, of *Daredevil*, *Sin City*, *Dark Knight Returns*, and *300* fame.

SIX GREAT SILVER AGE COMIC BOOK COVERS

DAVE GIBBONS

Most of these covers made me buy the issues off the stands at the time, and the ones I didn't see, I studied and fantasized about until I did manage to trade or buy them, years later. When I say fantasized, I mean that I imagined what the story inside might be like.

As we all know, that fantasy could sometimes prove better than the reality. Happily, with all of these images, that was not the case. Not only are they great covers but they all covered great comics.

In that case, let me tell you what excited the child in me then and still thrills the elder statesman of comics I have become.

① *Avengers* #4

Marvel had an abortive attempt at reviving Cap in an issue of *Strange Tales*, so we were all primed for his real reappearance. The *Avengers* title was still fresh enough that every issue was novel and exciting, which made the addition of Cap front and center almost too much to bear. Penciler Jack Kirby takes a viewpoint that makes Cap dwarf all his fellow Avengers—even Giant-Man—and gives us a glimpse of his fellow Golden Age stablemate the Sub-Mariner. Paul Reinman's jagged ink line adds grit, and whatever unsung colorist opted for a white background adds the final oomph to an irresistible design.

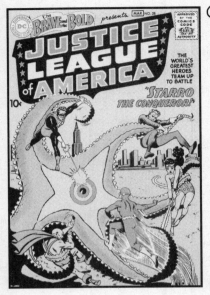

② *Brave and the Bold* #28

I've referred to the appearance of house ads featuring this cover as being the "Big Bang" moment of comics. This was the instant when the individual DC characters coalesced into creatures of the same universe. This almost diagrammatic design is a kind of reverse explosion, with Starro's markings and the tiny heroes pointing inward toward a bull's-eye, literally Ground Zero for all the multiverses and crises to come. Penciler Mike Sekowsky looks like he might have been working over a Carmine Infantino layout and his impressionistic tendencies are gorgeously reined in and sharpened by Murphy Anderson's inks.

③ *Brave and the Bold* #36

This and the *JLA* cover were the only issues I didn't buy off the stand at the time, due to the vagaries of importation into the UK. I lusted after it for years, admiring artist Joe Kubert's dynamic design and gutsy inking style, which always stood out from the calmer renderings of most of editor Julius Schwartz's stable. I was also fascinated by the technical innovation,

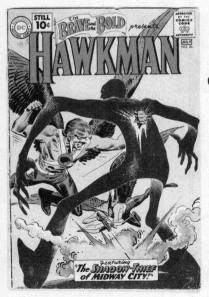

as it was then, of the Shadow Thief being printed without a black line—an early example of what I came to know later professionally as a "color hold." I finally got the issue in a trade for some old *Detective Comics*, I believe; whilst I eventually, and improbably, bought the *JLA* issue at a convention in France.

④ *Green Lantern #45*

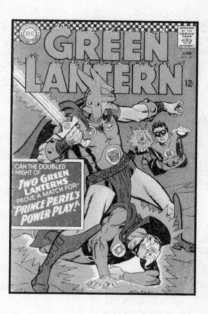

I'd stopped buying comics a few years before this issue appeared, preferring to spend my money on drinks, girls, and scooters. I was standing in line to buy some cigarettes when this cover jumped out at me. Things had clearly moved on since I last saw a *Green Lantern* comic; Gil Kane's figures leaped into action in a way they never had in the staid early sixties and even Sid Greene's fussy inking and a dark gray background couldn't sap the primal energy. When I noticed the Golden Age Lantern was in the issue, too, I was sold. To my shame, I think I mumbled something about it being for a nonexistent kid brother. If I hadn't seen this cover, I might never have gotten back into comics and my life would today be very different.

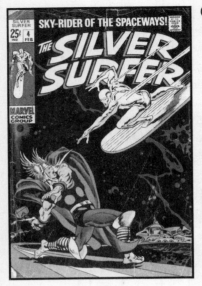

⑤ *Silver Surfer #4*

As always, penciler John Buscema makes it all look so easy. His wonderful grasp of human anatomy aside, it's the simplicity and directness of the composition that makes this so powerful. The Surfer's arrowing in on a diagonal, which continues through Thor's arms, then curves off along the Rainbow Bridge to Asgard, where an impressionistic zigzag of space stuff returns the eye to the Surfer once more. The curved logo adds an echo of the bridge and its warm colors repeat Thor's costume while setting off the Surfer's cold metal skin. Add Sal Buscema's crisp inking and Stan Lee's tasteful restraint in not dropping captions onto it and you have as perfect a cover as you'll ever see.

⑥ *X-Men #1*

If the *Surfer* cover showcases Buscema's classic draftsmanship and composition, this relatively cluttered image exemplifies penciler Jack Kirby's exuberance and invention. His instinctive sense of design ties the figures together with the background element of the Angel's wing and the abstract diagonal line that the unknown colorist has seen as

the edge of some kind of red carpet. The captions are distracting but cannot overwhelm the strength of Kirby's vision.

Dave Gibbons has been playing a major role in the world of comics for more than thirty years. He began his comics career in 1973, when he started to contribute to the magazine 2000 AD. *Since then he has drawn and written for all the major publishers in North America and his home country of Great Britain. He has depicted the adventures of Superman, Batman, Dr. Who, Dan Dare, and Green Lantern, among many others. His greatest success came when he collaborated with Alan Moore on the famous* Watchmen *series for DC Comics in 1986 and 1987, for which he got a Hugo Award. Among his many, many other works are the continuing, award-winning saga of* Martha Washington *with Frank Miller,* Batman versus Predator *with Andy Kubert, and* World's Finest *with Steve Rude. Recently he released his own graphic novel,* The Originals, *and wrote the* Green Lantern Corps *relaunch.*

FOUR STRANGE COMIC BOOK ADS FROM THE 1980s

Fads have always been a part of American popular culture, but during the 1980s, a boom in consumerism saw Americans embrace fads in ways never seen before. There were riots at toy stores as parents fought to buy the newest shipment of Cabbage Patch Kids, for crying out loud! Comic book ads of the decade were quick to cash in on the various fads of the era. Here are four interesting comic book ads from the 1980s.

① **Yes, you heard me, "Cube Lube."** One of the biggest fads of the decade was the Rubik's Cube, the 3-D mechanical puzzle. Presumably, if you are a hard-core Rubik's cuber and keep twisting your

cube around a lot, it might become difficult to move the pieces easily. Luckily, Bouge Industries is there for you with Cube Lube, lubricant for your Rubik's Cube to make it turn easier! Yes, Cube Lube. For two dollars a tube. Ah, the American dream—to come up with a tie-in product to bilk users of a second, more famous product!

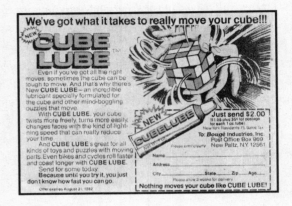

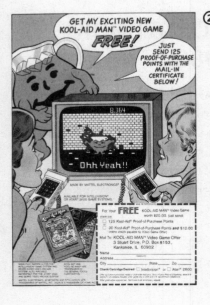

② So by "free" you mean, of course, not free at all. Besides the sheer absurdity of anyone wanting to play a Kool-Aid Man video game (then again, there *was* enough demand to get a *Kool-Aid Man* cartoon series on to the air, so perhaps I am misjudging the public interest in Kool-Aid Man circa 1983), this ad is awesome because it advertises a "free" Kool-Aid Man video game. "All" you have to do is send in *125 proof-of-purchase points*! Yes, kids, to get this "free" game, you only need to buy thirteen dollars' worth of Kool-Aid!

③ **They have the jazz? I want the jazz!** Advertising your Saturday morning schedule of cartoons has been going on in comics since the 1960s. It was during the 1980s, though, that this was brought to another level, with all three of the major networks dedicating one- or two-page ads to their fall lineup of cartoon shows. No group of shows quite captures the spirit of the 1980s better than seeing the visage of Mr. T shouting at you about NBC having "the jazz."

④ **What can I do to help, Meat Loaf?** This 1987 ad for the Special Olympics is obviously for a good cause, but when you consider the facts that (a) 1987-era Meat Loaf was probably at his lowest level of popularity and (b) the artist who drew Meat Loaf did so . . . well, let's just say "poorly," then you have all the makings for one extremely goofy-looking ad. At least it was for a good cause. (Although I can't be the only one whose eyebrow rises when I see "a *portion* of the proceeds goes to the Special Olympics" [italics added]—what a delightfully vague promise.)

THREE STRANGE PUBLIC SERVICE ANNOUNCEMENTS

Comic book characters have always been good tools for public service announcements, because really, if you won't listen to Spider-Man, who *would* you listen to? Here are three particularly strange PSAs from over the years.

① **Wait, we get *paid* for this?** In 1971, three years after they finished the *Batman* TV series, Yvonne Craig and Burt Ward returned to their roles (along with Dick Gautier filling in for Adam West) to film a PSA in support of the Federal Equal Pay Act for the Department of Labor. The act had passed in 1963, making it illegal to pay men and women different salaries if they performed jobs that

required equal skill, effort, and responsibility. Nearly ten years later, though, many employers still ignored the law. So the Department of Labor enlisted the Bat crew, including producer (and narrator) William Dozier. The ad shows Batman and Robin tied up in a warehouse with a bomb when Batgirl shows up and wants to talk about why it is that she gets paid less than Robin for doing the same job. Batman says they can talk about it later, but Batgirl seems willing to press the point as the time runs out on the bomb. The commercial ends on a cliffhanger—did Batgirl get a raise? Did Batgirl let Batman and Robin die? Sadly, we'll never know.

② **Nope, no ulterior motives here!** I love having a PSA devoted to how awesome gun events are. It's almost as if the number one sponsor of DC Comics were a BB gun company . . . oh, wait, DC was sponsored by Daisy BB guns.

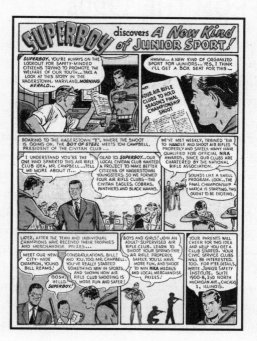

③ **Spider-Man sticking up for Planned Parenthood.** Called *Spider-Man versus Prodigy*, the comic appears like a "normal" Marvel comic book, including artwork by regular *Spider-Man* artists Ross Andru and Mike Esposito . . . but the tagline "A special Planned Parenthood issue" gives it away. The comic involves the evil Prodigy, an alien who has a terrible plot to take over the Earth. He will get the youth of America to have unsafe sex and get pregnant—that way, they will be weakened when his alien invasion comes! Spider-Man, as you might imagine, is quite dismayed at the situation. Luckily, Spidey defeats the bad guy in the end, and then readers are treated to some helpful information about sexual education.

FOUR STRANGE COMIC BOOK ADS FROM THE 1990s

The 1990s saw video games become the most popular product advertised in comic books, something that continues to this very day (as the audience overlap is quite high). Here are some odd comic book ads from the 1990s.

① **You know the good parts of role-playing games? Let's just skip that.** The best part about playing role-playing games like Dungeons and Dragons is interacting with your fellow game players. This bizarre 1990 ad for Castle Mammon took that fun out of the game completely with a phone line that would allow a person to call in to play a role-playing game. The developer, Steven Jackson, created F.I.S.T. (Fantasy Interactive Scenarios by Telephone) and made a *ton* of money off of it. Just look at the prices being charged! A dollar fifty for the first minute and seventy-five cents per additional minute! As most role-players know, games tend not to be particularly short, so Audio Communications, Inc., made a killing.

2 **That looks just like Wolverine!**

One of the more amusing products that Chef Boyardee has produced is licensed pasta. What makes these products *especially* amusing is that they would attempt to make the pasta into the shape of the characters being licensed. Sometimes this would be easy, but in the case of Wolverine, it resulted in him looking more like a sumo wrestler than anything else. It makes you wonder —they mention "mystery super villain shaped pasta" within, but if that's what they think Wolverine looks like, how would anyone guess who the villain is supposed to be?

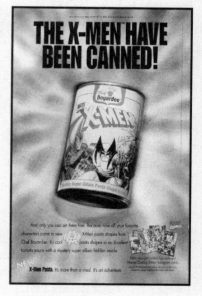

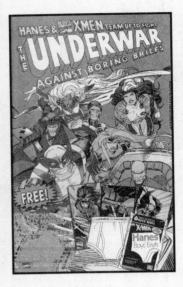

(3) **I said Underwar—what is it good for? Absolutely nuthin'.** The X-Men have long waged a war for the sake of tolerance and peace between human- and mutantkind. However, when it comes right down to it, what is that compared to the dangers of boring briefs? And thus, the underwar began!

(4) **Eau de Mario.** Like the Rubik's Cube, Pac-Man, Teenage Mutant Ninja Turtles, or pretty much any popular fad, companies were quick to cash in on the popularity of Super Mario Brothers. Here, we discover Super Mario and Princess bubble baths and shampoos. After all, who smells better than a plumber, right?

FIVE BEST COMIC STRIPS OF THE PAST THIRTY YEARS

PAIGE BRADDOCK

Arguably, *Peanuts* would likely be in any top five list of comic strips, but given my current job (creative director at Charles Schulz's studio), it would be a conflict of interest to list it here. I will instead list my personal top five comic strips, not viewed from the angle of an art historian or critic, but as a fan and fellow cartoonist who appreciates above all else the zany, unique voice of comics and darn funny drawings.

① *Monty,* **by Jim Meddick.** Jim Meddick and I have a very similar sense of humor: we both find whimsy in the mundane. He can make ordering a pizza funny. I love how he crams a lot of texture into every panel. His drawings have a flat look to them, but are so well rendered I never get tired of looking at them.

② *Cul de Sac,* **by Richard Thompson.** This is my favorite new comic. Richard is so cleverly subtle sometimes and over-the-top slapstick at other times. His kid characters talk like kids, are frequently clueless, and make hilarious assumptions. I love his loose drawing style (particularly his crazy-looking minivans).

③ *Bloom County,* **by Berkeley Breathed.** In the 1980s there was nothing funnier or more biting than *Bloom County*. Oh, how we need *Bloom County* back to offer us a running commentary on the conservative yahoos who are crowding the airwaves at the moment!

④ *The Far Side,* **by Gary Larson.** Gary Larson captured, more than any other cartoonist, the raw humor in drawing packs of wiener dogs. He gave us a behind-the-scenes glimpse into the goings-on in pastures, fish tanks, monkey cages, and postal offices across the nation.

⑤ *Calvin and Hobbes,* **by Bill Watterson.** *Calvin and Hobbes* was charming, whimsical, and beautifully drawn. This comic reminds you of what it was like to be a kid again. And, boy, can Bill draw trees. He has this simple, gesture-drawing approach to backgrounds. I never get tired of looking at them.

Highly respected indie cartoonist Paige Braddock is the creator of the Eisner-nominated comic Jane's World *and cocreator of* The Martian Confederacy. *Paige is also the creative director at Charles Schulz's studio in Northern California. Before accepting the position with Schulz, she worked as an illustrator for both the* Atlanta Constitution *and the* Chicago Tribune.

TOP TEN MOST ICONIC COVERS IN DC COMICS HISTORY

The following are the results of a survey of Comic Book Resources readers for the most iconic covers in DC Comics history, in ascending order.

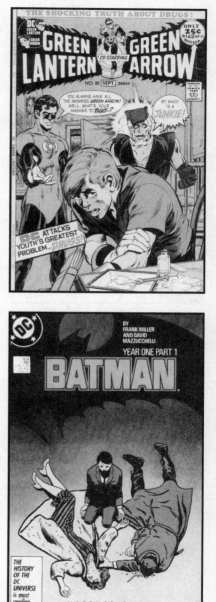

10 *Green Lantern* #85 (art by Neal Adams)

9 *Batman* #404 (art by David Mazzucchelli)

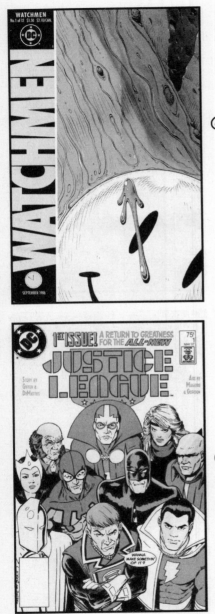

⑧ *Watchmen* #1 (art by Dave Gibbons)

⑦ *Justice League* #1 (art by Kevin Maguire and Terry Austin)

⑥ *Batman: The Dark Knight Returns* (art by Frank Miller)

⑤ *Batman: The Killing Joke* (art by Brian Bolland)

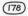

④ *Detective Comics* #27 (art by Bob Kane)

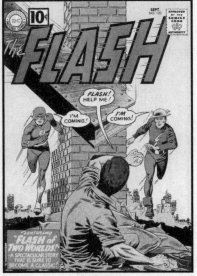

③ *Flash* #123 (art by Carmine Infantino and Murphy Anderson)

② *Crisis on Infinite Earths* #7 (art by George Perez)

① *Action Comics* #1 (art by Joe Shuster)

FOUR STRANGE COMIC BOOK ADS FROM THE TWENTY-FIRST CENTURY

Advertisements in comic books have gone down significantly in recent years, but the tradition of odd comic book ads continues to this day. Here are some strange ones from the period 2000–2011.

① **The death of a fad.** For a while, wearing trucker hats ironically was a hip trend, particularly among celebrities like Ashton Kutcher. You know a trend has ended the "hip" stage of its life when you start having Marvel Comics cover trucker hats.

② **Is that *the* Amazing Man?!** In 2010 Colgate ran an extensive series of ads in DC Comics coinciding with the seventy-fifth anniversary of the comic book company. The premise of the ads was celebrating seventy-five years of "the hero getting the girl." To demonstrate this, each week they showed a different notable DC cover or piece of art featuring characters kissing. The problem is

that there really aren't *that* many examples of this on superhero covers and if you want to have a racially diverse character, the examples are even fewer. This led to a national ad campaign using a cover featuring Amazing Man and Maxima, two of DC's most obscure superheroes (and both of whom had been killed off years earlier, Amazing Man in 1998 and Maxima in 2001).

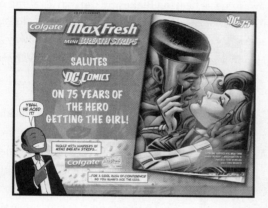

③ **Hey, did I mention how awesome avocado was?** In 2011, DC and Subway launched a four-part series of comic book inserts featuring famous athletes (as well as Subway spokesperson Jared Fogle) encountering DC superheroes in comic book stories that also, of course, involve the delicious goodness of Subway sandwiches. If you didn't know that Subway now has avocado in their sandwiches, you certainly will after you see the tenth athlete mention it in one of these ads. While seeing Laila Ali and Jared Fogle hanging out

in the fourth one is pretty trippy, I am going to pick the second one as my favorite, simply for the absurdity of Blake Griffin of the Los Angeles Clippers bumping into Carl Edwards (of NASCAR fame) at a Subway and Edwards giving him a ride in his race car (where they come across the Justice League fighting Gorilla Grodd and his army of evil gorillas, leading Blake and Carl to lend a hand). Nothing is quite as awesome as hearing Blake and Carl say (trading off lines at the ellipses), "Sorry, Grodd. Your mind control doesn't work on us . . . we're not tired . . . because we ate *right* at Subway . . . and got energized by the *avocado*, the superfood for the everyday hero!"

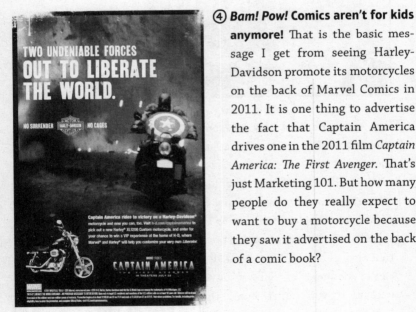

④ ***Bam! Pow!* Comics aren't for kids anymore!** That is the basic message I get from seeing Harley-Davidson promote its motorcycles on the back of Marvel Comics in 2011. It is one thing to advertise the fact that Captain America drives one in the 2011 film *Captain America: The First Avenger.* That's just Marketing 101. But how many people do they really expect to want to buy a motorcycle because they saw it advertised on the back of a comic book?

PART V

COMICS
AND CULTURE

FIVE COMIC BOOK INVENTIONS THAT EVENTUALLY BECAME REAL

Arthur C. Clarke once wrote, "The only way of discovering the limits of the possible is to venture a little way past them into the impossible." That is the very heart of comic book inventions—if you *can* do anything in the pages of a comic book, why *not* do anything? The interesting part is when "real life" catches up to the seemingly impossible fictions from comics. After all, just eight years after the Fantastic Four visited the moon, NASA did so, as well. Here are five comic book inventions that eventually became real.

① **Two-way wrist radio.** When Dick Tracy first came along, he was a traditional police officer. In fact, creator Chester Gould kept Tracy grounded for more than a decade. It was not until after World War II that he began to mix futuristic ideas with the down-to-earth style of Dick Tracy. One of those early attempts to mix the two came with the introduction of Dick Tracy's two-way wrist radio in 1946. A small portable device that can allow two people to talk to each other? I think the numerous cellular telephone companies out there can manage that nowadays.

② **Ping-Pong balls to raise a ship.** In a 1949 *Donald Duck* story, "The Sunken Yacht," Donald and his nephews raise a ship by filling it with Ping-Pong balls. In 1964, an inventor named Karl Krøyer was enlisted to help raise a sunken freighter in the freshwater harbor of Kuwait (it had thousands of sheep on it, so if the sheep were to rot in the fresh water . . . well, the water would not have been so fresh). Krøyer came up with a process that is basically a fancier way of saying "fill the boat up with Ping-Pong balls." His process (which specifically involved the insertion of twenty-seven million plastic balls made of expandable polystyrene foam) worked so well that he applied for patents in a number of countries. The only country that turned him down was the Netherlands. This was because the process had to be "novel" to be patentable. In other words, it could not have been thought of before Krøyer. Since it *had* essentially appeared earlier, even in a *Donald Duck* story that Krøyer clearly had never read (Krøyer was forty-five years old in 1949 and later specifically noted he had not read the comic in question), it was therefore ineligible for a Dutch patent.

③ **Flying camera drone.** In 1957's *Batman* #109, there is a story called "The 1,001 Inventions of Batman," in which Batman's various inventions from over the year are discussed. (The conceit of the story is that a villain has duplicated one of their devices, so they have to go through them all to see which one.) The invention that the villain ends up duplicating is the "Flying Eye," a flying mobile drone that relays images of whatever it "sees" back to Batman. In 1957, that was quite futuristic. In 2011, you would not believe how much further we've gone from that concept. Currently, the government has developed a spy plane that is roughly the size of—and has the same appearance of—a hummingbird! It was developed by the Defense Advanced Research Projects Agency (DARPA), and it was then built by AeroVironment with

funding from DARPA. It can fly for about eight minutes. Simply amazing.

④ **Video screens.** In *Strange Tales* #136, one of Nick Fury's S.H.I.E.L.D. agents calls him from their mission. They show up on a video screen and talk with him essentially face-to-face.

This was not the only comic to feature such video screens, of course, as it was prevalent in a number of superhero comics of the era. Still, this is a perfect example of what once was seen as a flight of fancy now being an everyday part of people's lives through the use of programs like Skype.

⑤ **Personal exoskeleton.** In *Tales of Suspense* #39, Iron Man is introduced when inventor Tony Stark develops an armor that works like a powerful exoskeleton. It allows him to become stronger and to fly. Amazingly enough, a Brooklyn defense contractor called Atair Aerospace has developed a working exoskeleton that the company refers to as "the world's smallest human-piloted jet airplane." It has twin micro-turbine-powered jets along with advanced aerospace composite materials to make it lightweight enough that a human can wear it and fly as his or her own personal "Iron Man." The day of government-issue "Iron Men" might soon be upon us. Imagine how cool the army recruitment commercials will look like then!

SIX MUSICIANS WHO HAVE WRITTEN COMIC BOOKS

Rock and roll and comic books have a lot of crossover appeal to each other's fans. Beyond just the fans, though, many rock musicians would love to write their own comic books. Here are six famous rock musicians who did just that.

① **Gene Simmons.** Simmons was a big Marvel Comics fan growing up, and he naturally jumped at the opportunity for KISS to have its own Marvel comic in the late 1970s. KISS has had a number of other comic book series over the years from both Image Comics and Dark Horse Comics, but in 2007, Simmons launched his own line of comics from IDW Publishing. Simmons came up with characters and plots for three miniseries that other writers then scripted, *Zipper*, *Dominatrix*, and *House of Horrors*. Simmons's son, Nick, wrote his own comic, *Incarnate*, which the family promoted on their reality show, *Gene Simmons Family Jewels*.

② **Claudio Sanchez.** Since 2004, Sanchez, the front man for the progressive rock band Coheed and Cambria, has used his comic book *The Amory Wars* to elaborate on the lyrics from Coheed and Cambria's albums.

③ **Glenn Danzig.** Danzig, founder and front man for the Misfits, then Samhain, and now Danzig, is a longtime comic book fan. Since the early 1990s, he has had his own publishing company, Verotik, which he has used to publish adults-only horror comic books.

④ **Rob Zombie.** Like Danzig, Zombie, the founder and lead singer of the band White Zombie and a multiple Grammy Award nominee,

is a lifelong comic book and horror fan. He has directed a number of popular horror films, and in 2003 he got into comic books as well, with the horror anthology *Spookshow International*. He has also written a number of comic books with former rock musician Steve Niles, who is now a renowned comic book creator.

⑤ **Gerard Way.** Way, the lead singer of My Chemical Romance, actually wrote a comic book when he was just sixteen years old for a small independent comic company. It was not until 2007, though, that Way returned to comics in a big way with the critically acclaimed miniseries *The Umbrella Academy* (with artist Gabriel Ba) for Dark Horse Comics, about a group of superpowered siblings who are reunited years after a tragedy tears them apart. It won the Eisner Award for Best Limited/Finite Series. He has since written a sequel and is planning a third.

⑥ **Scott Ian.** Ian has been the lead guitarist for the heavy metal band Anthrax since the band began in 1981. He has always been a vocal supporter of comic books, and in 2009, he got the opportunity to write one for DC Comics, starring the popular character Lobo. *Lobo: Highway to Hell* was created by Ian with noted comic book artist Sam Kieth.

FIVE ITEMS AND PHRASES THAT SURPRISINGLY CAME FROM COMICS

The influence of comics is widespread throughout modern popular culture. Nearly everyone has heard of Superman, Batman, Charlie Brown, Spider-Man, and the X-Men. However, there are a number of items in popular culture and notable phrases that you

might be surprised to learn gained their inspiration from comics. Here are five of them.

① **Yellow journalism.** For years, people have felt that the term "yellow journalism" was derived from the rivalry between publishing moguls William Randolph Hearst and Joseph Pulitzer, and their tendency to sensationalize rather than report news. However, the term did not originate with that practice—people had already been criticizing Pulitzer and Hearst for those theatrics for years before "yellow journalism" became a buzzword, using the derisive term "new journalism" to describe their practice. The usage of "yellow journalism" specifically came about when Hearst, in 1897, began featuring the popular comic *Yellow Kid* on the editorial pages, mixed in with actual news. *New York Press* editor Elvin Hardman found the idea of mixing cartoons with news highly offensive, and it was *this* that he used to knock Hearst, suggesting that the mix of information and entertainment was not a good sign for the sanctity of newspaper journalism. Hardman's term was quickly picked up by the other critics of Hearst and Pulitzer, and so a term was born!

② **The teddy bear.** In November 1902, Theodore Roosevelt, president of the United States and avid hunter, went on a bear-hunting trip while he was in Mississippi. Figuring that it would look good for the president to kill a bear (animal rights were not an issue at that time, clearly), Roosevelt's aides found a young black bear and, after clubbing it nearly to

death, managed to tie it to a tree. They informed the president that here, here is a bear you can kill! Roosevelt was disgusted at the unsportsmanlike nature of the notion and refused to shoot it (although he did tell his men to put the animal out of its misery). The news of Roosevelt's decision made its way back to Washington, DC, and legendary political cartoonist Clifford Berryman produced a cartoon that would become famous all throughout the United States, being reprinted in many newspapers. Titled "Drawing the line in Mississippi" (a play of words on the border dispute Roosevelt was there for), the November 16, 1902, cartoon depicts Roosevelt choosing not to shoot a cute little bear.

Berryman began to make the cute little bear his shorthand symbol for Roosevelt, using it in all of his cartoons about the president. The cartoon bear inspired a candy shop owner named Morris Michtom (who would often make little stuffed animals with his wife to sell in the store) to begin selling a stuffed bear toy (after receiving permission from Roosevelt) as "Teddy's Bear," which, of course, became known as a teddy bear and soon became one of the most popular toys in the world.

③ **The names of the Marx Brothers.** At the turn of the twentieth century, Charles Augustus "Gus" Mager was working on a funny animal strip called *Knocko the Monk*, starring a group of anthropomorphic monkeys called "Monks." Each of the Monks had a nickname to differentiate them from one another, and they would invariably end with an "o": Rhymo the Monk, Henpecko the Monk, Groucho the Monk, stuff like that. Around the same time when the strip took off, the Marx Brothers were just starting to gain attention with their vaudeville act. While playing poker with the brothers, fellow vaudeville performer Art Fisher began to come up with "o" names for each of the brothers, based on various facets of their personality, Harpo (played the harp), Chico (he got lots of "chicks"), Gummo (something to do with shoes), and Groucho

(people aren't actually sure exactly why he was called Groucho at the time). The names stuck, and the brothers soon became national stars.

④ **Back to the drawing board.** *The New Yorker* has always matched the cultural zeitgeist with its famous cartoons. A 1928 cartoon by Carl Rose (with a caption by E. B. White, later writer of *Stuart Little* and *Charlotte's Web*) turned "I Say It's Spinach" into a national catchphrase! But for adding to the common vernacular, it's hard to compare to Peter Arno's 1941 cartoon of a man reacting to a plane crash by simply saying, "Well, back to the old drawing board!" Naturally, the phrase became popular and now "back to the drawing board" is such a common phrase it is hard to believe that it ever was *not* a turn of phrase, let alone that it came from a cartoon!

⑤ **Sadie Hawkins Day.** Alfred Gerald Caplin, better known as Al Capp, began his legendary comic strip *Li'l Abner* in 1934. The series follows the misadventures of a group of hillbillies living in the poor town of Dogpatch, Kentucky. While the strip is an ensemble, the titular character is Li'l Abner himself (who is, in fact, quite a big guy). One of the recurring plots in the comic is how a beautiful girl, Daisy Mae, desperately wants to marry Abner, but he is routinely either oblivious or downright not interested in commitment. In a 1937 strip, Capp introduced an interesting concept—Sadie Hawkins Day! The idea was that the founder of Dogpatch had a daughter no one would marry (Sadie Hawkins). So he declared "Sadie Hawkins Day" and all the bachelors in town had to run all day and if Sadie caught any of them, they would have to marry her. It was clearly intended as a one-off bit, but the idea was such a massive hit that Capp was "forced" to make Sadie Hawkins Day a regular occurrence in the strip and poor Abner had to outrace Daisy Mae every year. *Li'l Abner* was a successful strip right out of the gate, but when Sadie Hawkins Day debuted in

1937, the strip was in the midst of a boom in popularity—all of these new readers soon got quite attached to the Sadie Hawkins idea (the popularity of comic strips during the 1930s would be similar to that of television series today). Just two years after the original strip, Sadie Hawkins Days were popping up on college campuses all over the United States. Even after Capp had Abner and Daisy Mae get married in the early 1950s, the Sadie Hawkins Day strips continued. Nowadays, Sadie Hawkins Day mostly survives through the use of the term in reference to school dances where the girls are the ones who ask the boys to the dance.

SIX BOB DYLAN REFERENCES IN COMIC BOOKS
SCOTT ALLIE

① *Watchmen* #1. While Dylan has been referenced many times over the years in comics, the lyrics of "Desolation Row" are used here as more than a nod to Bob, really setting the tone of the series. Dylan lyrics come up again in other issues of *Watchmen*, in similarly significant ways.

② *Betty and Veronica* #163. The cover blurb for this issue reads: "'The times they are a-changin'.' Now the chicks have to wait for us boys to finish dressing." This particular song title has been referenced so many times in pop culture it's ridiculous, but Archie had a unique way of addressing the changing culture.

③ *Ghost Rider* #3. Story title: "Wheels on Fire." Kudos to Gary Friedrich for referencing a slightly more obscure lyric on the "Son of Satan" splash page.

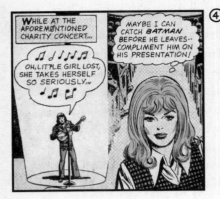

④ *Superman* #279. In this issue, Batman crashes a Madison Square Garden–type show at the Gotham City Coliseum. While the character couldn't look less like Dylan, his partner could pass for Joan Baez. He's referred to as Bobby, and he's singing Dylan lyrics, almost certainly without permission.

⑤ *The Goon* #1. When Goon gets lost in the Hobo Jungle, he encounters their king, a very Dylanesque mush mouth with an acoustic guitar.

⑥ *The Umbrella Academy: Dallas* #3. When Seance is shot in the head, he meets God. Fortunately, God is Bob Dylan, riding through the desert on horseback in his modern wizened cowboy persona. Not too long after this, *Umbrella* creator Gerard Way covered "Desolation Row" with his band My Chemical Romance for the film adaptation of *Watchmen*.

Scott Allie writes and edits for Dark Horse Comics and Glimmer Train Press. His writing includes the horror comic The Devil's Footprints, *set in his hometown of Ipswich, Massachusetts. Other works include tributes to H. P. Lovecraft, contributions to* Star Wars *and* Planet of the Apes, *and a series of self-published horror comics called* Sick Smiles, *from Aiiie! Comics.*

FOUR COMIC BOOKS PRODUCED BY THE U.S. MILITARY OR THE CENTRAL INTELLIGENCE AGENCY (PLUS, HOW JACK KIRBY PLAYED A ROLE IN A CIA OPERATION)

Comics have a sort of universal language, and because of that, the U.S. military and the Central Intelligence Agency (CIA) have used them for instructional purposes. In one operation, famed comic book artist Jack Kirby found his artwork assisting the CIA.

① **How to spot a Jap!** In 1942 the U.S. Army and Navy jointly put together a "Pocket Guide to China" for U.S. troops. In a comic strip initially included in the guide, famed cartoonist Milton Caniff (of *Terry and the Pirates* and *Steve Canyon* fame) drew a detailed examination of, well, how to "spot a Jap" (as opposed to someone from China). The whole thing was quite racist, as it involved statements like "the Chinese are about the height of an average American, while the Japanese are shorter and it appears as though their legs go right into their chests" and "Chinese eyes are set like any European's or American's—but have a marked squint. Japanese eyes are slanted toward his nose." This was not uncommon at the time: *Life* magazine had an extensive pictorial on how to differentiate

between Chinese and Japanese. They are equally abhorrently offensive.

② **How to tie down Marxist tyranny.** In 1983, the CIA dropped comic-book-like manuals into Nicaragua to teach Nicaraguans how to fight back against what the United States termed "Marxist tyranny." It gave them a good deal of advice on how to destabilize the government. The "Sabotage Manual" (as it came to be referred to) showed how to knock down telephone wires, break typewriters, and blow a fuse by putting a small coin in the socket. When the CIA involvement was discovered, President Reagan apologized and said that his administration would punish whoever was responsible. A few low-level CIA employees did receive letters of reprimand, but no other punishment for the distribution occurred.

③ **Grenada.** In 1984, the CIA dropped bundles of a twelve-page comic book into Grenada to tell the people the United States' reasons for invading the country in 1983. The best part of the comic is inarguably where it shows the USSR and Cuba playing Grenada like marionettes.

④ ***Dignity and Respect.*** In 2001, the U.S. military released a thirty-two-page comic book titled *Dignity and Respect* that was an extensive elaboration on the guidelines behind the military's "Don't Ask, Don't Tell" policy toward homosexuality in the military. It is very interesting to see the military's view of how the whole thing would unfold: "Hello, I would like to inform you that I am a homosexual."

As for the Jack Kirby–CIA connection . . .

In November 1979, Iranian students took over the American embassy in Tehran, Iran, taking fifty-two U.S. diplomats hostage for 444 days. A group of married couples managed to evade capture and eventually were given secret sanctuary in the Canadian embassy. The CIA tried to think of a way to get them out of the country. Faking passports would be easy; even passing them off as Canadians was simple enough—but explaining why six Canadians were in Iran during such a tumultuous time? Not simple at all. Eventually, CIA agent Tony Mendez came up with a plan—pass them off as film people scouting locations for a motion picture! Only, to make it look real, they needed to *create* a real motion picture. This is where Jack Kirby is involved. A fellow named Barry Geller had purchased the rights to Roger Zelazny's science fiction novel *Lord of Light* and hired Jack Kirby to do design sketches for the film. Like a lot of films, the project fell through. The CIA hired makeup artist John Chambers (Oscar winner for his work on *Planet of the Apes*) to help in the plan. Chambers had worked on *Lord of the Light*, so he had access to the film's documents, including Kirby's design sketches. The terrain of Iran fit the setting of the story perfectly, so now the project had a film to work with! They renamed the film *Argo* and proceeded with the CIA plan, including placing an ad for the film in *Variety*. The Kirby art was used extensively. Eventually, the six embassy workers disguised as film workers (now also all passed off as Canadian citizens, thanks to the superheroic work of the Canadian government in this time of crisis) went to Tehran's Mehrabad Airport and flew off to Switzerland. An amazing tale of ingenuity.

SIX INSTANCES OF ARCHIE COMICS VIGOROUSLY "PROTECTING" ITS INTELLECTUAL PROPERTY

I t's understandable that companies want to protect their intellectual property. Archie Comics has been *especially* litigious over the years. The company objected to anyone sullying the image of squeaky-clean Archie and his friends in Riverdale, so sometimes its attempts were, shall we say, extreme. Here are six notable examples.

① **Goodman Goes *Playboy*.** In 1962, Will Elder drew a parody of Archie Andrews in the pages of Harvey Kurtzman's *Help!* In it, the Archie Andrews stand-in "Goodman Beaver" and his friends embrace the "*Playboy* lifestyle" at Hugh Hefner's Playboy Club. The characters partied, drank, and caroused; it was *quite* a scene. Archie sued Kurtzman over copyright infringement and in 1964, they settled on one thousand dollars in damages, an apology, and a promise never to reprint it. Kurtzman and Elder then tried to alter the artwork and reprint the story. Archie Comics stepped in again, this time demanding that Kurtzman turn the copyright on the material over to Archie, which Kurtzman reluctantly did. Interestingly enough, Archie never renewed the copyright, so as of 2011, the story should be able to be printed free and clear.

② **Veronica.org.** In 1998, Archie Comics sent a cease and desist letter to David Sams over his website Veronica.org, which he had created for his infant daughter. Archie argued that it was a trademark of Archie Comics (which owned Veronica.com). Sams refused to

cave in and made the case public, ultimately shaming Archie into dropping the matter. Amusingly enough, as of August 2011, Veronica.org is not used by anyone.

③ **Jughead's Revenge.** In 2001, Archie Comics sent a cease and desist letter to the punk band Jughead's Revenge to get them to stop using the name, as Archie felt that it violated its trademarks. The band broke up soon after the letter was received (although it seems as though they were planning on going on hiatus anyway).

④ **Archie's Weird Fantasy.** In 2003, a new play entitled *Archie's Weird Fantasy* was scheduled to debut at Atlanta's Dad's Garage Theatre Company. It depicted Archie Andrews realizing that he was gay and moving out of Riverdale. The night before the show was set to premiere, Archie Comics delivered a cease and desist letter, threatening legal action and pointing out copyright violations that would cost in the six figures for each violation. Ultimately, Dad's Garage Theatre's artistic director decided to change the name of the play to *Weird Comic Book Fantasy*, and Archie Andrews became Buddy Baxter, Riverdale became Rockville, and so on. Interestingly enough, the playwright, Roberto Aguirre-Sacasa, has since written a number of comic books for Marvel Comics.

⑤ **The Veronicas.** Teen Australian twin rockers Lisa Marie and Jessica Origliasso began fronting their own group called the Veronicas in 2005, using the name people had given them for their resemblance to Archie's girlfriend. (The girls also suggest that they were influenced by the film *Heathers*, in which the outcast among all the popular girls named Heather is a girl named Veronica.) Archie Comics, naturally, did not approve and filed suit for trademark infringement. Rather than fight, both sides agreed to cut a deal and they would cross-promote each other. The Veronicas

made their comic book debut in *Veronica* #167 (along with a card that could be used to download one of their songs) and have popped up in Archie Comics regularly since.

⑥ **Fanfiction.net.** Fanfiction.net is a popular website where fans upload stories they've written about their favorite characters from TV, comics, and movies. The case for copyright infringement is always hanging over sites like this, and recently Archie Comics sent a cease and desist letter to the webmasters telling them to remove stories using Archie Comics characters. Its main concern was that some of the stories featuring the characters were adult-oriented and reflected poorly on Archie Comics titles. The site has since complied with Archie's decree.

SEVEN PRO ATHLETE NICKNAMES THAT CAME FROM COMICS

You can never predict just how certain players will be nicknamed—sometimes they make sense, and other times, they are just plain weird. Heck, Travis Hafner of the Cleveland Indians is nicknamed "Pronk" because people could not determine which sounded better as a nickname—"the Product" or "the Donkey." Here are seven professional athletes who have gained nicknames from comics.

① **Joe Gordon.** The nine-time Major League Baseball All-Star, five-time World Series champion, one-time American League Most Valuable Player, and member of the Baseball Hall of Fame took the nickname "Flash" after the popular comic strip.

② **Tom Gordon.** The three-time All-Star pitcher (who was successful as both a starting pitcher and a relief pitcher) was similarly nicknamed "Flash" after the comic strip character.

③ **Xavier McDaniel.** This former NBA forward was a one-time All-Star during his career and was drafted in the first round by the Seattle Supersonics. His first name made a pretty easy transition for fans to reference the famous *X-Men* comic books by dubbing him "the X-Man."

④ **Doug Mientkiewicz.** The former MLB Gold Glove–winning first baseman is one of only five players to have won an Olympic Gold Medal and a World Series ring. As you might have noticed, his name sometimes gives people trouble, and one of the many nicknames he was given was "Mr. Mxyzptlk," after the Superman villain with a hard-to-pronounce last name.

⑤ **Joe Montana.** The popular Hall of Fame quarterback for the San Francisco 49ers gained the nickname "Joe Cool" (after Snoopy from the *Peanuts* comic strip) for his cool demeanor under pressure, an attribute that served him well as he led the 'Niners to four Super Bowl titles.

⑥ **Mike Piazza and Robin Ventura.** When the slugging catcher Mike Piazza played on the New York Mets with third baseman Robin Ventura, they normally batted fourth and fifth, respectively, leading to them being dubbed "Batman and Robin."

⑦ **Nate Robinson.** The diminutive (five-feet-nine) shooting guard is the only three-time NBA Slam Dunk Contest champion in NBA history. In 2009, Robinson competed against Orlando Magic center Dwight Howard, who had won the contest the year before.

Howard is a big *Superman* fan so he did a routine where he dunked wearing a Superman cape. Robinson then came out dressed all in green, including green sneakers, referring to himself as "Krypto-Nate." KryptoNate then dunked over Howard to win the contest. As it turns out, kryptonite really *is* deadly for Superman.

THREE CELEBRITIES WHO, BEYOND ALL REASON, STARRED IN THEIR OWN COMIC BOOKS
(AND ONE GROUP WHO DID THAT MADE PERFECT SENSE)

MARK WAID

① **Roy Rogers's Trigger** (Dell Comics, 1951–1955). Radio and television star Roy Rogers was the undisputed "King of the Cowboys" for most of the 1940s and '50s, so it made sense for this merchandising mogul to get his own comic. Not to be outdone, Roy's equally famous wife, Dale Evans, "Queen of the Westerns," headlined her own DC title from 1948 to 1952. But so hungry were kids for all things Rogers that Roy's horse, Trigger, managed to capitalize on his owner's celebrity in his own series—that's right, a comic starring only a horse, no humans allowed—*for even longer than Dale's.* Forget her manager, give me Trigger's.

② **Bob Hope** (DC Comics, 1950–1968). Comedian, actor, USO spokesman, recipient of the Presidential Medal of Freedom, uncle of a student at a high school run by Dracula. Wait, what? Certainly Bob Hope was famous enough in 1950 to earn his own DC Comics series; what's befuddling is why ten-year-olds in 1968, at the

height of the youth revolution in this nation and with a spinner rack full of Marvel "Pop Art Productions" and Batman books to choose from, were voluntarily spending their twelve cents on a comic about a cornball right-wing sexagenarian they knew about only through their parents. For sixteen years straight, *The Adventures of Bob Hope* recycled the same exact story every issue: Hope, ever the unbelievably clever young charmer, saves an impossibly hot woman from madcap nefarious circumstances, foils the villain, and gets the girl.

③ **New Kids on the Block** (Harvey Comics, 1990–1992). For about an hour and a half in the caliginous musical age known as "the late 1980s," the New Kids on the Block were the biggest thing in music, reinventing and forever redefining the look and sound of the "boy band." And even though, by that time, the American comic book had already begun its slow transformation from kids' medium to nostalgic entertainment for developmentally arrested twenty-somethings, it wasn't out of the question that some publisher would try to draft off the NKotB fame and star them in a comic series. Or two. Or, in the case of Harvey Comics, *six of them. At once. New Kids on the Block: Backstage Pass. New Kids on the Block: Chillin'. New Kids on the Block: Comic Tour '90. New Kids on the Block: NKotB. New Kids on the Block: Not Everyone's a Wahlberg*, which I admit I just now made up. Somewhere, the Incredible Hulk wept.

And the group that actually made sense . . .

KISS (Marvel Comics, 1977–1978). There aren't as many differences between the Justice League and KISS as you'd think. Both are groups of characters possessing flamboyant costumes and masks, code names and secret identities. Both have legions of fierce fans and devotees who have been following their exploits for decades. Neither of them has made it into the Rock and Roll Hall

of Fame. In 1977 Marvel Comics writer (and sometimes rock journalist) Steve Gerber convinced both his corporate masters and KISS front man Gene Simmons to let him pen a one-shot, magazine-size KISS adventure under the "Marvel Super Special" banner. It was an easy sell to Simmons, a longtime Marvel reader whose name peppered Marvel's early fan-letter columns; reportedly, the Marvel brass were harder to convince. Nonetheless, the comic was a smash sensation, breaking sales records and making headlines (in part because, as a publicity stunt, the band mixed their own blood in with the printer's ink). As newly minted denizens of the Marvel Universe, the four KISS rockers received superpowers, fought Doctor Doom, and proved so popular that they were called back on stage by Marvel a year later for an encore performance.

Mark Waid has written a wide variety of well-known characters, from Superman to the Justice League to Spider-Man to Archie and hundreds of others. His award-winning graphic novel with artist Alex Ross, Kingdom Come, *is one of the best-selling comics collections of all time.*

SEVEN BANDS THAT GOT THEIR NAMES FROM COMIC BOOKS

If there were to be a Venn diagram displaying comic book fans and rock and roll fans, I have a feeling that there'd be a pretty big overlap. Here are seven rock bands that were clearly started by comic book geeks like you and me.

① **Thin Lizzy.** Eric Bell, the original guitarist for the band, was a huge fan of Eric Clapton and his band, John Mayall and the Bluesbreakers. When he saw Clapton reading a copy of the British comic book *The Beano* on the cover of their 1966 album, he bought a copy of

The Dandy, the sister magazine of *The Beano*. Bell then suggested to his own bandmates they name themselves Tin Lizzie after a robot character in the comic, but that they should change the spelling and add an "h" because, being Irish, they would typically pronounce the "th" sound "t" anyways, and the resulting confusion would be hilarious (indeed, early on, they tended to be referred to in print as "Tin Lizzy" or "Tin Lizzie").

② **Devo.** Devo is best known for their 1982 hit single, "Whip It," but the origins of the group go back more than a decade earlier to when Kent State art students Bob Lewis and Gerard Casale began joking about the concept of "de-evolution," the notion that human beings were becoming dumber and less thoughtful as time went on. There are a few examples of de-evolution found in pop culture (including an H. G. Wells novel), but oddly enough, they were inspired by an old issue of *Wonder Woman* by William Moulton Marston and H. G. Peter. In 1944's *Wonder Woman* #9, a scientist developed an evolution machine that is damaged, becoming a *de*-evolution machine. This same device appears in *Wonder Woman* #28 and subsequently reprinted in a 1971 *Adventure Comics*, which the guys from Devo picked up. In a 1978 interview Gerard Casale confirmed, "Devolution was a combination of a *Wonder Woman* comic book and the movie *Island of Lost Souls*."

③ **Suicide.** This protopunk band consisted of Alan Vega on vocals and Martin Rev on synthesizers and drum machines. Their comic connection is an interesting one, as I'm pretty confident that they named themselves in error. Vega was a big comic book fan and liked the *Ghost Rider* comic book that Marvel had released in 1972 (first as the featured character in *Marvel Spotlight* and then in his own title). He has repeatedly said in interviews that he named the group after the title of a story in *Ghost Rider* called "Satan's Suicide." When he suggested that to Rev, Rev countered with just

plain "Suicide." Vega has been very consistent with this version of the story. However, the problem is that there *is* no *Ghost Rider* story with that name and the phrase does not appear on any cover of *Ghost Rider* or *Marvel Spotlight*.

④ **The Mekons.** Formed in 1977, this British punk band was on the first wave of punk bands in the country. They named themselves after Mekon, the evil, super intelligent villain from the planet Venus that would fight space pilot Dan Dare in the *Dan Dare* comic feature in the British comic magazine *Eagle*.

⑤ **Thompson Twins.** This British synth pop trio had its biggest hit in the United States with "Hold Me Now" in 1983. The group was named after the bumbling twin detectives (with the different last names) Thomson and Thompson from Hergé's famous comic book, *The Adventures of Tintin*.

⑥ **The Teardrop Explodes.** The postpunk band the Teardrop Explodes debuted in 1978. While it was only around for a few years, its frontman, Julian Cope, has had a successful solo career in England since the early 1980s. This band is right up there with Devo for most obscure reference. The band took its name from an issue of *Daredevil* (#77, to be precise) written by Gerry Conway. In the comic, a giant fiery object that looks like a teardrop appeared over Central Park in New York City. The teardrop then speaks, asking for Namor, the Sub-Mariner. Naturally, with this object appearing in New York City, both Daredevil and Spider-Man show up. When Namor shows up as well, Spider-Man and Daredevil tussle with Namor for a while (that just seems to be what comic book characters do when they meet up with one another) before, well, the fiery teardrop explodes! Cope was inspired by the odd caption "The teardrop explodes!" and made it the name of his band.

⑦ **Love and Rockets.** Daniel Ash and Kevin Haskins were already quite famous from their old band, Bauhaus, before they formed the alternative rock band Love and Rockets. They reached greater levels of fame with their new band, including a top five hit with "So Alive" in 1989. The band was so famous that people are often confused as to the timeline of the band with regard to the comic book series *Love and Rockets*, which gave them their name. The acclaimed comic book series launched in 1982 and the band formed in 1985, a small enough distance that you can understand why people often believe that the comic took its name from the band.

ELEVEN CELEBRITIES WHO HAVE GUEST-STARRED IN COMIC BOOKS

Celebrities have been using comic books as cross-promotion for decades now. Here are some notable examples of celebrities willingly guest-starring in comic books.

① **Orson Welles** (*Superman* #62, 1950). As a bit of publicity for his new movie *Black Magic*, Orson Welles teamed up with Superman to fight martians. Welles's famous 1938 radio performance of *War of the Worlds* is referenced repeatedly.

② **Perry Como** (*Superman* #67, 1950). Lois Lane becomes a famous singer and spurns Superman for Perry Como. The problem is, Superman knows that her impressive singing is due to a cold she has, and when it finishes, so will her singing career. How to break the news to her?

③ **Pat Boone** (*Superman's Girlfriend, Lois Lane* #9, 1959). Superman surreptitiously gives Pat Boone a song to sing about Superman, but then realizes that he accidentally gave a clue inside the song's lyrics to his true identity (the first letter of each sentence spells out *Clark Kent*). He must keep this song from being performed! Lois Lane, who is singing with Boone, thinks Superman is just jealous of the hunky singer.

④ **Woody Allen** (*Showcase* #71, 1967). DC's response to the Monkees was the Maniaks, a wacky rock group introduced in the pages of *Showcase* (DC's try-out magazine, where such notable characters as Flash and Green Lantern got their starts). In their fourth appearance, comedian Woody Allen guest-stars with the band.

⑤ **Tom Wolfe** (*Incredible Hulk* #142, 1971). "Those Radical Chic Evenings" was an article that journalist Tom Wolfe wrote for *The New Yorker* and it was reprinted in his 1970 book, *Radical Chic and Mau-Mauing the Flak Catchers*. It tells the story of a party Leonard Bernstein threw at his New York apartment for his rich liberal friends who wished to support the Black Panther Party. In the article, Wolfe satirizes these rich white people as the "radical chic," people who are supporting causes like the Black Panther Party more for social status than for actual interest in the cause. Roy Thomas got permission from Wolfe to satirize the story in *The Incredible Hulk* #142, where a rich couple is desperate for a cause to throw a party. Their daughter wants them to support women's liberation, but they end up instead having a party for . . . the Hulk! Tom Wolfe makes an appearance in his trademark white suit.

⑥ **Don Rickles** (*Superman's Pal, Jimmy Olsen* #139 and 141, 1971). Jack Kirby hadn't been working on *Jimmy Olsen* very long when his assistants, Mark Evanier and Steve Sherman, told him it would be funny to have famed insult comedian Don Rickles appear in the

comic to insult Superman. Kirby liked the idea and they got permission from Rickles for the cameo. When DC higher-ups found out that they had permission from Rickles to use him, they insisted that it needed to be a big deal, not just a one-time thing. It morphed into a two-part story involving Rickles and his superhero alter ego, Goody Rickles. Rickles himself was not a fan of what his cameo turned into, but it was certainly memorable.

⑦ **Original cast of *Saturday Night Live*** (*Marvel Team-Up* #74, 1978). In this story, John Belushi is accidentally sent an ancient ring belonging to the villainous Silver Samurai, who shows up backstage to claim his property. Stan Lee is hosting *SNL* that night and Peter Parker was lucky enough to get tickets for himself and his date. When Peter's spider-sense clues him in to what is going on, he sneaks backstage and, along with the cast, manages to overpower the Samurai and his team of goons. But the show must go on! So they continue doing sketches while *also* fighting the bad guys. Talk about multitasking. A tricky piece of writing by Chris Claremont!

⑧ **Muhammad Ali** (*Superman vs. Muhammad Ali*, 1978). In this classic team-up, an alien race demands that Earth's greatest champion face their planet's greatest champion or else they will invade with an alien armada. Superman is chosen, but Muhammad Ali convincingly argues that he should get the opportunity to fight. The two decide to let a boxing match determine who will go, with Superman stripped of his powers for the bout. Naturally, Ali defeats the powerless Superman. Ali then conquers the alien champion, but the alien leader decides to invade anyway. Superman (whose powers have returned) fights the armada while the alien champion deposes their ruler. The cover has a *ton* of other celebrities on it, too, including President Jimmy Carter.

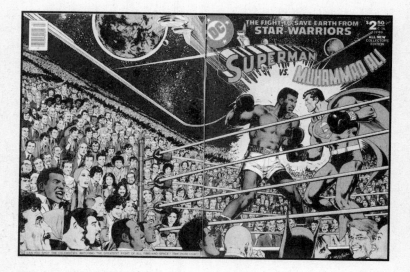

⑨ David Letterman (*Avengers* #238, 1983). In 1983 Marvel had an idea called "Assistant Editor's Month." The concept was that while all of the editors were in San Diego for Comic-Con, their assistants would take control of the books, and of course, wacky hijinks happened in most of the titles. In *The Avengers*, former Avenger Wonder Man is trying to make it as an actor and gets the chance to appear on *Late Night with David Letterman*. The catch is that he has to appear *with* the Avengers. While they are on the show, a hapless would-be villain attacks the heroes. Letterman ends up saving the day by knocking the villain senseless with a giant doorknob.

⑩ John Walsh (*Outsiders* #17, 2004). The Outsiders were a short-lived team of "out-of-the-box" superheroes who would go places where no other heroes would dare go (like into countries that had committed atrocities not yet recognized by the United Nations). When they come across a child-trafficking ring, they decide to call John Walsh, host of TV's *America's Most Wanted*. Walsh lost his son to a kidnapper-murderer and has been working to help protect chil-

dren ever since, so he gladly went along with the guest appearance to bring awareness to the too-real horror of child trafficking.

(11) **Stephen Colbert** (*Amazing Spider-Man* #573, 2008). Stephen Colbert is a very vocal comic book fan, even having Marvel chief creative officer Joe Quesada on his TV program. As a joke, Colbert was shown as a presidential candidate in 2008 in the Marvel Universe. After that joke, they worked out a deal where Colbert would actually guest-star in an issue of *Spider-Man* about his run for the presidency.

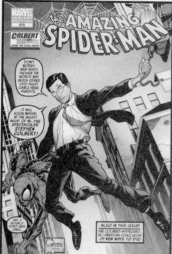

FOUR OBSCURE REFERENCES IN *WATCHMEN*

What is so amazing about Alan Moore and Dave Gibbons's *Watchmen* is that for all the power and poignancy of the main story, a proverbial treasure trove of ideas lies just below the surface —little references here and there that open up the meaning of the text even more. Here are four interesting references within the pages of *Watchmen*.

(1) **Pale Horse.** Throughout the series, there are many mentions of a rock band, Pale Horse, and a concert they are playing in New York City on November 2, 1985. That, of course, is the same date that Adrian Veidt's "alien invasion" destroys much of New York City, including everyone at the concert. The name "Pale Horse" comes from the Bible, specifically Revelation 6:8, "And I looked, and

behold a pale horse: and his name that sat on him was Death, and Hell followed with him. And power was given unto them over the fourth part of the earth, to kill with sword, and with hunger, and with death, and with the beasts of the earth." So it's true, "Hell" did indeed follow Pale Horse.

② **Nova Express.** *Nova Express* is a magazine that is critical of costumed adventurers that shows up throughout the series as the counterpart to the archconservative *New Frontiersman* magazine. It is named after a 1964 novel by William S. Burroughs of the same name. In chapter 11, Veidt makes reference to the "multi-screen" approach of watching a series of different monitors at once to get the full sense of events. He then explains that it was based on William S. Burroughs's "cut-up" method, where he would take a text and "cut it up" to reassemble it into nonlinear patterns, so you could read the text in any order you like, but only by reading it all would you get the full picture. This is how Burroughs wrote his famed novel *Naked Lunch*, and it is also how he wrote *Nova Express*. Alan Moore cited Burroughs as one of his inspirations in writing *Watchmen*.

③ **Watchmaker.** Chapter 4 of *Watchmen* is titled "Watchmaker" and it contains a quote from Albert Einstein where he says, "The release of atom power has changed everything except our way of thinking. The solution to this problem lies in the heart of mankind. If only I had known, I would have become a watchmaker." However, the title of the chapter does not just mean that, it also refers to the "Watchmaker analogy," a famous theological argument that posits the following: If you discover a watch, then you know it must have had a watchmaker, right? Someone had to make something so intricate. So if you see a human being, then there must have been a human being maker. This is important in *Watchmen* because

it ties in with Doctor Manhattan's sense of separation from humanity as he begins to feel like a god among men.

④ **Ozymandias.** In chapter 11 of *Watchmen*, the chapter quote is from Percy Bysshe Shelley's poem "Ozymandias." It reads, "My name is Ozymandias, King of Kings: / Look on my works, ye mighty, and despair!" What it cuts off is very important. The next line is "Nothing beside remains." This obviously ties into the notion that Veidt's plan succeeds in this issue, and most of New York is brutally wiped out.

FIVE EASTER EGGS WITHIN SUPERHERO VIDEO GAMES

The idea of "Easter eggs," hidden jokes or references that you have to find within material, really took off in the world of video games, as bored programmers would put little hidden pieces of code into games that they worked on. Early on, it was just hiding their names inside the game, but now they have gotten much more elaborate in the Easter eggs that they leave behind. Here are five Easter eggs hidden in superhero-based video games.

① **Arkham City hint!** In Batman: Arkham Asylum, if you go into the Warden's office in Arkham Mansion, you can eventually get into a room with a fireplace. Look at the left wall and then bombard it a few times with explosive gel. After it explodes, it will reveal a blueprint showing an expansion of Arkham Asylum into a city, with the blueprint stamped "Approved." The sequel to Arkham Asylum was Arkham City, which came out in fall 2011, and this was an early hint regarding the sequel.

② **A visit from Jason.** You have to do this in Batman: Arkham Asylum before you face off against the final "boss" but after the Joker appears to you in a TV message. Go to the room where the Joker message came from and look to your left. You should see a sofa and some papers on a wall. If you zoom in, you should see a drawing of Jason from *Friday the 13th* fame, complete with a chainsaw.

③ **Tony Hawk shout-out.** In PlayStation 2's Spider-Man game, there is a billboard featuring an advertisement for Tony Hawk's Pro Skater 2. Both games were designed by Neversoft. (Spider-Man was even an unlockable character in Pro Skater 2.) If you get Spider-Man to swing close enough to the billboard, he'll remark about how he's skated with Tony Hawk before.

④ **Scarecrow shout-out.** In Batman: Arkham Asylum, if you collect at least one interview tape, you can go to the character bios to listen to it. In the one where doctors are worried about Scarecrow and his fear gas, the two doctors talking about him are Drs. Murphy and Combs. Cillian Murphy played Scarecrow in *Batman Begins* and Jeffrey Combs played the Scarecrow in *Batman: The Animated Series*.

⑤ **WoW!** In X-Men Origins: Wolverine, after you receive your adamantium skeleton and leave the Weapon X facility for the first time, go run into the woods but keep an eye out on the right. You will eventually see a crack in the ice that is big enough for you to enter. Once inside, you'll see the skeleton of Arthus from World of Warcraft lying inside next to the Frostmourne sword from World of Warcraft 3. If you're playing the game on X-Box 360, it will unlock an achievement titled "WoW."

FIVE BEST *SUPERMAN* REFERENCES ON *SEINFELD*

Jerry Seinfeld is a renowned fan of *Superman* and often made references in episodes of his eponymous show. In fact, for much of the series, there is either a Superman figurine visible on Jerry's stereo in his apartment or a Superman magnet on Jerry's refrigerator. However, there were many more notable *Superman* references on the show. Here are five of the best ones.

① **"The Bizarro Jerry."** This is probably the most elaborate Superman reference, episode-wise. Elaine is dating a guy named Kevin who has two friends who are very similar in appearance to George and Kramer but the opposite in personality. Kevin and his friends are actually *nice* to one another. Kevin's Kramer even brings Kevin groceries (while Kramer always takes food from Jerry's refrigerator). Jerry remarks that Kevin is the Bizarro Jerry, just like Superman's complete opposite was named Bizarro. Later in the episode, we even see that Kevin has a Bizarro figurine on his stereo!

② **"The Race."** In this episode, Jerry is dating a woman named Lois, and he continually gets a kick out of referring to her like Superman refers to Lois in the *Superman* films. Lois's boss went to high school with Jerry and thinks Jerry cheated him in a race back in the day, so he insists that they race again or he will fire Lois (and if Jerry wins, Lois will get a free vacation to Hawaii). Jerry decides he must "save" Lois by racing the guy. Jerry inadvertently cheats once again and wins (while the theme from *Superman* plays in the background). Lois asks him, "So will you come to Hawaii with me, Jerry?" Jerry responds, "Maybe I will, Lois. Maybe I will," and then winks to the camera, just like Superman.

③ **"The Secret Code."** A subtle but excellent reference. In this episode, viewers learn that Jerry's PIN for the ATM is Jor-El, the name of Superman's father.

④ **"The Invitations."** In a demonstration of why Jerry and his new girlfriend, Jeanine, are perfect for each other, they are shown reading *Superboy* and *Supergirl* comics side by side.

⑤ **"The Lip Reader."** Jerry is dating a deaf woman who can read lips. He and George decide to use it to their benefit. George compares this to having Superman for a friend, and Jerry agrees, saying it's like having X-ray vision.

FOUR STRANGEST SUPERHERO PRODUCTS FOR KIDS

Superheroes go with children's products like peanut butter and jelly—a perfect fit. However, when you combine comic book companies' willingness to get whatever licensing money they can with the broad imagination of companies that want to sell whatever they can to kids, you end up with some unusual superhero products. Here are four of them.

① **Justice Jogger.** When Kenner put out a line of DC Comics action figures, it also made vehicles to go with them. Naturally the makers wanted one for Superman as well. But the problem is, Superman is, well, Superman. He doesn't need a car or a plane to do anything, and he *especially* didn't need the Justice Jogger, a vehicle that was a chair whose legs gave it "power stepping action!" They do realize that one of Superman's whole catchphrases is that he already can leap over tall buildings in a single bound and is

faster than a speeding bullet, right? So why does he need a machine to walk for him?

② Batman squirt gun. Batman was everywhere during the 1960s when "Bat-Mania" reigned supreme. One of the many, many toys he had was a squirt gun that, well, was unusual to say the least. The trigger was in Batman's crotch. You had to squeeze his crotch to squirt liquid from his mouth . . . yeahhh. Not going to touch that one.

③ Beach Spider-Man. Until Disney purchased it recently, Marvel was owned by the toy company Toy Biz, so naturally Toy Biz released tons of Marvel merchandise. I don't think anyone quite expected just how much, though. Beach Spider-Man is one of a line of toys that also consisted of Basketball Spider-Man, Baseball Spider-Man, Soccer Spider-Man, Safari Spider-Man, and Fireman Spider-Man. Crazy.

④ *Super-Dictionary.* In the 1970s DC produced a special dictionary called the *Super-Dictionary*, where their various characters would explain various words to kids. For instance, for the word "world," they depict Supergirl looking at Earth from outer space and thinking, "I love this world. I love the Earth. Does the world know that? Do all the people on Earth know that?" Many of the entries are just as weird as that. The most famous, though, is definitely the definition for the word "forty." It shows Superman's archrival Lex Luthor dragging a large baker's rack with forty cakes on it and the

text reads, "When no one was looking, Lex Luthor took forty cakes. He took 40 cakes. That's as many as four tens. And that is terrible."

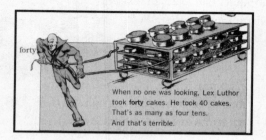

forty

When no one was looking, Lex Luthor took **forty** cakes. He took 40 cakes. That's as many as four tens. And that's terrible.

The sheer absurdity of this drawing has made it a popular joke all over the Internet.

EIGHT CELEBRITIES WHO GUEST-STARRED IN COMICS ... WITHOUT THEIR PERMISSION

While plenty of celebrities are willing to give their approval to guest-star in comic books as a sort of cross-promotion, a number of celebrities have made appearances in comic books without giving permission to use their likeness. Here are nine celebrities who have showed up in comic books without their approval (and sometimes without their knowledge). . . .

① **President Barack Obama.** In November 2008, Jon Swaine of the *Telegraph* wrote an article entitled "Barack Obama: The 50 Facts You Might Not Know." The first item on the list was "He collects Spider-Man and Conan the Barbarian comic books." Whether that

was meant to be in the present tense or not, it inspired Marvel Comics to quickly put out a variant edition of January 2009's *Amazing Spider-Man* #583, complete with a short story about Spider-Man attending Barack Obama's inauguration and preventing the villainous master of disguise Chameleon from taking Obama's spot as president. Obama made a number of appearances early in his presidential tenure. They all tended to be fairly positive portrayals, even while fighting zombies in the aptly titled *President Evil*.

② **President George W. Bush.** Generally speaking, Obama's predecessor, George W. Bush, made out well in his various comic book appearances, which were usually the standard "briefing the president about the danger we're in" type. One early one, though, is something that I imagine Bush would not be thrilled with. In 2001, in the early issues of *Ultimate X-Men*, the X-Men initially gain the support of the new president when they rescue his daughter from Magneto and Magneto's band of mutant terrorists. However, after continued terrorist attacks by Magneto, Bush splits from the X-Men and orders an all-out assault on Magneto's Savage Land home. Magneto, naturally, turns the attack around and decides to annihilate the United States. First off, he captures Bush, strips him naked, and forces him to lick his boots clean on national television (luckily, this is all off panel). He then tries to drop a car on the naked president, but Professor X and the X-Men show up in time to stop him.

③ **President Ronald Reagan.** President Reagan appeared in a number of DC comics during the 1980s without incident. However, he was not so lucky with a *Captain America* storyline in 1988. The basic idea of the story, which came to a head in *Captain America* #344, is that the villainous Viper has drugged the drinking water

of Washington, DC, and turned everyone into snakelike beings. Captain America goes to the White House, where he finds President Reagan has also been drugged! In the end, Reagan recovers from the toxin. Or does he?

④ **Henry Kissinger.** Kissinger, who was secretary of state under Nixon and continued for the rest of Gerald Ford's time as president, made a strange appearance in 1976's *Super-Villain Team-Up* #6 when the Fantastic Four show up in Doctor Doom's kingdom of Latveria only to discover that Kissinger has signed a nonaggression treaty with Doom.

⑤ **President Bill Clinton.** Clinton appeared in many comic books during the 1990s, including eulogizing Superman after his death in 1992. However, the one he probably would least enjoy was 2001's *Uncanny X-Men* #401. In #399, the mutant prostitute Stacy-X made her debut. After antimutant terrorists destroy the brothel where she works, Stacy-X ends up joining the X-Men. She cannot quit her ways right away, though, and spends the night with the former president.

⑥ **Ayatollah Khomeini.** In 1988, a controversial storyline appeared in the pages of *Batman* #427, in which the Joker beats Robin nearly to death. At the end of the issue, the Joker leaves the nearly lifeless Robin in a locked warehouse with explosives. Robin tries to free himself, but the issue ends with the warehouse exploding. Readers were then given a choice—dial one number if they wanted to see Robin survive and dial another if they wanted Robin to die. The readers voted for death. Batman, naturally, wants revenge on the Joker for his crimes, but the Joker discovers an unusual ally— the Ayatollah Khomeini!

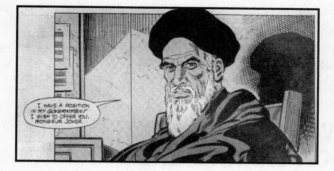

The Joker is given an ambassadorship and thus Batman can't lay a finger on him! Naturally, the Joker is too unstable for that line of work and he eventually betrays the Iranian leader.

⑦ **The Beatles.** The Fab Four made an amusing guest appearance in 1964's *Strange Tales* #130, when the Thing and the Human Torch keep getting derailed when they are trying to watch the Beatles in concert with their girlfriends. The cover of the issue is particularly interesting, as it has the Thing and the Human Torch in Beatle wigs.

⑧ **Ira Glass.** The great cartoonist Lynda Barry had a regular comic strip on Salon.com that she later put together to form her excellent 2002 release, *One! Hundred! Demons!* The concept of the series was to do a twist on the Japanese Zen painting exercise called "One Hundred Demons," where you paint your "demons" in an effort to get them out of your system. In this case, Barry turns her demons into funny, engaging, and heartfelt comic stories. Probably the most popular story from the book is "Head Lice and My Worst Boyfriend," which explores the troubles she had with who she described as her "worst boyfriend," a guy who made her feel worthless. That boyfriend? None other than the host of *This Amer-*

ican Life, Ira Glass. Barry and Glass dated in the late 1980s and early 1990s. Admirably, Glass confirms pretty much every story Barry has to tell about him. "I was an idiot. I was in the wrong. About the breakup . . . [a]bout so many things with her. Anything bad she says about me I can confirm."

SEVEN SONGS ABOUT COMIC BOOK CHARACTERS

So many songs have been written about comic book characters that I could probably fill an entire book with just those. Since that would not be a very fun read, how about just seven?

① **"(Wish I Could Fly Like) Superman" by the Kinks.** Ray Davies has always referenced pop culture in his music (heck, he wrote an entire song about pop culture—"Village Green Preservation Society"!) and he is in fine form with this tune about a regular grade-A loser who dreams of how being Superman would make his life so much better.

② **"Matter-Eater Lad" by Guided by Voices.** This tune is about the Legion of Super-Heroes member whose power was, well, to eat anything. He could eat through iron, steel, anything. The song opens by noting that the Heroes member constructed a factory "just to see how it tasted."

③ **"I'm No Superman" by Lazlo Bane.** Bane's song is similar to Davies's tune, about a typical schlep who would have liked it if he was Superman, only in Bane's song the narrator is ultimately fine with his lot in life. This song gained popularity by serving as the theme for the TV show *Scrubs*.

④ **"Superman (It's Not Easy)" by Five for Fighting.** As a counter to Davies and Bane, John Ondrasik writes a song from Superman's perspective to note that it isn't as easy to be Superman as people might think, especially since everyone is constantly relying on him. Fine, Superman, we acknowledge the pressure must be considerable.

⑤ **"Sgt. Rock (Is Going to Help Me)" by XTC.** In this poppy tune the narrator wishes he had Sgt. Rock on his side, so he could win the battles of the sexes.

⑥ **"Dan Dare: Pilot of the Future" by Elton John.** Bernie Taupin and Elton John wrote this ode to the classic British hero for John's 1976 album, *Rock of the Westies*.

⑦ **"Jimmy Olsen's Blues" by the Spin Doctors.** The song has Superman's pal, Jimmy Olsen, bemoaning the fact that he has no shot at Lois Lane and wondering if he maybe should do something with his "pocketful of kryptonite" (which is the name of the album, too).

PART VI

COMIC BOOK MOVIES

AND TV SHOWS

FIFTEEN ACTORS WHO WERE OFFERED THE ROLE OF SUPERMAN (AND ONE SURPRISING "ACTOR" WHO AUDITIONED FOR THE PART)

After purchasing the rights to make a *Superman* film in late 1974, father and son producer team Alexander and Ilya Salkind and their partner, Pierre Spengler, spent more than two years looking for an actor to play the title role. Ultimately they went with Christopher Reeve; however, they debated a long list of famous and not-yet-famous actors before landing on him. The following is a list of fifteen actors who were offered the role by the producers, along with what each actor was best known for at the time.

① **Charles Bronson** (*Death Wish*; *Dirty Dozen*; *The Magnificent Seven*; *The Great Escape*)

② **James Caan** (*The Godfather*)

③ **Ryan O'Neal** (*Love Story*; *Paper Moon*)

④ **Sam Elliott** (*Mission: Impossible*)

⑤ **Perry King** (*The Lords of Flatbush*)

⑥ **Jeff Bridges** (*The Last Picture Show*; *Thunderbolt and Lightfoot*; *King Kong*)

⑦ **Jan-Michael Vincent** (*The Undefeated*; *Buster and Billie*)

⑧ **David Soul** (*Starsky and Hutch*)

⑨ **Robert Wagner** (*The Towering Inferno*; *The Pink Panther*; *It Takes a Thief*)

⑩ **Lyle Waggoner** (*The Carol Burnett Show*; *Wonder Woman*)

⑪ **Kris Kristofferson** (*A Star Is Born*; *Alice Doesn't Live Here Anymore*)

⑫ **Nick Nolte** (*Rich Man, Poor Man*)

⑬ **David Wayne** (*The Green Berets*; *The Rounders*) (backed out when his father, John Wayne, was diagnosed with cancer)

⑭ **Robert Redford** (*Butch Cassidy and the Sundance Kid*; *The Sting*) (Redford politely declined in a letter, stating, "Look, I don't think people are going to believe me flying. It's not going to work.")

⑮ **Jon Voight** (*Midnight Cowboy*; *Deliverance*; *Coming Home*) (Voight signed on to be the backup if no one else was cast in time)

And the surprising "actor"?:

Bruce Jenner. After winning the gold medal in the decathlon at the 1976 Summer Olympics, few people in the world were more famous than Bruce Jenner (a.k.a. the dad in the reality show *Keeping Up with the Kardashians*). His fame was great enough that the desperate *Superman* producers actually gave the athlete a screen test in September 1976. Suffice it to say, Bruce's athletic skills were far greater than his acting ones.

FIVE MOVIES YOU MIGHT BE SURPRISED TO LEARN WERE ADAPTED FROM A COMIC BOOK

Comic books make great fodder for film and television adaptations. Audiences generally regard many of these as strictly superhero movies. *Batman*, *Spider-Man*, *Superman*—that sort of thing. On

the other hand, some films wear their comic book heritage on their sleeve, like *Jonah Hex*, *300*, *Ghost World*, and *Sin City* (heck, *300* and *Sin City* were almost literally lifted from Frank Miller's art right into the movie theater). Here are a few ones that defy either category.

① **Men in Black** (1997, 2002, 2012). The fact that this film was based on a comic book is such a secret that when I was looking at a list of the highest-grossing comic book movies, this was not even on it! *The Men in Black* debuted at Aircel Comics, which was then purchased by Malibu Comics, which was *then* purchased by Marvel Comics. By the time the film (which, like the comic, is about the mysterious men in black who investigate alien activity on Earth) was released, the last *Men in Black* series was five years old from a defunct publisher. It is understandable how it could have flown under the radar.

② **From Hell** (2001). It is almost a bit curious why the Hughes brothers (best known for their film *Menace II Society*) even chose to adapt Alan Moore and Eddie Campbell's extensive and intricate examination into the Jack the Ripper murders. I say this because they took nearly the entirely opposite approach of Moore and Campbell's, so you wonder why they just didn't do their *own* Jack the Ripper story. Unlike his later works, Moore actually allowed his name to be used in association with this film (it was his first comic to be adapted into a film), but the slick, action-oriented drama bears little resemblance to Moore's comic.

③ **Road to Perdition** (2002). Paradox Press was formed in 1993 as a place at DC Comics where creators could produce original graphic novels that were neither superhero based (like most of DC's comic line) nor fantasy based (like most of DC's Vertigo comic line). The end result was a line of graphic novels that many missed the first time around. However, some very compelling work came out of

this line (which shut down in 2001), including this wonderful drama by Max Allan Collins and artist Richard Piers Rayner, about a hit man who loses all of his family except his young son. The man and son then travel across the country to get revenge on the mob leader who ordered the hit. Paul Newman costarred in the film as the gang leader whose son ordered the hit against his wishes and received an Academy Award nomination for Best Supporting Actor.

④ *A History of Violence* (2005). Another veteran of Paradox Press, writer John Wagner (cocreator of *Judge Dredd*) and artist Vince Locke released *A History of Violence* in 1997. This taut graphic novel is about a man who is living peacefully with his family when he stops an attempted robbery with some shocking fighting skills. His instant celebrity draws in outsiders who believe that he is a fugitive from the mob. David Cronenberg adapted the book into a film starring Viggo Mortensen as the protagonist. William Hurt received an Academy Award nomination for Best Supporting Actor for playing his brother.

⑤ *30 Days of Night* (2007). *30 Days of Night* was originally a film pitch by writer Steve Niles, and it certainly sounds like it—vampires attacking a small Alaskan town during the time of the year when the town is without daylight for a month. That's certainly a great high concept. However, after it was not picked up, Niles adapted it into a 2002 comic book miniseries for IDW Publishing, along with artist Ben Templesmith. The comic was a hit and, naturally enough, it was eventually turned into a film.

TEN HIGHEST-GROSSING COMIC BOOK MOVIES OF ALL TIME

Movies based on comic books are big business, as you can see from this list of the ten highest-grossing films in the United States based on comic books (as of August 2011).

① *The Dark Knight* (2008) $533,345,358
② *Spider-Man* (2002) $403,706,375
③ *Spider-Man 2* (2004) $373,585,825
④ *Spider-Man 3* (2007) $336,530,303
⑤ *Iron Man* (2008) $318,412,101
⑥ *Iron Man 2* (2010) $312,433,331
⑦ *Batman* (1989) $251,188,924
⑧ *Men in Black* (1997) $250,690,539
⑨ *X-Men: The Last Stand* (2006) $234,362,462
⑩ *X2: X-Men United* (2003) $214,949,694

TEN HIGHEST-GROSSING COMIC BOOK MOVIES
(ADJUSTED FOR INFLATION)

One of the problems with comparing films from different times is the idea of inflation. Movie tickets cost more today than they did five years ago, let alone twenty years ago. So, adjusted for inflation, here are the ten highest-grossing films in the United States based on comic books (as of August 2011).

① *The Dark Knight* (2008) $592,028,200
② *Spider-Man* (2002) $553,793,400
③ *Batman* (1989) $501,748,300
④ *Spider-Man 2* (2004) $479,465,200
⑤ *Superman* (1978) $457,144,300
⑥ *Men in Black* (1997) $435,294,900
⑦ *Spider-Man 3* (2007) $389,846,900
⑧ *Iron Man* (2008) $322,212,669
⑨ *Iron Man 2* (2010) $312,433,331
⑩ *X-Men: The Last Stand* (2006) $253,064,698

Amazingly enough, even adjusted for inflation, *The Dark Knight* and *Spider-Man* are still the two highest-grossing comic book movies of all time!

FIVE MOST AWKWARD SEX SCENES IN COMIC BOOK MOVIES

Sex scenes and superhero movies do not necessarily mix too well, and yet they keep on coming (pun very much intended). Here are five of the strangest sex scenes in comic book movie history.

① Howard the Duck and Beverly. I don't believe anything can quite match the sheer horror of Lea Thompson beginning to do certain things to a giant anthropomorphic duck in bed in 1986's *Howard the Duck.*

② **Return of the Swamp Thing.** If there is going to be a challenger to a giant duck and a woman in bed together, it would have to be a giant plant creature and a woman. In Alan Moore's *Swamp Thing*, Swamp Thing and Abby Arcane have sex in an incredibly interesting and passionate way. In one of the more brilliant issues of the series, Swamp Thing produces a tuber that Abby eats and she experiences a psychedelic journey that blows her mind. As handled by Alan Moore, Stephen Bissette. and John Totleben, it truly is magical. When they tried to adapt that idea into the film *Return of the Swamp Thing*, it did *not* translate so well. Here, Swamp Thing tells Abby (played by Heather Locklear) that he can't give her the kind of love she wants. When she asks why not, he tells her, "Because I'm a plant." She quickly retorts, "That's okay, I'm a vegetarian." They then proceed to sort of make out while she takes bites out of him, causing her to dream about having sex with a human man. Not *quite* as original or romantic.

③ **Batman.** In the 1989 film, Bruce Wayne has dinner with Vicki Vale at his mansion. She gets drunk while he is stone sober. He has sex with her anyway and then proceeds to blow her off in the morning (nice, Batman, real nice). When he goes to visit her apartment later to "apologize," things get weirder. She berates him for treating her so badly and he responds the best way he knows how: he throws her down on her bed (literally in the middle of her telling him he is acting like a jerk) and says, "Look, you're a really nice girl and I like you a lot but for right now, shut up." Shady ethics, here, Batman.

④ **Watchmen.** This is a bit of a tough one, because while it certainly is a strange sex scene, it is translated well from the comic and the intent is that it is *supposed* to be strange. During the film, the ultrapowerful Doctor Manhattan is slowly losing touch with his

humanity, so much so that he sends two clones of himself to have sex with his wife while he is in another room doing work. It's undeniable that the sight of multiple blue naked guys having sex with a woman is bizarre, though it is true to the novel.

⑤ **Watchmen again.** Score two for *Watchmen* and awkward sex scenes. Later on in the film, Laurie tries to have sex with her friend Daniel (who is the former superhero known as Nite Owl), but Daniel cannot perform. The two then go out and save some lives in their superhero identities and once they've finished, they are together in Daniel's owl-shaped aircraft and, suddenly, he's ready to go. The two have sex and, in an incredibly cheesy gag, the flamethrower on the ship is accidentally activated in sync with the climax.

NINE EASTER EGGS IN DC SUPERHERO FILMS

There has always been the desire to sneak hidden references into your movie as a sort of in-joke between you and certain members of your audience. With the proliferation of DVDs, these references have become even more prolific, as directors know that what might be missed the first time around will certainly be seen when the film is watched later. Here are nine hidden "Easter eggs" in DC superhero films.

① **Sneaky Bob Kane reference.** In *Batman*, reporter Alexander Knox is being heckled by his colleagues over his reports of the mysterious Batman. Someone hands him a sketch done of a "Bat-man," a fellow in a suit with a giant bat head. This sketch is distinctively signed by Bob Kane, original artist and cocreator of Batman.

② **A world without Batman?** In the long opening sequence of *Watchmen*, the original Nite Owl punches out a thug in an alley where "Gotham" can be seen in the background; also clearly seen are the thug's would-be victims, a well-to-do couple who are clearly intended to be Thomas and Martha Wayne. Their murder has been averted!

③ **A reference to the original Superman in *Superman Returns*? No way!** In *Superman Returns*, Bryan Singer's ode to Richard Donner's original *Superman*, Lex Luthor steals some kryptonite. The label on the kryptonite reads "1978," which is when the first *Superman* film was released.

④ **That sounds like it could work!** In *Batman and Robin*, when Batman and Dick Grayson are thinking up possible names for Dick, one of the names thrown about is "Nightwing," which is the superhero name that Dick Grayson uses in the comics today.

⑤ **Visual reference to a prior film.** In the scene where the Comedian is murdered in *Watchmen*, he throws his coffee cup at his assailant. It misses, but hits the number of the Comedian's apartment. His apartment is #3001. When the cup breaks against the number, the 1 falls off, leaving just 300, an homage to director Zack Snyder's previous film (and also a comic book adaptation), *300*.

⑥ **Strike a pose!** In *Superman Returns*, Superman saves a woman in a car. Later on, we see the cover of the *Daily Planet* with a picture of the event. It is designed to look just like the cover of *Action Comics* #1, the first appearance of Superman (where he lifts a car).

⑦ **Fallen foes.** In *Batman and Robin*, Bane goes into a room to get Mister Freeze's outfit for him so that Freeze can escape Arkham

Asylum. Also hanging in the room are the outfits for the Riddler and Two-Face, the villains from the previous *Batman* film, *Batman Forever*.

⑧ **Three generations together.** In the extended version of the original *Superman*, we see young Clark Kent race a train. A young girl says that she sees him do it, and her mother tells "Lois" not to fib. Clearly, this is meant to be a young Lois Lane. To extend the joke even further, the actress who plays her mother is Noel Neill, who played Lois Lane in the 1950s *Adventures of Superman* TV series, and her father in the same scene is played by Kirk Alyn, who played Superman in the 1940s *Superman* film serials.

⑨ **Keeping the tradition alive.** In *Superman Returns*, Noel Neill once again appears, this time playing Gertrude Vanderworth. In addition, Jack Larson, who played Jimmy Olsen on the 1950s TV series, makes an appearance as a bartender in the film.

SIX NOTABLE GOOFS FROM THE SAM RAIMI *SPIDER-MAN* FILMS

Goofs in films are always fun to catch. Here are six interesting ones from Sam Raimi's *Spider-Man* trilogy.

① **Self-healing wood.** In the famous mugging scene from *Spider-Man*, when Spidey saves Mary Jane from four muggers (and then Spidey and Mary Jane kiss in the rain), he tosses the first two crooks through two boarded-up windows. Then you see Spider-Man beat up the other two. In the next scene, the camera switches back to Mary Jane, and the windows behind her are clearly not broken.

② **Resilient lamp.** Earlier in the first film, when Peter is practicing shooting his webs, he accidentally latches on to a lamp in his room and pulls it down, breaking it. Aunt May eventually comes to check in on Peter and he opens the door just a crack to talk to her (he obviously can't let her in, since his room is filled with webs). Next to him we see the unbroken lamp back where it originally was.

③ **Oops, everyone's blind now, sorry.** In *Spider-Man 2*, Doctor Octavius has to wear special goggles while he is working on his fusion process because the light would blind him otherwise. However, no one else watching or working alongside the process are wearing goggles, neither the first time nor the second time they show it in the film.

④ **Alternate realities?** In *Spider-Man 3*, when Peter removes the symbiote in the church, Eddie Brock is downstairs praying, and it is clear that it is daylight outside, as all of the stained glass windows are lit up. However, in the Spider-Man scene, it is dark outside and raining. The Eddie scene directly follows the Spider-Man scene, sooo . . . alternate realities, anyone?

⑤ **Crummy gift.** In *Spider-Man 3*, everything Flint Marko had on him was turned into the special sand, just like him. His clothes, his belt buckle, everything. So how was he able to give his daughter a locket without it turning to sand?

⑥ **Cleveland rocks!** In the fight sequence in *Spider-Man 3* between Spider-Man and Sandman in the armored car, the Terminal Tower can be seen in the background. The Terminal Tower is a Cleveland landmark (which is where the film was shot). However, the film was set in New York City, not Cleveland.

FOUR MOVIE SUPERHEROES WHO WERE NOT FROM COMIC BOOKS

The math here is quite clear. Superhero movies sell, so if you can come up with your *own* superhero for a movie instead of having to license it from a comic book company, you could potentially make even *more* money. The key is, of course, that you have to be able to come up with a superhero as good as the ones they have in the comic books. That is a much trickier thing to do. Here are four films that used their own superheroes.

① **The Incredibles.** This is a bit of a cheat; while there is certainly a prototypical superhero ideal that most films use, the Incredibles were much more specific than that. Here, filmmaker Brad Bird essentially appropriated the idea of the Fantastic Four (a family of superheroes) and made them a *literal* family of superheroes, with Mr. Incredible, Elastigirl, Violet, and Dash (and later Jack-Jack). However, Bird did such a good job that you could make a strong argument that he surpassed his source material.

② **Hancock.** Vincent Ngo came up with the character that would ultimately become Hancock in 1996. Ngo was a big Superman fan, but was interested in seeing a version of Superman that was more "real." Eventually, his script was adapted by Vince Gilligan and John August into Hancock, about a superpowered alien (played by Will Smith) who cannot seem to quite get the hang of using his powers for good.

③ **Green Hornet.** It would surprise many people to learn that Green Hornet is not a comic book hero, and in fact, Green Hornet predates the very *idea* of a comic book superhero! Green Hornet actually made his debut in 1936 on the radio. His show was created by George Trendle and Fran Striker, the same people behind the popular *Lone Ranger* radio series. Green Hornet has been adapted into movies and films on a number of occasions, with Seth Rogan's turn as the Hornet in 2011 being the most recent.

④ **Darkman.** Darkman's origins lie with *The Shadow* and *Batman*. Not only was Darkman clearly inspired by these characters, but he was created only after director Sam Raimi could not secure the rights to adapt either of those other two characters into a film in the late 1980s.

EIGHT EXAMPLES OF COMICS REVERSE ADAPTING IDEAS FROM SUPERHERO FILMS AND TV SHOWS

Naturally, film and TV adaptations are going to change things from the comic books. Often these changes are tied in to casting (like the Kingpin being African American in *Daredevil*) and therefore do not affect the comics. Sometimes even particularly notable changes are not adapted to the comic (for instance, Superman did not suddenly have a kid with Lois Lane in the comic books). Occasionally, though, the comic books decide to implement the ideas originated on the film and television adaptations and you get a sort of "reverse adaptation." Here are eight examples of that.

① **Spider-Man's organic web-shooters.** In his very first comic book appearance in *Amazing Fantasy* #15, Spider-Man has created mechanical devices that can shoot sticky webs from them. In the film *Spider-Man*, though, these web-shooters come from his own body when Peter transforms into Spider-Man. After the film came out, the comics eventually had Spider-Man mutate a bit so that he, too, would have organic web-shooters, but in recent years, he has returned to the mechanical ones.

② **Clark and Lex, best pals.** This is a somewhat tricky one, because it was during the 1960s that the idea of Clark and Lex being friends when they were younger was introduced. This idea was dropped when they rebooted Superman in the mid-'80s. On *Smallville*, though, Clark and Lex are good friends as teens. So slowly over the years, Clark and Lex's background together in the comic books has begun to reference Lex growing up in Smallville and being old friends with Clark Kent.

③ **John Stewart's personality.** When the *Justice League* cartoon started, rather than choosing Hal Jordan, the character most associated with the Green Lantern, the producers chose John Stewart, another notable Green Lantern from Earth. In the show, John's personality is much different from the comics. He is depicted as a former U.S. marine with a very stoic personality. In the comics, he is an architect and much more sensitive. Over time, they have merged the two depictions within the comics, adding his marine background and spotlighting the seeming contradictions in his life and personality.

④ **Bat-Cave.** The Bat-Cave made its debut in the *Batman* film serial in 1943. Before this, Batman did his indoors crime-fighting in various hidden rooms within his mansion and a hangar that is accessible via an underground tunnel. However, film serials were

meant to be done *cheap*, and they did not have hangar sets or mansion sets (single rooms, yes, a full mansion, no). What they did have access to was a cave set (caves were very popular in serials). So, enter . . . the Bat's Cave, which debuted in the second chapter of the serial, where Batman and Robin take a bad guy to their cave to question him. Within a matter of months, the cave idea was adapted into the comics and has been featured ever since.

⑤ **Wonder Woman's method of transformation.** The producers of the Lynda Carter *Wonder Woman* series knew that they were going to use some sort of special effect when Diana Prince turned into Wonder Woman, but they weren't sure what exactly. They were thinking maybe she would just stand up and light would emanate from her and voilà—Wonder Woman! It was Lynda Carter, actually, who came up with the idea that she spin around and the burst of light come at the apex of the spin. The idea was soon adapted to the comic book and has been her method of transformation ever since.

⑥ **Thin Alfred.** Initially, in the *Batman* comic books, Alfred was a short, rotund fellow, but in the film serial from 1943, he was depicted by the tall, thin William Austin. The writers actually address this in the comic by having Alfred take a vacation and when he returns, he is thin! He has appeared as thin in the comic books ever since.

⑦ **Resurrected Alfred.** At the time that the 1960s *Batman* TV series was going to start filming, Alfred was dead in the *Batman* comic books. When the TV series was green-lit, producer William Dozier wanted Alfred to be in it. Once it was announced that he was going to be on the TV show, DC quickly brought Alfred back to life in the comics (and also finished the long-running mystery of who the

villain Outsider would be—he turned out to be Alfred, driven temporarily insane).

⑧ **Green Arrow's new series.** Oliver Queen became a popular supporting character on the TV series *Smallville* in the later seasons, eventually also showing up as the costumed hero Green Arrow. He even ended up marrying the popular supporting character Chloe Sullivan. In September 2011, DC debuted #1 issues for all of its superhero titles and decided in the process to revamp Green Arrow (who has always been much older in the DC Universe) to appear closer to how actor Justin Hartley portrayed the character on *Smallville*.

TEN RIDICULOUS RULES THAT THE 1990S *SPIDER-MAN* CARTOON HAD TO FOLLOW

When the *Spider-Man* animated series debuted in 1994, parent groups everywhere were complaining that the children's fare on TV was too violent. *Power Rangers* was the main target of this parental outrage but *Batman: The Animated Series* was also called out, since its adaptations were seen as too "adult." When you combine that concern with the fact that Marvel saw this cartoon series as one big commercial to sell Toy Biz action figures, producer John Semper was in a tough bind. He wanted to tell compelling stories in the cartoon, but that often clashed with the objectives of the decision makers higher up than him, particularly when you consider these ten crazy rules.

① **No Sinister.** In the comics, a team made up of Spider-Man's villains is called the Sinister Six. For the TV series, though, that was

considered too provocative of a name. Instead, they were called the Insidious Six.

② **No guns with bullets.** Guns were allowed on the show, of course, but only if they fired beams or other sorts of projectiles. No one ever shot a gun with bullets on the series in its five seasons and sixty-five episodes.

③ **Punching is a no-no.** Spider-Man only throws three punches in the entire series: once in the season two finale, once in the season three finale, and one other time during season three.

④ **No killers.** When they adapted the character of Carnage, the serial killer who gained a symbiote similar to Venom, the character could no longer be a killer and now had to be just some crazy guy.

⑤ **No fire.** Yes, there could not be any fire on screen!

⑥ **No breaking glass.** Again, I don't even know where to begin with the logic behind some of these rules.

⑦ **No use of the words "death," "die," or "kill."** At least you can understand the theory behind this a bit more than breaking glass and fire. The term "destroy" got used a lot as a result of this.

⑧ **No blood.** Pretty logical if you abide by the other rules.

⑨ **No real vampires.** The whole "no blood" rule really put a damper on the introduction of Morbius, who is a vampire. You can't show blood. You're not even supposed to *reference* blood. So how do you show a vampire? Well, in the case of Morbius, he has tiny mouth-like things in his hands that he attaches to people's faces and he

sucks "plasma" from them through their skin without breaking the skin. Yes, this looked as insane as it sounds.

⑩ Don't hurt the pigeons! The most inexplicable of the bunch: "When Spider-Man lands on the rooftop, be sure that he doesn't harm any pigeons."

FIVE FAMOUS CHARACTERS WHO WERE CREATED IN AN ANIMATED SERIES

Comic book fans have been quite lucky over the years with some of the animated series based on comic books. Not only have shows like *Batman: The Animated Series* and *Justice League Unlimited* provided good stories featuring characters who fans love, but they occasionally introduce new characters who later make their way into the comics. Here are five notable examples of that changeover.

① Harley Quinn. Probably the most famous example is Harley Quinn, the sidekick to the Joker that Paul Dini and Bruce Timm introduced in *Batman: The Animated Series* in 1992. She made her way to the "official" *Batman* comic book continuity in 1999 after Dini and Timm wrote the Eisner Award–winning one-shot comic book *The Batman Adventures: Mad Love*, which revealed Harley's origin for the first time. She has since gotten her own ongoing series and costars in *Gotham City Sirens* and *Suicide Squad*.

② Firestar. Initially, *Spider-Man and His Amazing Friends* was going to star Spider-Man, Iceman, and the Human Torch. Torch's rights, though, were tied up somewhere else, so the show's team decided

to create their own replacement. Veteran comic book costume designer John Romita Sr. designed the costume for Firestar. Romita clearly patterned her basic look on Mary Jane Watson, whose costume Romita had designed years earlier. The show proved to be popular and after it ended, Firestar was introduced into the Marvel Universe. She had her own miniseries and has since appeared as a member of the New Warriors and the Avengers.

③ **H.E.R.B.I.E.** The rights problem that the *Spider-Man* series had also affected a late 1970s *Fantastic Four* adaptation, depriving them of one fourth of the Fantastic Four! So they replaced the Human Torch with a tiny robot named H.E.R.B.I.E. A few years later, after the show had been canceled, H.E.R.B.I.E. was written into the *Fantastic Four* comics and given the duty of being the babysitter for Franklin Richards, son of Reed and Sue Richards (Mister Fantastic and Invisible Woman, respectively). Recently, Franklin and H.E.R.B.I.E. have starred in their own series of comic books called *Franklin Richards: Son of a Genius*.

④ **Renee Montoya.** Montoya is an unusual case, as she appeared in the *Batman* comic books before she ever appeared on *Batman: The Animated Series*. However, that was simply to get fans comfortable with the character. She was created by Paul Dini and Bruce Timm. She has gone on to become probably the most important police character in the *Batman* comic books outside of Commissioner Gordon. She was more or less the star of *Gotham Central*, a comic book series starring the cops of Gotham City. In that title, she dealt with the stigma that came with being a lesbian. After her partner was murdered, she, in turn, murdered the crooked cop who did her partner in. She quit the police force and eventually assumed the mantle as the new Question, replacing the former Question, who trained her while he was slowly dying of cancer.

⑤ **X-23.** X-23, a female clone of Wolverine, first appeared on the animated series *X-Men: Evolution* in 2003. She made her comic book debut in 2004 in the series *NYX*, about a group of young mutants in New York City. When she appeared in the comics, she was working as a prostitute. Her creators, Craig Kyle and Christopher Yost, were soon hired by Marvel to work on comic books there. They wrote two miniseries telling her origin story (and doing a good job explaining away the prostitute part). Currently she stars in her own ongoing series written by noted novelist Marjorie Liu.

EIGHT EASTER EGGS IN MARVEL SUPERHERO FILMS

When you're working on an expensive film for months, one of the ways to keep yourself entertained is to work in little hidden references or in-jokes. Here are eight hidden Easter eggs from Marvel's superhero films.

① **Dramatic irony.** In *Daredevil*, Bullseye kills a man with a pen. That man was played by Frank Miller, the famed writer and artist on the *Daredevil* comic book.

② **Captain America's mighty shield.** In *Iron Man*, when Tony is taking off his armor after having a dogfight with the F-22s, you can see Captain America's shield on the workbench behind him.

③ **Sneaky Bill Bixby cameo.** In *The Incredible Hulk*, Bruce Banner is flipping through channels when he stops for a moment on an episode of the old TV series *The Courtship of Eddie's Father*, which, of course, starred Bill Bixby, who later played Banner in the *Incredible Hulk* TV series.

④ **Familiar ringtone.** When Tony Stark gets a call on his cell phone in *Iron Man*, the ring tone is the theme song to the 1966 *Iron Man* cartoon show.

⑤ **Map of the Marvel Universe.** Near the end of *Iron Man 2*, when Nick Fury talks with Tony Stark at a S.H.I.E.L.D. safe house, there is a map in the background where certain locations have been circled. Those locations all match up with notable places in the film versions of the Marvel Universe (like New Mexico, which is where Thor's hammer shows up).

⑥ *Captain America* **comic.** In *Captain America: The First Avenger*, after Captain America is introduced and he becomes a media sensation selling war bonds, there is a quick montage of all the products he's being put onto. One of them is a comic book, and they use the actual cover of *Captain America Comics* #1!

⑦ *Incredible Hulk* **and** *Iron Man* **timing.** During the same meeting described above with Nick Fury and Tony Stark in *Iron Man 2*, there is a TV in the background showing a news report detailing the events that take place at the end of *The Incredible Hulk* (an incident at Culver University). So the endings of *Iron Man 2* and *The Incredible Hulk* are apparently concurrent with each other!

⑧ **Lots of Marvel names!** In *Daredevil*, seemingly every time a character needed to be named, they would go with a famous Marvel writer. Matt Murdock's boxer father fought against John Romita (named for early *Daredevil* artist, John Romita Sr.). Kevin Smith's character is named Jack Kirby. Early on, Matt Murdock is defending Mr. Quesada (Marvel's editor in chief at the time was Joe Quesada).

FOUR INTERESTING WAYS THAT ACTORS LOST OUT ON SUPERHERO ROLES

Typically, when an actor or actress is not chosen for a film, it's quite simply, "We don't want to cast you." However, on occasion, there are extraneous circumstances involved. Here are four actors and actresses who lost out on notable roles in superhero TV series and movies for interesting reasons.

① **Richard Kiel as the Incredible Hulk.** Richard Kiel is best known to audiences as the steel-toothed villain Jaws in the James Bond movies *The Spy Who Loved Me* and *Moonraker*. Casting for the Hulk was down to Kiel and a then-unknown Arnold Schwarzenegger. Ultimately, Kiel was chosen because of his great advantage in height over Schwarzenegger (over seven feet tall compared to Schwarzenegger's six). However, after filming began, the producers decided Kiel just did not look the part. He was tall, yes, but he did not have the muscular bodybuilder form they wanted the character to have. Thus, bodybuilder Lou Ferrigno was brought in as a replacement.

② **Sean Young as Vicki Vale.** Sean Young was not only cast as reporter Vicki Vale for Tim Burton's 1989 *Batman* film, she actually was involved in preproduction right up until one week before the film began shooting. There was a horse-riding scene in the film, and Young was practicing her riding. However, she was thrown from the horse and she broke her arm, forcing her out of the film. The producers brought in Kim Basinger at the last minute and the rest

is movie history. Young tried to win the role of Catwoman in the sequel by showing up at director Tim Burton's house in a homemade Catwoman outfit, but clearly, that tactic didn't work.

③ **Dougray Scott as Wolverine.** For a while there, things were looking good for Dougray Scott: he had won the coveted role of Wolverine in *X-Men and* he was cast as the bad guy in the *Mission: Impossible* sequel opposite Tom Cruise. The problem was that Tom Cruise just did not like the script of *Mission: Impossible II*. So right before filming was to begin in March 1999, production was delayed for two months, therefore making the filming of *Mission: Impossible II* overlap with the filming of *X-Men*. Ultimately, Scott had to drop out of his role as Wolverine. With very little time to prepare, the producers of the film had to find a replacement, so they went back to one of the early candidates for the role (from nearly ten months earlier), Hugh Jackman. Jackman later noted that, when he spoke with Scott years afterward, "I didn't quite have the guts to say thank you; I kind of apologized to him."

④ **Benjamin Walker as the Beast.** In 2010, the brash young star of the off-Broadway sensation *Bloody Bloody Andrew Jackson* won the role of the young Hank McCoy in the 2011 film *X-Men: First Class*. However, after learning that *Bloody Bloody Andrew Jackson* was going to get a run on Broadway, Walker quit the *X-Men* role to reprise his role in the musical. He was replaced by Nicholas Hoult. Sadly, the musical opened in October 2010 and closed on January 2, 2011. (True story, I had tickets to the January 4 showing.) Still, you have to admire a guy for sticking to his roots like that. Walker landed on his feet, though, as just a few weeks later he signed on to play the lead in *Abraham Lincoln, Vampire Hunter*.

FOUR PILOTS FOR SUPERHERO TV SERIES THAT NEVER GOT PICKED UP

Superhero characters are ripe for adaptation into films and TV series, and a number of them have been made over the years. However, for every one sold, there are likely three that don't even get as far as making a pilot. Of the shows that have actually gotten to make a pilot, here are four superheroes whose pilots did not get turned into a television series by the networks.

① **Thor.** In 1988, the characters from the *Incredible Hulk* TV show returned in a TV movie aptly titled *The Incredible Hulk Returns*. In it, Dr. David Banner (Bill Bixby) is approached by a former student named Donald Blake (Steve Levitt), who has found a hammer that allows the Norse god Thor to appear if he shouts "Odin!" As it turns out, Thor (Allan Kramer) has been assigned to be a sort of guardian angel for Blake and he has to do a certain amount of good for Blake before Odin will allow him back to Asgard. Naturally, Thor and the Hulk (Lou Ferrigno) battle it out. The TV movie was to be a pilot for an ongoing Thor series, but that did not work out. However, if at first you don't succeed . . .

② **Daredevil.** In 1989, David Banner is on the run after the disastrous fight with Thor in the previous TV movie described above. He witnesses a murder and finds himself framed for the crime by the evil mob boss Wilson "the Kingpin" Fisk. Thus begins the next TV movie featuring the Hulk, called *The Trial of the Incredible Hulk*. Banner's attorney is Matt Murdock (played by Rex Smith), who is blind. When Banner, in prison, freaks out, turns into the Hulk,

and escapes, Murdock tracks him down as the vigilante Daredevil. He asks for Banner's help in taking down the Kingpin. Together they clear Banner's name. Amusingly enough, the jury foreman on Banner's trial is played by Stan Lee, his first cameo appearance in a Marvel film of any kind. This was meant to work as a pilot for a Daredevil series. It did not work out.

③ **Justice League of America.** In 1997, CBS produced a pilot trying to adapt the Keith Giffen–J. M. DeMatteis era of the *Justice League* into a TV series. Giffen and DeMatteis's run was often referred to as being sitcomlike, and that's just what the TV series was like— it was essentially a sitcom with superheroes—really, really low-budget superheroes.

It had some major names attached, but it turned out quite cheesy and unsurprisingly was not picked up.

④ **Wonder Woman.** This revamp of the *Wonder Woman* concept (which was a hit TV series for ABC during the 1970s) was handled by David E. Kelley, the same guy who won about 457 Emmys during the 1990s for shows like *L.A. Law, Picket Fences, The Practice,*

and *Ally McBeal*. The show would star Adrianne Palicki as Diana Themyscira, who owns a corporation that funds her crime-fighting as Wonder Woman. For the sake of some anonymity, she also lives under the name Diana Prince, in a small apartment with a cat. In the first episode, she battles against an evil CEO named Veronica Cale (a character from the *Wonder Woman* comics in the 2000s), who Wonder Woman believes is selling mutated forms of steroids to teens. Before starting her career as Wonder Woman, Diana dated a man named Steve Trevor. At the end of the episode, he shows up as her new liaison with the U.S. Justice Department. However, he has gotten married since they last saw each other. Hey, it worked for *Ally McBeal*, didn't it? After initially turning down the idea, NBC was bought and the new management wanted the show and had Kelley make the pilot. However, with its high budget, NBC had to be *positive* that the show would be a success, and with some initial negative buzz on the Internet regarding the show (including Palicki's costume), they felt it was too risky so they passed.

FIVE ODD SUPERHERO CARTOON ADAPTATIONS THAT NEARLY HAPPENED

When you consider the fact that the *Thing* cartoon, with little Benjy Grimm using a magic ring to transform into the Thing, was picked up and lasted a season, it really makes you wonder what kind of superhero cartoon would *not* get made. Well, here are five odd animated superhero TV show ideas that never made it to series.

① **The X-Men.** Of the shows on this list, this is the only one that actually had a pilot that aired on television. Entitled "Pryde of the

X-Men," this was a fairly strong adaptation of the X-Men as they existed in the early 1980s. In any event, the animation on the series was excellent and the choice of characters was also quite impressive—in fact, the popular X-Men arcade game of the early 1990s was based on the characters in this pilot. However, the personalities of the characters tended to be a bit campy and perhaps the most notable problem was that they decided to make Wolverine Australian. The sound of Wolverine talking like Crocodile Dundee was extremely jarring for most fans. Of course, the amusing irony is that Wolverine was eventually quite successfully portrayed on film by Hugh Jackman—who is Australian. Still, the failure of this show led to the later success of the 1992 series, so all's well that ends well.

② **Daredevil.** During the early 1980s, after the success of *Spider-Man and His Amazing Friends*, Marvel looked to release a new cartoon series, and this time the subject was to be a hero who had yet to appear in his own cartoon series—Daredevil. The approach, however, was a bit . . . interesting. The series was to star blind attorney Matt Murdock and his Seeing Eye dog, who would fight crime as Daredevil and Lightning, the Super-Dog! Mark Evanier later noted that he worked on the show and by the time he was finished with it, while Murdock still had a Seeing Eye dog, it did not help him fight crime. Sadly, nearly just as soon as the people at ABC decided to order the series they quickly changed their minds and dropped it.

③ **Wonder Woman and the Star Riders.** In 1992, DC and Mattel got together and discussed creating a new toy line of "action figure Barbies" based on Wonder Woman. It had been a while since the last major girl action figure line (the He-Man complementary line, She-Ra), and Mattel figured it would be worth a shot. So was born *Wonder Woman and the Star Riders*! The basic gist was that Wonder

Woman, Dolphin, and Ice (plus two superheroines original to the show) would ride around on flying horses and help stop the bad guys. The legendary DC artist José Garcia-López actually designed the characters. A prototype of the toy line was produced for the 1993 Toy Fair, but the line, and the proposed TV series (which apparently never went past storyboards), fell apart. The canceled toy designs were recycled as part of the Tenko and the Guardians of the Magic toy line, and the characters actually did appear once: in a tie-in comic with Kellogg's Mini Muffins!

④ **Captain America.** During the mid-1990s, Marvel began work on a *Captain America* animated series with legendary writer Steve Englehart at the helm. It was set during World War II in Europe, but amusingly enough, the bad guys were not allowed to be called "Nazis." Red Skull was the bad guy still, but he could not be called a Nazi and, of course, no swastikas were allowed to be shown. Englehart recalled that Marvel's mid-'90s financial problems (the company eventually declared bankruptcy toward the end of the decade) ended the series.

⑤ **Gotham High.** Comic book artist and writer team Celeste Green and Jeffrey Thomas sent DC a pitch for a Batman cartoon featuring all the major characters as teenagers in high school together. DC editors liked it enough that they asked Green and Thomas to develop it further, but ultimately it never made it to air. I wonder how you would go about sending the Joker to detention.

SIXTEEN STAN LEE MOVIE CAMEOS

As the longtime editor in chief and main writer of Marvel Comics (and later the publisher), Stan Lee has for years been the public

face of the company and the various characters he cocreated. As a result, when Hollywood began adapting Marvel characters into major motion pictures, Lee went along for the ride and made cameos in nearly every major Marvel film of the twenty-first century. Here are all of Stan the Man's Marvel film cameos, plus one utterly bizarre noncomic-book film cameo. . . .

1. **X-Men** (2000). Lee is a hot dog vendor on the beach when Senator Kelly emerges from the water after escaping from Magneto.

2. **Spider-Man** (2002). Lee plays a bystander who saves a little girl from falling debris during a battle between Spider-Man and Green Goblin.

3. **Daredevil** (2003). Young Matt Murdock shows off his "radar sense" by stopping Lee from crossing the street and getting hit by a bus.

4. **Hulk** (2003). Lee plays a security guard alongside Lou Ferrigno (who played the Hulk in the 1970s TV series). This is Lee's first speaking part in a Marvel film.

5. **Spider-Man 2** (2004). Once again, Lee plays a bystander who saves someone from falling debris, this time during a fight between Spider-Man and Doctor Octopus.

6. **Fantastic Four** (2005). Lee plays Willie Lumpkin, the Fantastic Four's mailman. Lumpkin was a mailman character Lee created for a short-lived comic strip before he created the Fantastic Four. He later wrote Lumpkin into the *Fantastic Four* comic book.

7. **X-Men: The Last Stand** (2006). Lee plays a neighbor of Jean Grey who is watering his lawn when her telekinetic powers cause the water from his hose to float into the air.

⑧ *Spider-Man 3* (2007). Lee actually interacts with Peter Parker. The two are standing in Times Square looking at a news bulletin when Lee says to Parker, "You know, I guess one man can make a difference," finishing with his catchphrase, "'Nuff said."

⑨ *Fantastic Four: Rise of the Silver Surfer* (2007). Playing himself, Lee is barred from attending the wedding of Reed Richards and Sue Storm, something that previously happened in the original comic book version of the wedding in 1965's *Fantastic Four Annual* #3 (where Lee and *Fantastic Four* cocreator Jack Kirby are rebuffed at the door).

⑩ *Iron Man* (2008). At a gala, Tony Stark mistakes Lee (who is surrounded by three beautiful women) for Hugh Hefner.

⑪ *The Incredible Hulk* (2008). Lee plays a regular guy who accidentally drinks a soft drink that was infected with Bruce Banner's blood. This lets the government know that Banner is hiding out in a Brazilian bottling plant.

⑫ *Iron Man 2* (2010). During Stark Expo, Tony Stark refers to Lee (who is wearing suspenders, a red shirt, and a black and purple tie) as Larry King.

⑬ *Thor* (2011). Lee is one of many people trying to lift Thor's hammer early in the film. Lee tries to pull it using a chain on his pickup truck, but it just tears off the back of his truck.

⑭ *Captain America: The First Avenger* (2011). Lee is a general in World War II in a scene where Captain America is set to receive an award.

⑮ *The Amazing Spider-Man* (2012). Lee plays a librarian wearing headphones who continues stamping books while a fight between Spider-Man and the Lizard goes on behind him.

And the bizarre non-comic-book-related film that Lee had a cameo in?

⑯ *The Princess Diaries 2: Royal Engagement* (2004). Lee plays a Spanish wedding guest who only knows English through watching Three Stooges films, so he acts like one of the Stooges. Strange, inexplicable, and purely awesome.

LIST OF COMIC BOOK ARTIST NAMES ALONG WITH ISSUE NUMBERS

(If two artists are listed, the first artist is the penciler and the second artist is the inker.)

⑧ Dave Gibbons, *Green Lantern* (Vol. 2) #188 (interior panels)

⑬ John Byrne and Terry Austin, *Marvel Team-Up* (Vol. 1) #79 (interior panel)

⑭ Terry Dodson and Rachel Dodson, *Marvel Knights: Spider-Man* #4 (interior panel)

⑮ Jack Kirby and Paul Reinman, *X-Men* (Vol. 1) #1 (interior panel)

⑮ Bruno Premiani, *My Greatest Adventure* (Vol. 1) #80 (interior panel)

⑯ Gary Frank and John Dell, *Black Canary/Oracle: Birds of Prey* #1 (interior panel)

⑯ Jack Kirby and George Tuska, *Captain America* (Vol. 1) #112 (interior panel)

⑰ Gil Kane and Sid Greene, *Green Lantern* (Vol. 2) #34 (interior panel)

⑰ Jack Kirby and Vince Colletta, *New Gods* (Vol. 1) #1 (interior panel)

⑱ Win Mortimer, *Batman* (Vol. 1) #92 (cover)

㉘ Phil Jimenez and Andy Lanning, *New X-Men* (Vol. 1) #148 (interior panel)

(29) Billy Tan and Jonathan Sibal, *Marvel Knights: Spider-Man* #13 (interior panel)

(36) Ron Frenz and Brett Breeding, *Thor* (Vol. 1) #390 (interior panel)

(37) George Perez, *Avengers/JLA* #4 (cover)

(38) Mike Deodato and Jose Pimentel, *Amazing Spider-Man* (Vol. 1) #512 (interior panel)

(45) Mike Sekowsky and Pablo Marcos, *The Brute* #1 (interior panel)

(52) Bill Sienkiewicz, *Daredevil: Love and War* (interior panel)

(53) Ashley Wood, *Zombies vs. Robots vs. Amazons* #1 (cover)

(59) Glenn Fabry, *Preacher* #1 (cover)

(59) Frank Miller, *Batman—The Dark Knight Returns: Tenth Anniversary Edition* (cover)

(59) Jack Kirby and Joe Sinnott, *Fantastic Four* (Vol. 1) #49 (cover)

(60) Dave McKean, *The Sandman* #1 (cover)

(60) Dave Gibbons, *Watchmen* Collected Edition (cover)

(61) John Byrne and Terry Austin, *Uncanny X-Men* (Vol. 1) #141 (cover)

(61) Neal Adams, *Batman* (Vol. 1) #244 (cover)

(62) J. H. Williams III and Mick Gray, *Absolute Promethea* (interior page)

(62) Jack Kirby and unknown inker, *Fantastic Four* (Vol. 1) #1 (cover)

(76) Bob Kane, *Detective Comics* (Vol. 1) #33 (interior panel)

(76) Henry Vallely, *Big Little Book: Gang Busters in Action* (interior page)

(76) Bob Kane, *Detective Comics* (Vol. 1) #33 (interior panel)

(76) Henry Vallely, *Big Little Book: Gang Busters in Action* (interior page)

(77) Bob Kane, *Detective Comics* (Vol. 1) #27 (interior panel)

(77) Henry Vallely, *Big Little Book: Gang Busters in Action* (interior page)

(77) Bob Kane, *Detective Comics* (Vol. 1) #27 (interior panel)

(77) Henry Vallely, *Big Little Book: Gang Busters in Action* (interior page)

(78) Darwyn Cooke, *Jonah Hex* (Vol. 2) #50 (interior panels)

(79) Jim Steranko, *Nick Fury, Agent of S.H.I.E.L.D.* (Vol. 1) #2 (interior panels)

(79) Jaime Hernandez, *Love and Rockets* (Vol. 1) #23 (interior panels)

(80) Todd McFarlane, *Spider-Man* #3 (interior panel)

(85) Bob Kane, Jerry Robinson and George Roussos, *Batman* (Vol. 1) #3 (interior panels)

(88) Bob Kane and Jerry Robinson, *Batman* (Vol. 1) #1 (interior panel)

(93) Ramona Fradon, *Adventure Comics* (Vol. 1) #271 (interior panel)

(94) Gil Kane and John Romita Sr., *Amazing Spider-Man* (Vol. 1) #121 (interior panel)

(94) John Byrne and Terry Austin, *X-Men* (Vol. 1) #132 (interior panel)

(95) John Romita Sr. and Mike Esposito, *Amazing Spider-Man* (Vol. 1) #50 (interior panel)

(95) Frank Miller and Klaus Janson, *Daredevil* (Vol. 1) #181 (interior panel)

(96) John Romita Sr., *Amazing Spider-Man* (Vol. 1) #42 (interior panel)

(100) 20th Century Fox

(106) Carl Pfeufer, *Super Green Beret* #1 (cover)

(117) Jack Derby and Dick Ayers, *Fantastic Four* (Vol. 1) #8 (interior panel)

(137) Tony Abruzzo, *Secret Hearts* #83 (interior panel)

(138) Irv Novick, *All-American Men of War* #89 (interior panel)

(139) Tony Abruzzo, *Secret Hearts* #83 (interior panel)

(140) Russ Heath, *All-American Men of War* #89 (interior panel)

(141) Dick Giordano, *Strange Suspense Stories* #72 (interior panel)

(142) Jack Kirby and Paul Reinman, *X-Men* (Vol. 1) #1 (interior panel)

(149) Gil Kane, *Showcase* #22 (cover)

(150) Gil Kane and Murphy Anderson, *Green Lantern* (Vol. 2) #52 (cover)

(150) Neal Adams, *Green Lantern* (Vol. 2) #76 (cover)

(151) Neal Adams, *Green Lantern* (Vol. 2) #85 (cover)

(151) Brian Bolland, *Green Lantern* (Vol. 2) #127 (cover)

(152) Brian Bolland, *Tales of the Green Lantern Corps* #1 (cover)

(152) Darryl Banks and Romeo Tanghal, *Green Lantern* (Vol. 3) #49 (cover)

(153) Ivan Reis, *Green Lantern* (Vol. 4) #29 (cover)

(153) Ivan Reis and Oclair Albert, *Green Lantern* (Vol. 4) #39 (cover)

(155) Kyle Baker, *Elseworlds 80-Page Giant* #1 (interior panel)

(161) Jack Kirby and George Roussos, *Avengers* (Vol. 1) #4 (cover)

(162) Mike Sekowsky and Murphy Anderson, *Brave and the Bold* (Vol. 1) #28 (cover)

(162) Joe Kubert, *Brave and the Bold* (Vol. 1) #36 (cover)

(163) Gil Kane, *Green Lantern* (Vol. 2) #45 (cover)

(164) John Buscema, *Silver Surfer* (Vol. 1) #4 (cover)

(164) Jack Kirby and most likely Paul Reinman, *X-Men* (Vol. 1) #1 (cover)

(175) Neal Adams, *Green Lantern* (Vol. 2) #85 (cover)

(175) David Mazzucchelli, *Batman* #404 (cover)

(176) Dave Gibbons, *Watchmen* #1 (cover)

(176) Kevin Maguire and Terry Austin, *Justice League* #1 (cover)

(177) Frank Miller, *Batman: The Dark Knight Returns* (cover)

(177) Brian Bolland, *Batman: The Killing Joke* (cover)

(178) Bob Kane, *Detective Comics* (Vol. 1) #27 (cover)

(178) Carmine Infantino and Murphy Anderson, *Flash* (Vol. 1) #123 (cover)

(179) George Perez, *Crisis on Infinite Earths* #7 (cover)

(179) Joe Shuster, *Action Comics* (Vol. 1) #1 (cover)

(187) Jack Kirby and Dick Ayers, *Strange Tales* (Vol. 1) #136 (interior panel)

(190) Clifford Berryman, "Drawing the line in Mississippi" (panel)

(194) Curt Swan and Frank Giacoia, *Superman* (Vol. 1) #279 (interior panel)

(194) Gabriel Bá, *The Umbrella Academy: Dallas* #3 (interior panel)

(210) Joe Kubert and Neal Adams, *Superman vs. Muhammad Ali* (also known as *All-New Collectors' Edition* #C-56) (cover)

(211) Joe Quesada, *Amazing Spider-Man* #573 (cover)

(218) Joe Kubert, *Super-Dictionary* (interior panel)

(221) Jim Aparo and Mike DeCarlo, *Batman* (Vol. 1) #427 (interior panel)

ALSO AVAILABLE FROM
BRIAN CRONIN

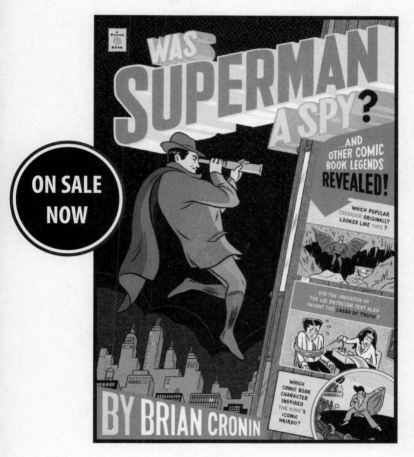

ON SALE NOW

WWW.LEGENDSREVEALED.COM
AVAILABLE WHEREVER BOOKS ARE SOLD.

PLUME
A MEMEBER OF PENGUIN GROUP (USA) INC.
WWW.PENGUIN.COM